Art Classics

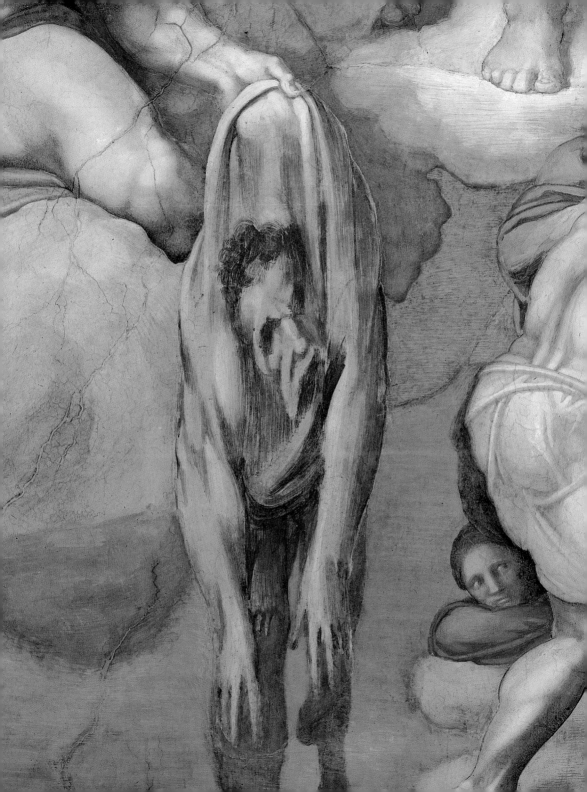

Art Classics

MICHELANGELO

Preface by Eugenio Battisti

RIZZOLI
NEW YORK

ART CLASSICS

MICHELANGELO

First published in the United States
of America in 2005 by
Rizzoli International Publications, Inc.
300 Park Avenue South
New York, NY 10010
www.rizzoliusa.com

Originally published in Italian by
Rizzoli Libri Illustrati
© 2004 RCS Libri Spa, Milano
All rights reserved
www.rcslibri.it
First edition 2003
Rizzoli \ Skira - Corriere della Sera

2005 2006 2007 2008 2009 /
10 9 8 7 6 5 4 3 2 1

Printed in China

ISBN: 0-8478-2678-3

Library of Congress Control
Number: 2004099914

Director of the series
Eileen Romano

Design
Marcello Francone

Editor (English edition)
Julie Di Filippo

Translation
David Stanton
(Buysschaert&Malerba)

Editing and layout
Buysschaert&Malerba, Milan

Cover
Creation of Adam
(detail), 1510
Vatican City, Sistine Chapel

Frontispiece
Saint Bartholomew
(detail of the *Last Judgment*),
1537–1539
Vatican City, Sistine Chapel

The publication of works owned by
the Soprintendenze has been made
possible by the Ministry for Cultural
Goods and Activities.

© Archivio Scala, Firenze
© Vatican Museums

Contents

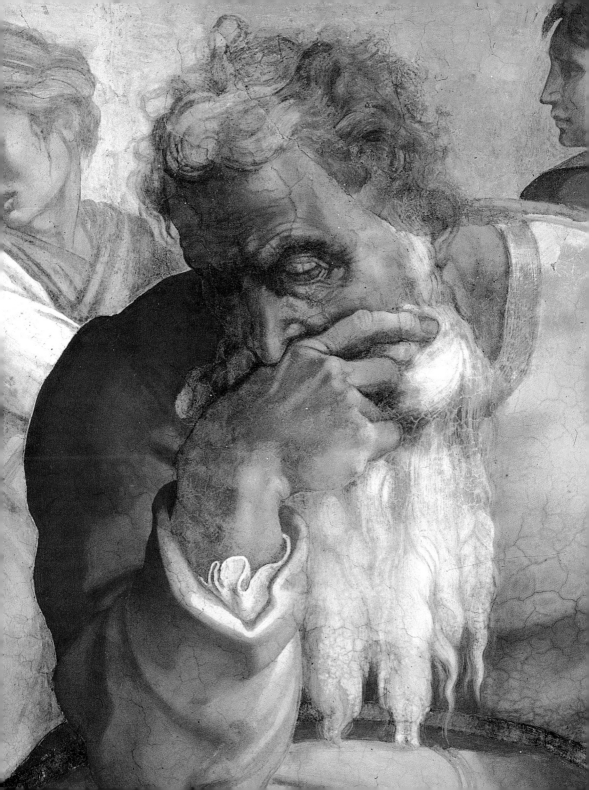

The Divine Rebel
Eugenio Battisti

Like Raphael, Michelangelo Buonarroti was a man of the court. His activity was carried out on behalf of members of the aristocracy and popes and was determined by their objectives. By serving the courts he won immense glory and suffered an infinity of disappointments: he had to accept contact with a milieu that offended his religious scruples; he had a lot of trouble getting paid; he felt he was tied to a regular job, as demanding as any other occupation, but much more stressful.

Rather than in the magnificence of the works he conceived and executed—but which were commissioned and paid for by the papal court—the miracle of Michelangelo's art lies in his moral rectitude and the way his style adhered to this. In order to assess this phenomenon, it is necessary to compare his behavior with that of his main adversary—Raphael. The latter was enthusiastic about his social position: he built a palace and held a small court; he escaped the boredom of fashionable society by seeking out plebeian lovers; with nonchalance he passed from a biblical scene to a profane theme, and members of his school even engraved pornographic subjects. There is not even a trace of the problems of Roman politics and the tribulations of the religious life in Raphael's work; the great frescoes of the Stanze manage to convey a sense of sumptuousness and majestic calm, but they do not suggest emotions. Raphael was naturally given to facility and spontaneity, and when he abandoned his real talents for Ciceronian rhetoric, not only did the quality of his work decline alarmingly but he even ended up by leaving the execution of his cartoons and drawings to his eager pupils.

Prophet Jeremiah (detail), 1511 Vatican City, Sistine Chapel

Michelangelo could have done the same. In Rome people were surprised that he did not obtain or establish a school. Those who had many pupils executed lots of works and, of course, earned plenty of money. But Michelangelo lived a miserable, solitary existence, "with many worries and great fatigue." The letters that he wrote to his brother are very sad: "I don't have any money. What I'm sending you, I've drawn from my heart and I don't think it's right to ask for any more because I don't have anybody working for me and, on my own, I don't work much." His contemporaries did not understand this attitude. Leo X was desperate: "It's terrible," he once said, "you can't negotiate with him." In reality, for Michelangelo, difficulty was his tutelary deity: the more a problem was difficult, the more he tried to resolve it and the more he showed his ingenuity. His best works are the most tormented ones. The artist not only had an introspective character but he also nurtured himself on fantasies. He saw symbols and allusions everywhere: from Medicean Platonism he had derived, above all, the concept of a universe full of occult entities that it was man's task to reveal. Mean, presumptuous, arrogant and stubborn, he allowed himself to be carried away by uncontrolled passion: he had such ardent friendships that he acquired an ambiguous reputation and, despite his adoration of the divine beauty, he fell in love with an ugly, but holy, woman.

Michelangelo had been like this since he was a child, since the angry angel that accompanies Niccolò dell'Arca's less distraught ones in Bologna, since his early marble tondi in which where the Virgin, who ought to be playing with the Christ child, is sad and thoughtful like a sibyl. Already in his early works the artist's characteristic moral attitude is evident: pensiveness nurtured by reflection; sadness pervaded by disquiet and nightmares, obsessed by the passage of time, by the idea of death, troubled by a secret inner struggle, downcast and discontented.

following
pages
*Virgin and
Child with the
Infant Saint
John the
Baptist and
Four Angels*
(detail),
c. 1495–1497
London,
National
Gallery

Were these works to receive the attention of a psychoanalyst, surely a sad childhood would be revealed. Michelangelo believed he was the descendant of a noble family, which had then declined; the beginning of his artistic career was certainly hastened by the need to earn money. He probably would have preferred to study literature. Moreover, his training coincided with a very disturbed period for Florence during which, for economic reasons, the arts were declining and commercial success—that is, the craft—was supplanted by the approval of Lorenzo de' Medici's cultured coterie: in other words, the taste of the literati. Thus the artist felt the impact of the court culture right from the outset: his abandonment of Ghirlandaio's workshop—where he learned the fresco technique—for the Medici gardens, its avenues lined with statues where, in what was a kind of art school, Bertoldo di Giovanni taught a group of young artists a style based on that of Donatello with the addition of archaeological elements, also marked his definitive transition from the free economy of the artist's workshop to the protected one of the court employee. After Lorenzo de' Medici (also known as Lorenzo the Magnificent) died, Michelangelo sought to live on the income from his independent work, but he had a bitter experience in this respect. He even attempted to pass off his representation of Cupid as a classical work, but the deception was discovered and it was rejected. Success only arrived with the official commissions for the *David* and the fresco of the *Battle of Cascina* for the Palazzo della Signoria. In these works his main concern was with their monumentality. Later he was to move to Rome.

That a potential rebel like Michelangelo was willing to execute commissioned works for the whole of his life was not only due to financial reasons. He had, in fact, a calling for life at court. As mentioned above, he felt he was an impoverished aristocrat and his dream was to restore his family's power and prestige. He put himself at the service of others in order to free his descendants from servitude: he accepted abjection as redemption from future degradation. He descended into vulgarity in order to free himself

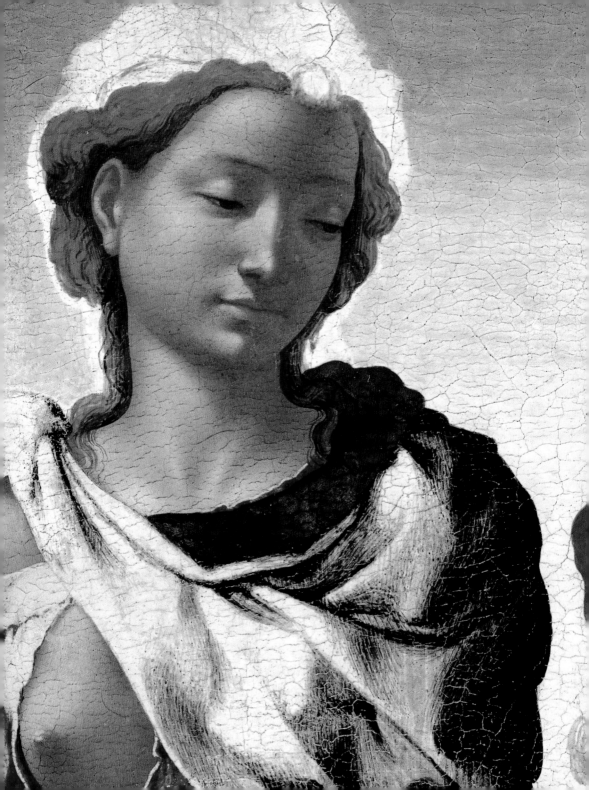

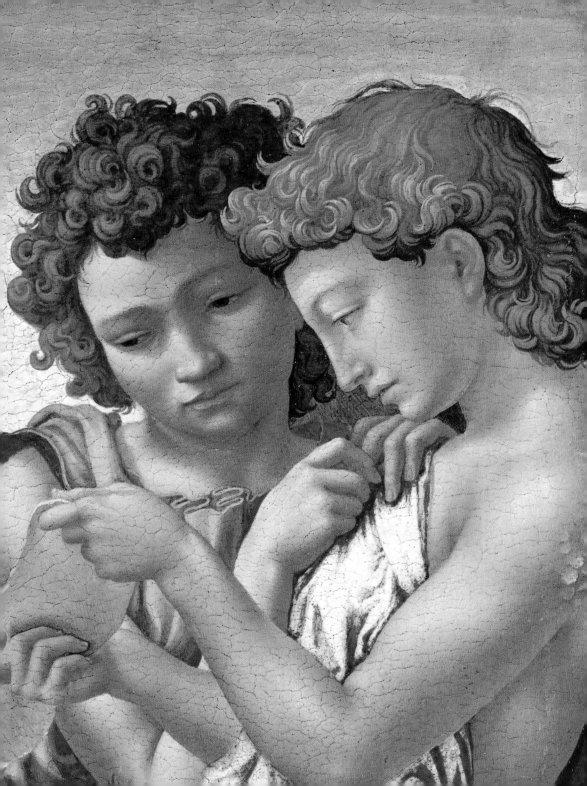

from it and felt that only he was to blame for his condition. Thus his ambition was colored with religion.

This aspiration to nobility had important consequences for the whole of his art. First of all he endeavored to ennoble it, giving great weight to his allegorical and literary inventions: painting and sculpture were still regarded as manual crafts, while poetry enjoyed all the honors. Thus the figurative arts attempted to rival literature. He gave particular importance to drawing—that is, to invention. Drawing recorded fantastic ideas, which—according to the theories of the period—were the transcendental element of art. He affirmed the need to create new forms, not to adhere to pre-existing models, to always devise different solutions: in this way he accelerated the technical progress of art, creating a stylistic break with the Quattrocento. And since the Platonic philosophy, which Michelangelo had absorbed in Lorenzo the Magnificent's court, created a hierarchy of beings, constituting a ladder that from the inanimate elements reached the celestial essences and, by placing man at the highest level between earth and heaven, the artist did not wish to represent anything other than man in his ideal beauty. What is usually described as "heroic humanity" is nothing more than humankind imagined without the imperfections due to matter or the adverse influence of the stars.

This mystical adoration of man coincided with the enthusiasm, then at its height, for archaeological investigation, which was already carried out with scientific rigor. Classicism had been exalted by the church on various occasions, as confirmation of the continuity between the Roman Empire and the papacy. It was especially under Nicholas V that the reconstruction of Rome was deliberately undertaken in order to renew its ancient splendor. Nicholas's program was still relevant in Michelangelo's day. The reference to the antique served, furthermore, to endow style with grandeur and nobility and allowed a number of naiveties of the Quattrocento tradition to be abandoned. Thus

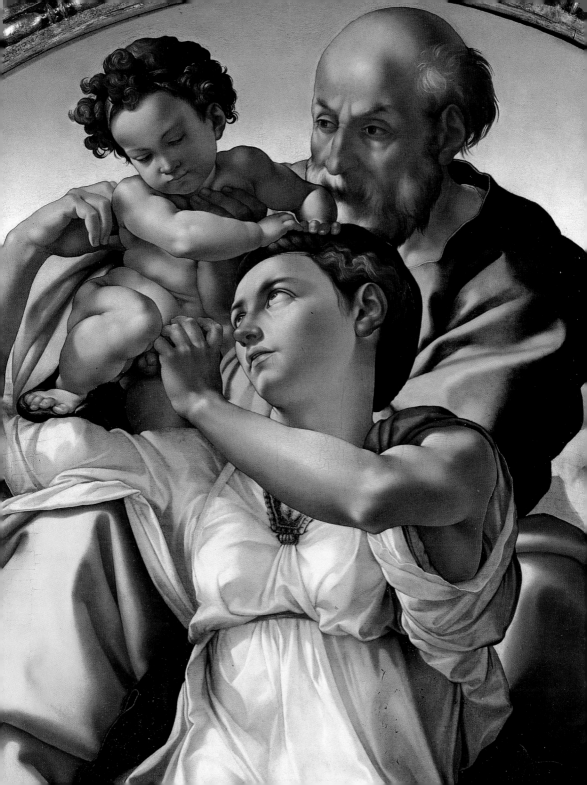

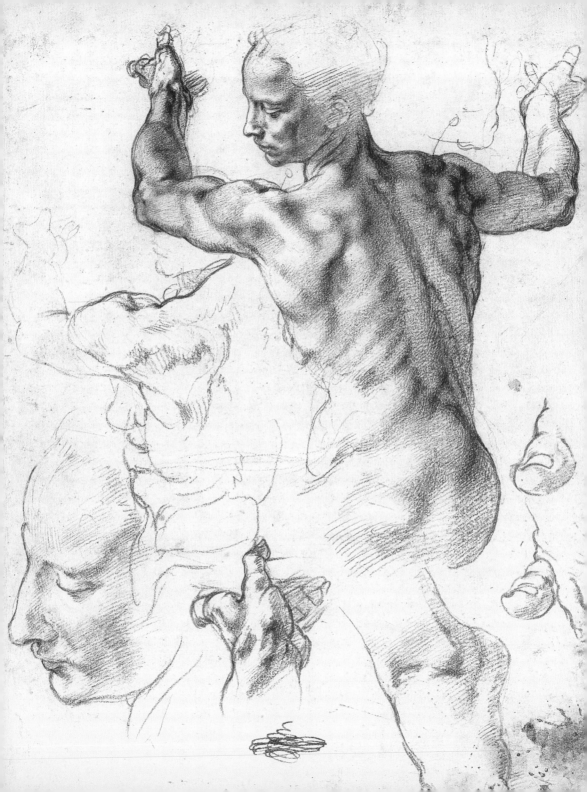

Michelangelo admired with great excitement—as his contemporaries did—poor copies from antiquity, believing them to be the work of the famous sculptors praised by Pliny.

However he was particularly interested in the technical skill of the sculptors of antiquity and their precise rendering of the human anatomy, and compared their works with the real thing by dissecting cadavers and studying the movement of the limbs, following the example of Aristotle and perhaps Galen. Movement gradually became an obsession for him and, since he was a vigorous person, he ended up by reacting violently to the classical models. While, above all as a result of Pietro Bembo's theories, the principle of the imitation of the works of antiquity became more binding, Michelangelo formulated a theory that was quite the opposite: the artist only had to represent what germinated spontaneously in his mind. From this was born Mannerism—that is, a style that was imaginative and fantastic, with the unnatural, visionary forms that were favored, in particular, by El Greco.

Despite his poetic aspirations and the intensity of his feelings, Michelangelo only managed to free his imagination from the study of nature and antique works toward the end of his life. On various occasions he abandoned works before he had finished them and he was always tormented by doubts. His last work, the *Pietà Rondanini*, is perhaps the only one that is the perfect representation of his poetic purpose. Previously he had been preoccupied with problems of technique, culture and even excessive ambition. It is true that the responsibility for certain important undertakings, such as the enormous tomb of Julius II—in reality, a mausoleum for Old Saint Peter's—lay with the patrons; but it is also true he was particularly stimulated by the idea of doing things on a grand scale. Thus Michelangelo expressed the political ambitions of the papacy through a solemn monumental style with its sense of enchanted grandeur.

Yet, even in these dreams of power, he was sincere. He obeyed, in fact, an inner religious calling: he opposed the facile appeal of sensuality and

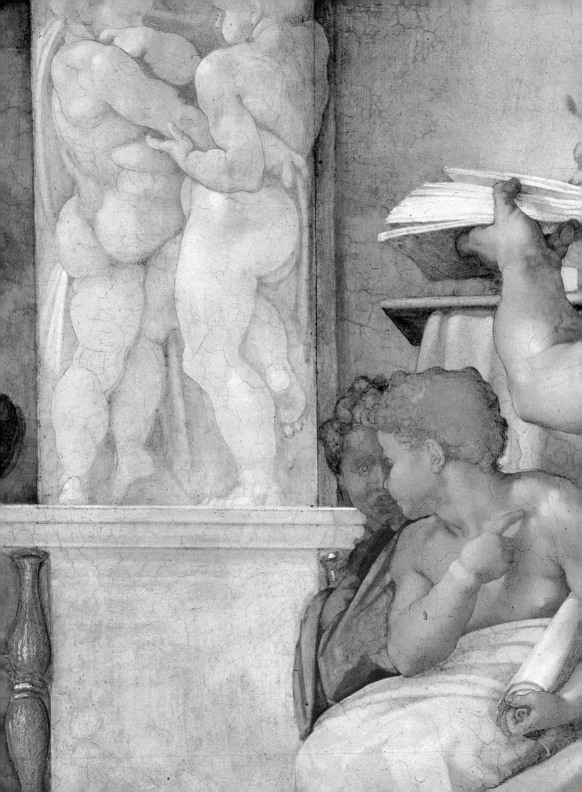

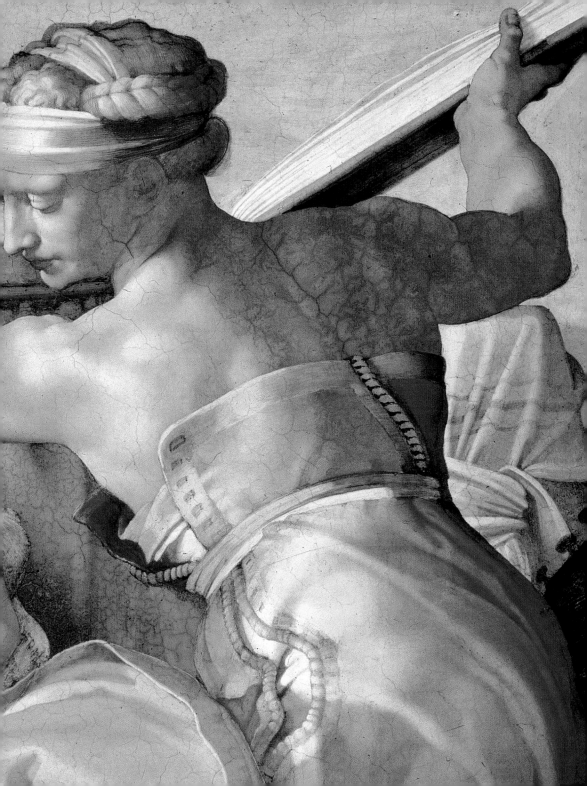

sentiment, the quasi-romantic allure of Netherlandish painting for the viewer; he preferred the pure, unadorned mode of the simple proportions characteristic of Brunelleschi and Alberti, the simple color that clothes the image and without transforming it, the historical account reduced to its essential elements. Thus he wished to return not only to antiquity but also to periods of intense spirituality, such as that of the early Renaissance in Florence. This was the climate in which the austere epic of the Sistine ceiling took place. Here the almost monochrome sacred figures rose in a superhuman manner, moving away in time and space toward a remote lost golden age in which the gods descended to earth to speak among men and the biblical patriarchs grazed their flocks on the hills. Prophets, sibyls, ancestors of Christ, and biblical episodes followed each other, as in a scroll, marking the stages of redemption. In order to understand the painter's frame of mind it is necessary to consider the particular significance of the chapel, which is a parallelepiped isolated in the labyrinth of the papal palaces. Its form imitates the Ark of the Covenant, or rather the building housing it, Solomon's Temple. The idea of the ark—the vessel that saved Noah and the human race from the Flood and the chest containing the covenant between God and Moses— is clearly present in the building's structure. The Sistine Chapel is thus itself a symbol of redemption, a temple in which God dwells, so that when Michelangelo painted it he felt he was face to face with God. If we turn our attention from the ceiling to the altar wall, we have the impression of an even deeper religious feeling. The bodies are twisted and deformed: no longer sculptures of figures assuming a pose, they preserve the flexibility of the mutable inner imagination. The color is darker, and more intense and spiritual. The *Last Judgment* gave rise to scandal and violent attacks: it was inconceivable that there should be so many nudes above the altar, and soon the religious and allegorical meanings were forgotten. However, what is truly remarkable is the way that, with this fresco, Michelangelo managed to almost entirely destroy the mythology of the rocklike heroes created on the ceiling.

Prophet Jonah (detail), 1511 Vatican City, Sistine Chapel

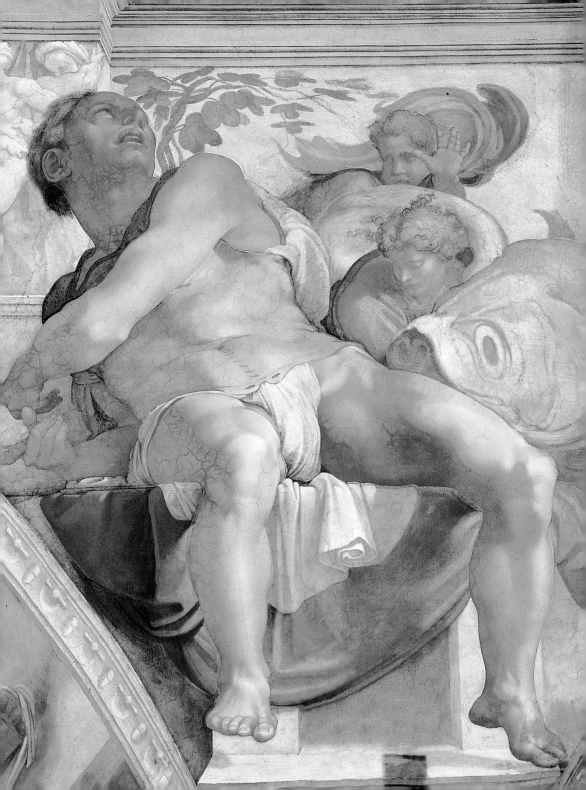

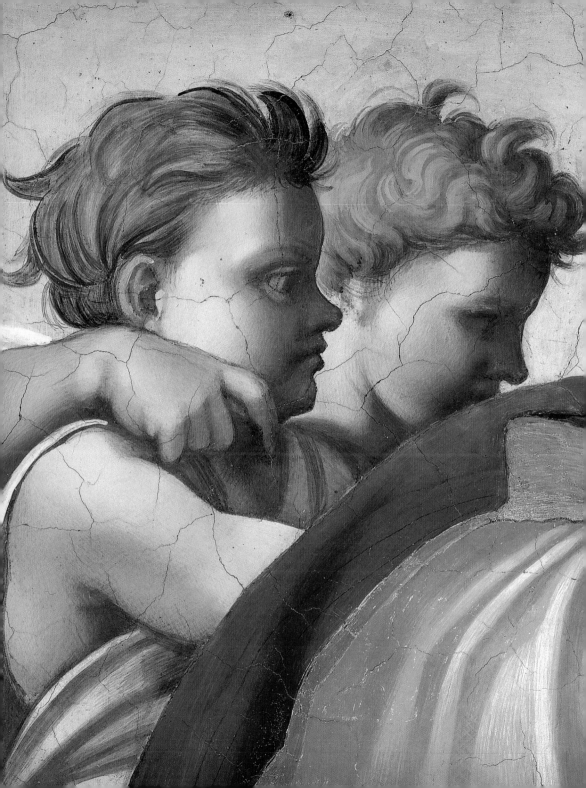

Between the execution of the Sistine ceiling and the *Last Judgment* Michelangelo experienced a profound religious crisis. In his poems the artist accused himself of having loved the beauty of the world to excess, and its forms that had previously seemed to him to be a reflection of the Godhead became, for him, slaves, bound to sin. Before he believed that it was enough to purify nature, now he did not believe any longer in the possibility of salvation without divine intervention. The difficult problem of grace, the determinant for salvation, became obsessive. His dream was now to free the bodies from matter, while previously it had been that of finding them, harmoniously arranged in the amorphous stone. The elect ascending to heaven are beings freed from any weight, transformed from sinners into flames of pure faith.

Dating from this period are a number of moving drawings, where the suffering of Christ crucified is expressed lyrically. Those who visited the elderly Michelangelo were impressed by the fact that his appearance was that of a venerable sage who tended to express himself mainly through maxims. But his calm was only apparent: in the privacy of his home he struggled until his dying day against his own faith in art and his own skill in the name of an insatiate, terrible lack of trust in the fate of humankind. No one saw the *Pietà Rondanini*, tormented by his despair, before his death.

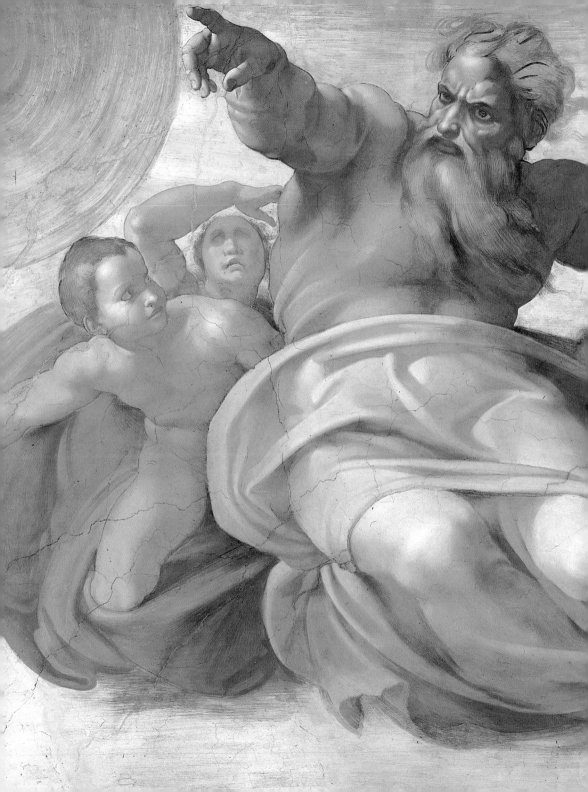

His Life and Art

On February 18, 1564 Michelangelo, now nearly ninety years old, died. The pope wanted to have him buried in Rome, where the artist had settled permanently thirty years previously, but Florence laid claim to his body in accordance with the instructions in his will, so a solemn funeral ceremony could be held in that city. Shortly afterward, a nephew secretly removed the body and took it to Florence. It was not only a question of family or civic pride, but there also the need to make him the tutelary deity of the new Accademia del Disegno, founded the year before by Giorgio Vasari under the auspices of Duke Cosimo I.

It was Vasari, in fact, who promoted the legend of Michelangelo when he published his famous *Lives of the Most Excellent Painters, Sculptors and Architects* in 1550. He had conceived them as a clearly articulated account of the variety of the talents, but proceeding upwards, with Michelangelo at the highest point in the process of perfection followed by art. From this matchless summit only two paths could be seen: a slow and inexorable decline or else the codification of the artist as an imitable model—that is, the reduction of the artist's figurative syntax to a series of rules that provided, however, for a wide use of poetic license and capriccios. This was the Academy with which the new European artistic language was legitimated: the Maniera, the intellectual imitation not of nature, but of art itself through the practice of drawing. It was *disegno* that united painting, sculpture and architecture like three intertwined rings: an image conceived by Michelangelo himself, this was to become the emblem of the Academy by changing the rings into three laurel crowns, the symbol of the new professional dignity of the artists, who, thanks to Michelangelo's fame, could regard themselves not just as craftsmen but rather as intellectuals. In Michelangelo's work, in fact, a fourth ring was added, poetry, which originated when he wrote on the same sheets he used for elaborating, or concluding, his designs. On these sheets, one next to the other, he wrote a line of poetry, sketched a figure, formed a composition or drew the plan of a building. When, after his death, the Accademia del Disegno erected a

on page 22
Creation of the Sun and the Moon
(detail), 1511
Vatican City, Sistine Chapel

large catafalque in his honor, it placed at the corners statues with personifications of the four arts of which he had been master: painting, sculpture, architecture and poetry.

Yet the Academy was the result of a paradox: Michelangelo was inimitable and reducing his *modus operandi* to a series of rules meant depriving his work of the existential tension that agitated and seemed to distend his figures and architecture from within and cause them to pulsate. Every gesture, sign and word was the result of an inner process, an uncontainable quest for perfection, the anguish caused by the impossibility of attaining this, a mixture of anger, pride, regret and renunciation. His entire work was full of renunciation and second thoughts, but it was also solidly kept together by unity of thought and objectives, by a complete, all-absorbing investigation that created an indissoluble link between the drawings and the poetry, the sculpture and the frescoes, the architecture and the urban planning projects or the fortifications. He was not trying to assert that the arts were the same thing, nor that it was of no great consequence

if he switched from one to the other. What he could express well with a sculpture or a poem could not be equally well expressed with a painting or an architectural work, or vice versa. He used different means because he had a single end: perfection in art. In his work many threads were left dangling and were then periodically taken up again or finally cut, but also in these fragments it was possible to grasp the whole of his thought.

He continued to try out new forms, without eclecticism. What he was attempting to do was neither to expand the field of art in order to make it a tool for investigating all natural phenomena, as Leonardo da Vinci wished to do, nor to assimilate elements and styles in the search for variety and grace, as Raphael did, but to eliminate what was taken for granted, to select a problem and work hard at it until it had been resolved, and to reduce every aspect of art to the absoluteness of a quest without contamination. This is what he meant in the reply he gave to the Florentine historian and humanist Benedetto Varchi with regard to the latter's inquiry as to which of the

arts—painting or sculpture—was greater than the other. He said that sculpture in marble, because it involved removing material and not adding it, as in painting, terracotta or bronze. For Michelangelo it was not a question of the hierarchy of the arts, but of one mental process compared with another: it was a metaphor for life. Wisdom did not originate from the accumulation of knowledge, but rather from discovering one did not know; it was what the German philosopher and mathematician Nicholas of Cusa called "learned ignorance." On various occasions Michelangelo had stated that he was neither a painter nor an architect nor a man of letters, and, lastly, by breaking and remaking the last *Pietà*, he admitted he was not even a sculptor. He took the technical, visual, cultural and philosophical acquisitions of his formation to their utmost limits. In his old age he even repented for having wasted time making "so many dolls": by reducing everything to essentials and verifying the authenticity of his research, he was left with only one subject, that of the Pietà—that is, of sin and redemption, death and resurrection.

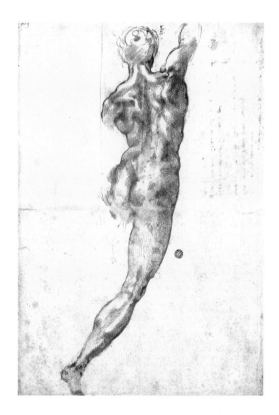

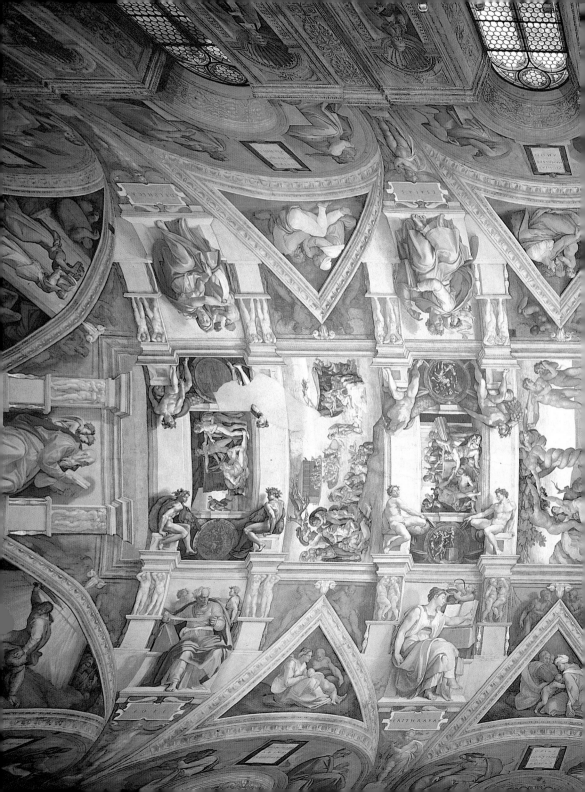

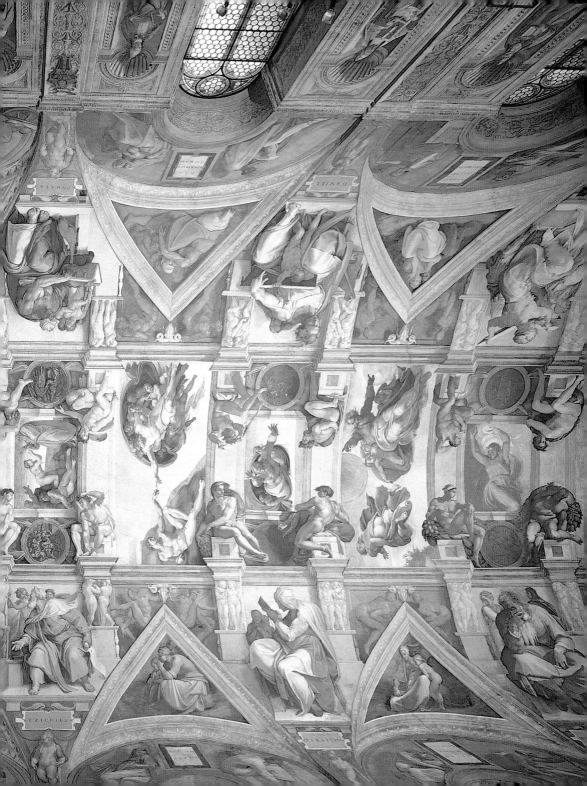

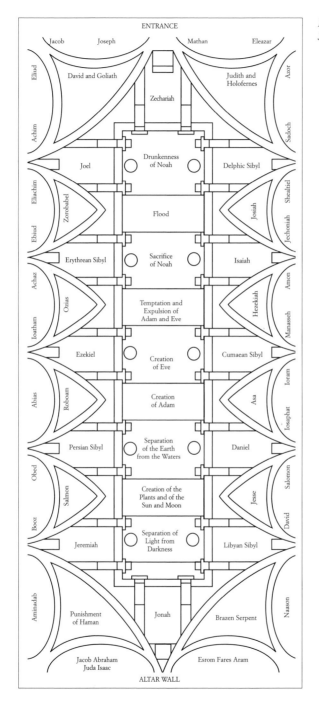

*Layout of the
Sistine Chapel Ceiling*

ENTRANCE

Jacob Joseph	Mathan Eleazar

Eliud — David and Goliath — Judith and Holofernes — Azor

Zechariah

Achim — Sadoch

Joel — Drunkenness of Noah — Delphic Sibyl

Eliachim — Shealtiel

Zorobabel — Flood — Josiah

Ebiud — Jechoniah

Erythrean Sibyl — Sacrifice of Noah — Isaiah

Achaz — Amon

Ioatham — Ozias — Temptation and Expulsion of Adam and Eve — Hezekiah — Manasseh

Ezekiel — Creation of Eve — Cumaean Sibyl

Abias — Roboam — Creation of Adam — Asa — Ioram

Iosaphat

Persian Sibyl — Separation of the Earth from the Waters — Daniel

Obed — Salmon — Creation of the Plants and of the Sun and Moon — Jesse — Salomon

Booz — David

Jeremiah — Separation of Light from Darkness — Libyan Sibyl

Aminadab — Punishment of Haman — Jonah — Brazen Serpent — Naason

Jacob Abraham Juda Isaac — Esrom Fares Aram

ALTAR WALL

28

His life was not, however, that of a capricious person unaccustomed to the ways of the world. He paid attention to expenditure, even to the point of meanness, but with some he was generous and, on occasion, extravagant; careless in his dress, he was instead very shrewd when buying houses and land and arranging the marriages of his nieces and nephews. When asked if he felt the need for a wife and children, he replied that he had wedded art and his offspring were the works he had produced over the years; they would bring him fame much more than wayward descendants. Nonetheless he was obsessed by the financial redemption of his family and, by the time he died, he had accumulated a princely fortune. He also claimed to be a descendent of the counts of Canossa and, for this reason, said he never had anything to do with the practices of the workshop; based on the nobility of the creative act, his work was a mental process even when he struggled with the inertia of matter. He was, therefore, an aristocrat without ever becoming a courtesan.

His melancholic and solitary disposition did not prevent him from having passionate love affairs with handsome gentlemen or virtuous ladies. To use the terminology of the medical science of his day, he was affected by "erotic melancholy"—that is, by the continuous fixation of an image, which impresses itself on the imagination or memory and from one cannot subsequently detach oneself. The beauty that he sought was a phantasm, which became reality by imprinting itself on the sculptured or painted forms. This was almost a mystical process: the amatory experiences were, in the end, sublimated by the contemplation of the Divinity. At a very early date—starting with the poet Ludovico Ariosto—the epithet "divine" was associated with the artist's name because he, like God, created perfect forms and did not merely imitate them.

Often emphasis has been laid on the distinction between works that were simply interrupted and those that Michelangelo deliberately left unfinished. But this is not an important difference: in the majority of cases, in fact, it was the artist himself who blocked or slowed down the commissions he had accepted. When he had a new idea that stimulated him, he was

completely transported by it and it obsessed him to the extent that it prevented him from carrying on with the work in hand. That he was capable of completing a sculpture with an enamel-like surface was demonstrated in the Vatican *Pietà*, and it was not necessary to repeat this remarkable feat. The idea was already contained in the marble, Michelangelo said: it was only necessary to remove the excess material that prevented it from being seen and stop when the image suddenly became visible. In the course of time, in his sculptures the rough-hewn or unfinished parts had assumed increasing importance, becoming deliberate choice on the part of the artist. Sometimes his dissatisfaction led him to abandon his work, but renunciation and starting again meant reducing the gestures and words to a minimal amount of action and the maximum of effect. Thus he had abandoned and restarted his late *Pietà Rondanini* many times, continuing to work on it as long as his strength held out, day and night with a candle attached to his hat, until just before his death, when the *non-finito* (unfinished) in art was equated with the *non-finito* in life.

In painting Michelangelo began by following the solid Florentine example, selecting just a few pure colors, as in the *Doni Tondo*. While he was working on the Sistine ceiling he experimented with iridescent colors that run into each other. This was the equivalent of the *non-finito* mentioned above: neither the smoothness of the surfaces or the integrity of the colors gave power to the things represented, but the light, which, as it flowed and vibrated, brought the forms to life. Unlike Leonardo, he did not take into account the density of the air, the "aerial perspective" that envelops and unifies everything; for him, it was the variety of the light effects that determined the plasticity of the figures and the change in the colors, and thus established the intensity of the concept that the artist had in mind. Foreshortening, of which he was past master, constituted another element of intensity; two distant points came closer until they coincide, conquering space in an illusionistic manner. Once again there was an abbreviation, the reduction of the figure to its concept. Then, in the *Last Judgment* and in the Paolina Chapel, he aban-

doned the iridescence of the colors and his quest for bright harmonies, producing painting that was increasingly rarefied: the light of the revelation was sufficient. In his last works he also reduced the use of foreshortening; huddled together, the figures became cylinders and cones containing only their pain and their fear.

In poetry he had attained similar effects to those of foreshortening, with the contraction of the syntactic elements, the torsion of the phrases and the accumulation of the words, with the repetition of negations and opposites, with the words that become symbols and the concepts defined only by their antitheses. This is a mixture of passion and bitterness, of burlesque spirit and scornful disillusion, rigid Platonism and burning eroticism, very personal confessions and mystical aspirations that determined true "poetics of difficulty, of abstruseness, of the singular" (Walter Binni).

In architecture he began in the New Sacristy (or Medici Chapel) and the Laurentian Library (San Lorenzo, Florence), depriving the ornament of its decorative function and turning it into part of the structure; he began with a secular undertaking on the Piazza del Campidoglio in Rome and a religious one in his project for the new Saint Peter's, identifying his work with the salvation of the sinful church. He ended his life and career with an act of renunciation. In sculpture he had experimented with the *non-finito*; in architecture he applied the principle of the *non-cominciato* (unbegun): "Santa Maria degli Angeli, his last work, was neither a design nor a construction, but merely a gesture or a thought" (Giulio Carlo Argan).

Michelangelo was born on March 6, 1475 to Lodovico di Lionardo di Buonarroto Simoni and Francesca di Neri di Miniato del Sera. The Buonarroti family was of ancient Florentine lineage, adhering to the Guelph faction, and in the past had obtained important posts and enjoyed moderate prosperity. The financial decline began in the middle of the fifteenth century with Lionardo, so that his son Lodovico had to accept posts outside the city and in 1474 became *podestà* (governor) in the Arezzo area, firstly in Chiusi then in Caprese, the birthplace

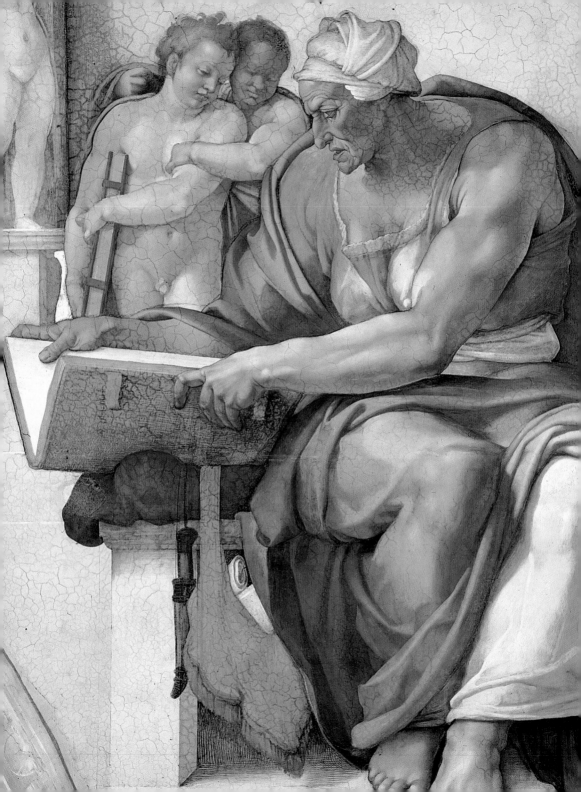

of his second son, to whom the name of the archangel Michael was given; his mother died six years later. In the meanwhile, his family moved to Settignano, near Florence, and the child was put out to a wet nurse, the wife of a stonecutter. Hoping to improve the family's fortunes, his father had him study under the guidance of the humanist Francesco da Urbino and attempted to thwart his instinctive passion for drawing. In the end, however, he relented and in 1487 sent him to the workshop of the painters Domenico and Davide Ghirlandaio, who were engaged in one of the most prestigious pictorial undertakings in that period, the decoration of the Cappella Tornabuoni in the choir of Santa Maria Novella. In their workshop, the young Michelangelo learned the fresco technique and practiced drawing; however, his stylistic development was independent of the Ghirlandaio brothers' cultured, but conventional painting. He dissented from their refined linear style, the profusion of portraits in every scene, the meticulously depicted fabrics, and the spectacular use of perspective.

It is likely that he did not leave the workshop almost immediately, as is often stated, but that he honored the indenture signed by his father in 1488, which allowed the boy to have three years of paid apprenticeship; but, he was, above all, self-taught, and his training consisted essentially of the study of the antique sculpture and the works of the first great renovators of Florentine art. Dating from this period are a number of drawings reproducing frescoes by Giotto and Masaccio, from which he isolated solid figures enveloped in heavy draperies, seen in profile as if they were reliefs. These drawings reveal a strong personality and a propensity for sculpture. Thus, together with his painter friend Francesco Granacci, he began to frequent the Medici gardens near the church of San Marco, which were looked after by one of Donatello's pupils, the sculptor Bertoldo di Giovanni. In the gardens, adorned with antique and contemporary marbles, Michelangelo not only completed his training as a sculptor from 1490 to 1492 but also made the acquaintance of the *de facto* ruler of Florence, Lorenzo the Magnificent.

The biographer's recount that Lorenzo, who, when inspecting the sculptures realized in the garden, was impressed by the head of an old faun gnashing his teeth, called over the young sculptor and pointed out that old people usually had some teeth missing. Thus Michelangelo seized a drill and removed a tooth from the faun's mouth. Lorenzo took a liking to him and invited him to live in his household, where he was educated together with his sons under Agnolo Poliziano, the great humanist and poet who wrote *La giostra* and *La favola d'Orfeo*. Lorenzo was himself a poet who experimented with a wide variety of genres, from burlesque poems, to religious lyrics, classicizing rhymes and carnival songs, albeit tinged with hypnotic melancholy. At the Medici court, Michelangelo came into contact with such erudite Florentine Neoplatonists as Marsilio Ficino, Cristoforo Landino, and Pico della Mirandola—that is, with the syncretism of pagan myths and Christian themes fused in an esoteric philosophy that was often related to the Judeo-Hermetic sapiential culture and saw in reality the reflection of the world of the ultramundane ideas and in the forces of nature and the cosmos the graduated action of universal and eternal love.

After the faun's head, Michelangelo made, also in the Medici gardens, two marble reliefs, now in the Casa Buonarotti in Florence. Clearly influenced by Donatello's work, the *rilievo schiacciato* (flattened relief) known as the *Madonna of the Stairs* portrays a pensive Virgin, seen in profile, with, on her lap, the sleeping Christ child partly wrapped in his mother's mantle, while, in the background, a number of putti are spreading a cloth at the top of stairs that do not observe the rules of perspective. The various elements may be explained as portents of the fate of the Redeemer: the sleep as his death, the cloth as his shroud and the stairs as the Resurrection. As happened repeatedly in his following works, a religious subject was matched by a pagan one, which in the case of the second relief was suggested by Poliziano himself. The battle of the Centaurs has been variously interpreted as the rape of Deianira or Heracles fighting, but the subject has been intentionally left in the background in order to

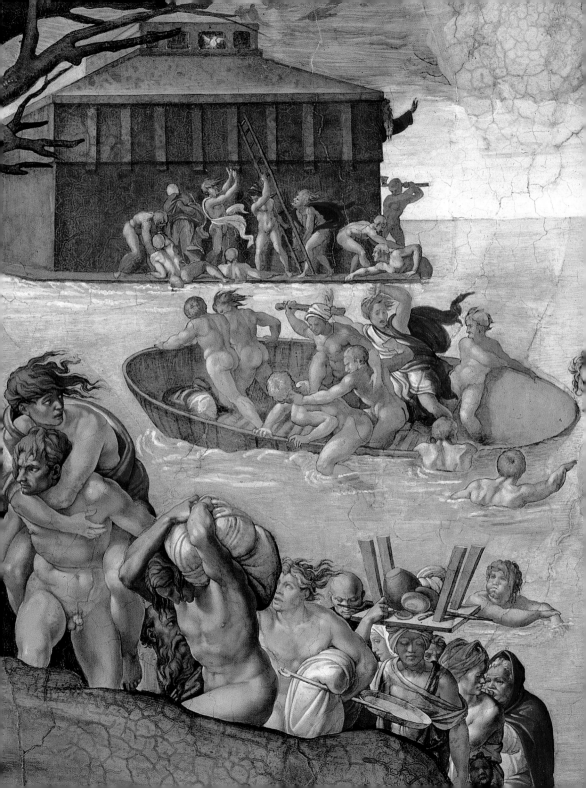

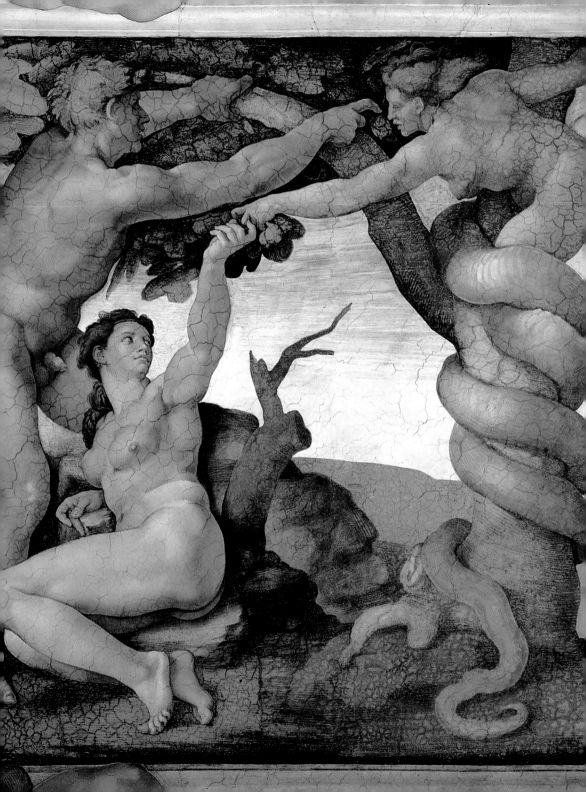

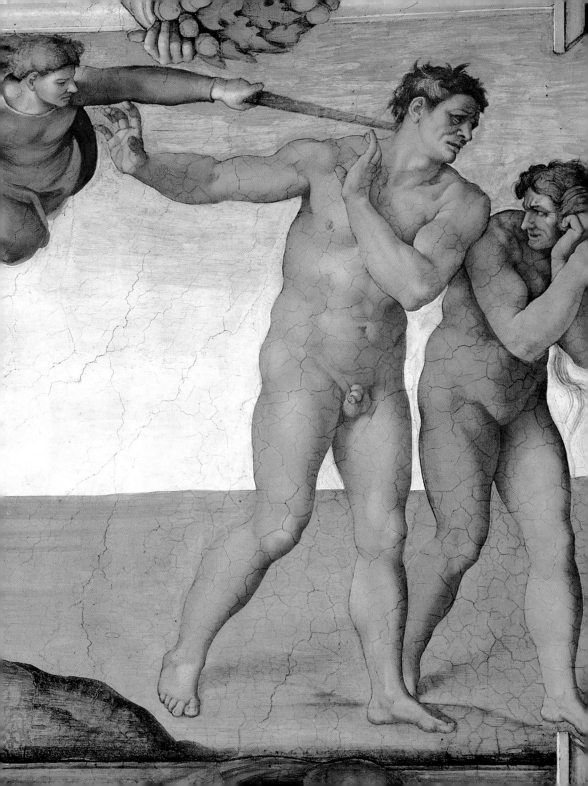

concentrate on the tangle of bodies, the effects of which are enhanced by different degrees of finish in the relief, which was executed over a number of years. This work is a superb example of the artist's poetics of fury: the heroic ideal is reduced to brute force, man reveals his bestiality and the Dionysian spirit sets off a violent chain reaction that continues like perpetual motion within the confines of the marble slab.

In April 1492 Lorenzo the Magnificent died and Michelangelo returned to his father's house. However, the prior of the Augustinian monastery of Santo Spirito, Niccolò di Giovanni Bicchiellini, allowed him to continue his studies of the human body there; adopting a system that had few precedents, the young artist had a number of corpses delivered from the nearby hospital and dissected them to learn the secrets of anatomy. He was particularly interested in the bone and muscle structure, while Leonardo's parallel anatomical studies focused on the nervous and circulatory systems. In gratitude for this privilege, Michelangelo carved a wooden crucifix for the church of Santo Spirito; the body of the dead Christ is modeled softly, without the accentuation of the muscles found in his later works. This work may be associated with the delicate *Young Archer* in New York, which has been attributed to the artist in recent years. His first important marble statue was, however, a larger than life-size *Hercules* that originally stood in the Palazzo Strozzi and was then taken to France, where it disappeared in the eighteenth century, although attempts have been made to identify it. The pacific world of Lorenzo's politics was, however, destined to be shattered with his successor, his son Piero de' Medici, called "The Unlucky." Michelangelo remained in his service but did not receive important assignments (it is uncertain whether he commissioned the *Hercules*); the sources only mention that in January 1494, after a heavy snowfall, Piero asked the young sculptor to make a snowman, a sad presage of a world ready to melt away when summer arrived. The glorious age of Laurentian humanism was drawing to a close. In the monastery of San Marco the friar Girolamo Savonarola spoke out with increasing

Male Nude and two studies
for the *Battle of Cascina*
(detail), 1504–1506
Haarlem, Teylers Museum

vehemence against the corruption of the church and worldly vanity. Poliziano died in September 1494; on November 17 of that year Pico dell Mirandola was poisoned, and, on the same day, the troops of the French king, Charles VIII, entered Florence. Shortly before this the Medici prudently left the city and Michelangelo, panic-stricken, fled to Venice.

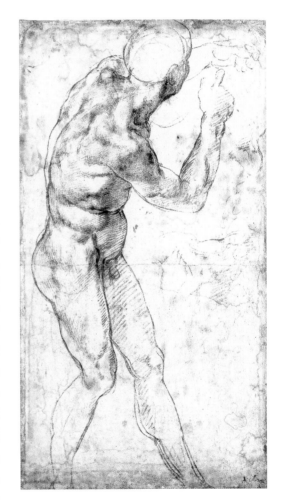

When Michelangelo fled from Florence he was not yet twenty and he had spent the previous four years at the Medici court: the danger of retaliation was certainly very real. Perhaps he was carrying a letter of presentation; in any case, as a visiting card he could certainly count on his remarkable talent. But where should he go? In Bologna the court of the Bentivoglio was closely linked to the Medici, who arrived in the city a few months after being expelled from Florence (in 1495 Giovanni Bentivoglio negotiated the repurchase of the San Marco gardens, which had been confiscated by the Florentines). It is probable that the Medici themselves advised Michelangelo to go to

Bologna, but, after a brief stay there, he left for Venice. Just whom he met and what he saw in Venice remains obscure; he must certainly have been aware of the difficulties the Venetians had caused for Verrocchio while he was working on the equestrian statue of Colleoni, and it was no easy matter to obtain a commission under the rigid guild system. Thus he did not stay long in the city and returned to Bologna, where he was a guest of the nobleman Giovan Francesco Aldovrandi, who offered him protection in exchange for some drawings and obtained a prestigious commission for the young artist.

A few months earlier, in March 1494, the sculptor Niccolò dell'Arca had died leaving unfinished the work from which his name derives, the tomb (*arca*) of Saint Dominic in the church of San Domenico in Bologna. Two statuettes, Saint Petronius and Saint Proculus, were still missing from the tomb's magnificent marble lid, as was, on the altar, an angel bearing a candlestick symmetrical to the one already realized. Michelangelo conformed his three sculptures to those of Niccolò, imitating in part their poses and expressions; but his personality was evident in the tension of the figures, the compact hairstyles, and the drapery adhering to the bodies, stressing their solid volumes. While Niccolò's sculpted clothes fall in loose waves, those of Michelangelo seem to be held in place by a dynamic force. It has been suggested that the artist was inspired by the hard sculptural style of Ferrarese painting, although we do not know what he actually saw of this; there is, however, no doubt that he was influenced by Jacopo della Quercia's sculptures on the façade of San Petronio.

He stayed little more than a year in Bologna. The biographers recount that his protector, Aldovrandi, "finding Michelangelo's Tuscan accent pleasant, willingly listened to his reading of Dante, Petrarch, Boccaccio, and other Tuscan poets," and it is probable that, because of his lack of commissions, the artist started to write his first poems.

Meanwhile in Florence the situation had temporarily become more stable. After the flight of Piero de' Medici, the citizens supported the creation of a republican government inspired

41

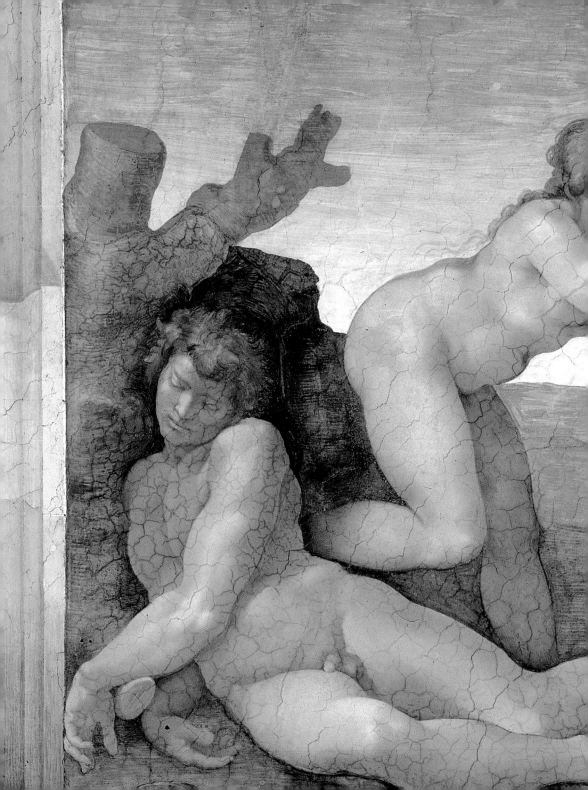

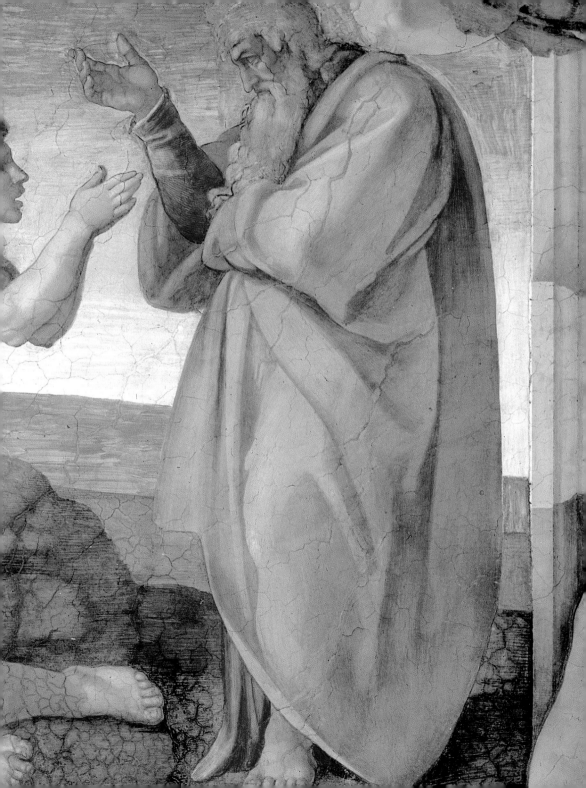

by Girolamo Savonarola's sermons. For four years the city was guided by his religious doctrine, with his calls on people to repent and threats of divine punishments for sinners, and the zeal of his followers, known as *piagnoni* (snivelers), who despised wealth and organized bonfires of the vanities. Books and pictures with pagan or lascivious subjects, portraits, mirrors and bric-a-brac were thrown into the flames. The city was proclaimed a "republic of Christ" in contrast to Rome, denounced as Babylon, where the Borgia pope, Alexander VI —who was compared to the Antichrist— reigned. This is what Savonarola wrote in a poem: "Let each one cleanse his intellect, / memory and will, / of vain worldly desire; /let him burn with charity, / contemplating the goodness / of Jesus, king of Florence."

Induced by Pico della Mirandola, his great admirer, the Dominican friar came to Florence in 1490. Lorenzo the Magnificent was himself fascinated by him and Michelangelo must have listened to his fiery sermons before fleeing to Bologna. Many artists, such as Lorenzo di Credi, Andrea della Robbia and Baccio da Montelupo, heeded Savonarola's call for spiritual renewal, while Baccio della Porta stopped painting to join the Dominican order (he started working again under the name of Fra Bartolomeo); Botticelli, the leading painter of classical and neo-Platonic subjects, ended up by rejecting the conquests of the Renaissance, seeking solace in mystical archaism. Savonarola's influence on Michelangelo was not immediate, but the friar's preaching was certainly one of the elements in the religious formation of the artist, who, in the last years of his life, became intensely devout. This experience also had an effect, on a visual plane, on the radical nature of his artistic choices: the abandonment of the mathematical perspective system, his obsession with the human figure, the nudity of the bodies as liberation from vain appearances, the rejection of hedonistic portraiture and his indifference to landscape painting (he later told the Portuguese painter Francisco de Holanda that this was only suitable for old people and devout ladies).

The artist was in Florence from November 1495 to June of the following year. His return

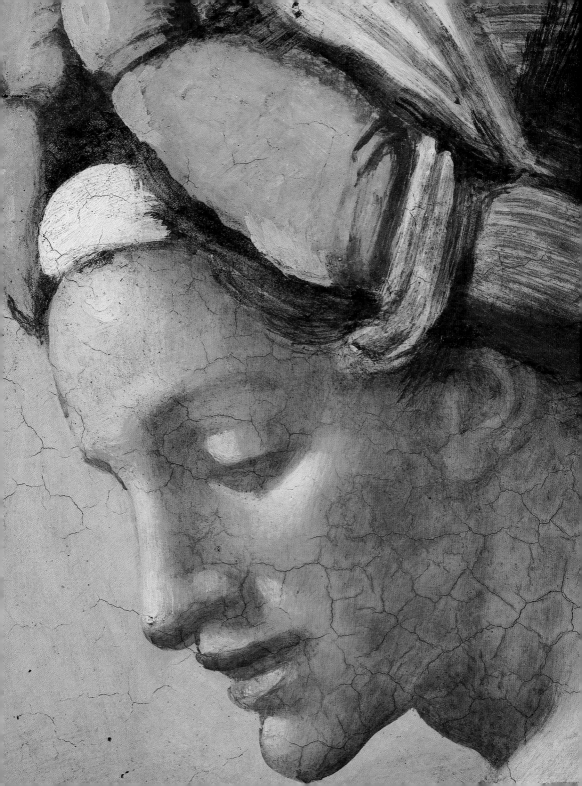

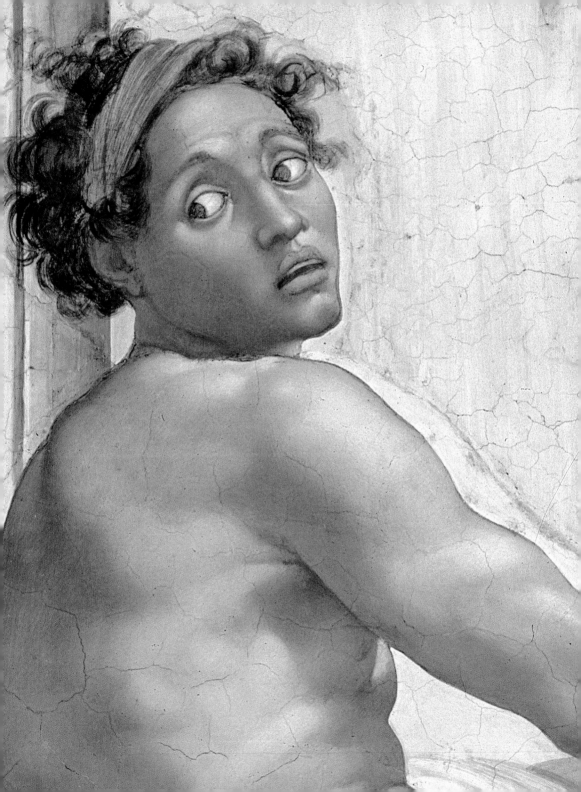

to the city was made possible by Lorenzo di Pierfrancesco, a member of the cadet branch of the Medici family who had lived in exile and went back to Florence as a fervent Savonarolan, changing his surname to Popolano (commoner). A cultured patron of Botticelli (from the *Allegory of Spring* to his illustrations of Dante's *Divine Comedy*), Lorenzo Popolano commissioned Michelangelo to sculpt a statue of the young Saint John the Baptist, which has, however, been lost.

The panel painting known as the *Manchester Madonna*, now in London, probably dates from this period. Although its attribution has long been open to debate, with uncertainty about its date, this *Virgin and Child with Saint John the Baptist and Four Angels* is now generally accepted as an authentic work by Michelangelo and has been ascribed to his early years, so that it may be regarded as one of the first paintings entirely by the artist. On the basis of stylistic and iconographic considerations, it may be supposed that the work was executed during the brief period the artist spent in Florence while it was under Savonarola's sway.

In particular, the prominence given to the prophetic objects—a book and a scroll—should be noted, although these have been hidden from the Christ child's sight: their reference to the fact that Christ's sacrifice was predestined may be deduced from the sad expressions of the Virgin and the angels. More than any other works by Michelangelo, this reveals the influence of Botticelli, which suggests it may have been commissioned by Lorenzo Popolano. Lastly, there are numerous resemblances to the works he executed shortly before this one: the *Young Archer* in New York, if the attribution and dating to 1494 are accepted, and, above all, the *Angel Bearing a Candlestick*. The fact that the painting is unfinished may be due to the artist's departure for Rome.

Michelangelo's move to Rome was a result of the fraud of the *Sleeping Cupid*. The artist had sculpted a small marble statue, but its pagan subject made it difficult to sell in Florence now that it was dominated by Savonarola. Thus, on Lorenzo Popolano's suggestion he decided to pass it off as antique and have it taken to Rome by Baldassarre del

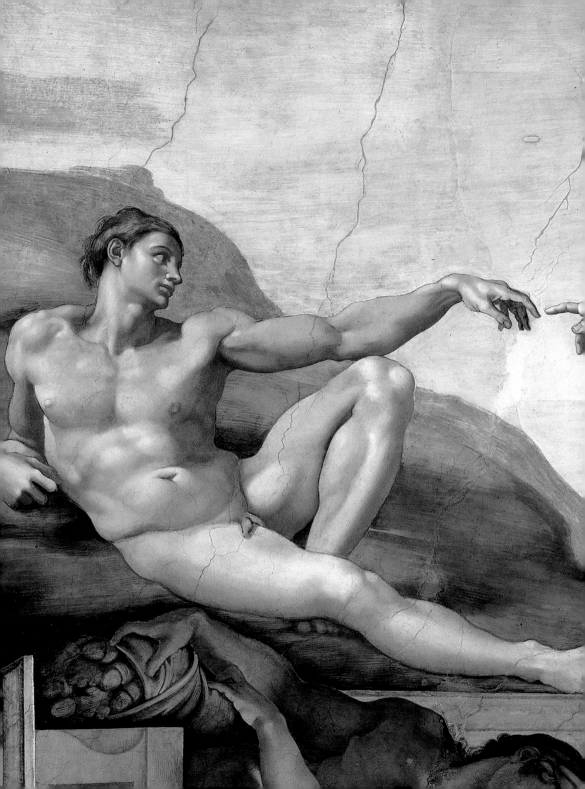

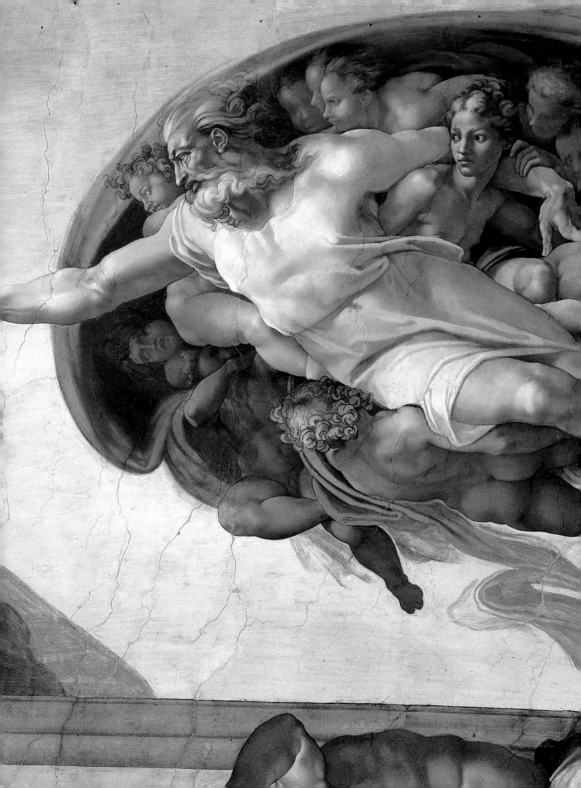

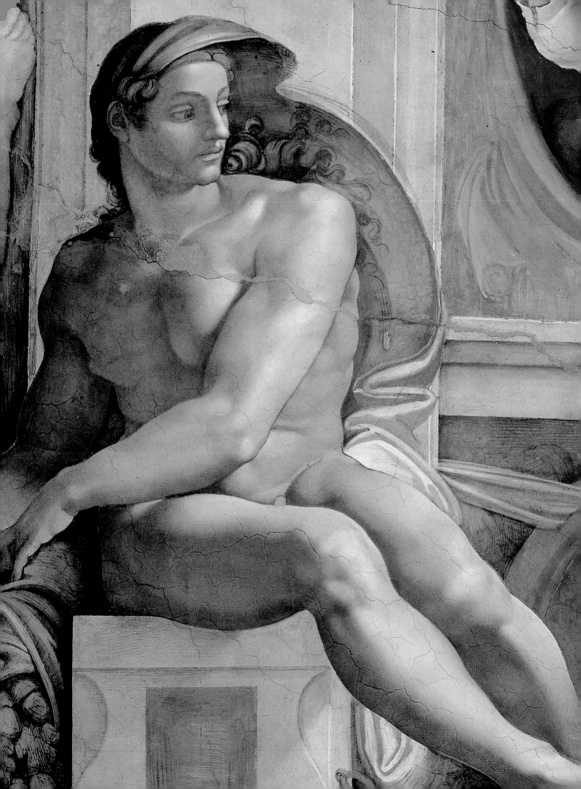

Milanese, who sold it to Cardinal Riario, Sixtus IV's nephew. Once he had discovered the deceit, the cardinal demanded his money back, but also wanted to know the skillful artist; for this purpose he sent his banker, Jacopo Galli, to Florence. Michelangelo was persuaded to move to Rome, where Riario commissioned a large statue of *Bacchus,* which was executed in 1496–1497. The theme of the god's drunkenness was celebrated in famous poems by Poliziano and Lorenzo the Magnificent, but in the context of Rome under the Borgia it became the symbol of the orgiastic dissolution of the papal court: this may be why Cardinal Riario prudently sold it to Galli (the work is now in the Bargello, Florence). For Michelangelo it was, above all, a way of measuring himself against classical antiquity, the works of which he was able to see for the first time in such large quantities. The result is a marvelous union between the elegance of the Quattrocento and the revival of classicism.

The second important commission he received in Rome was a marble group representing a sacred subject that was requested by Cardinal Jean Bilhères de Lagraulas, the abbot of San Dionigi and ambassador of Charles VIII. When the contract was drawn up in August 1498, the artist's guarantor was once again the banker Jacopo Galli. The work is the very famous *Pietà,* originally intended for the chapel of Santa Petronilla, in Old Saint Peter's. As required by the patron, the artist based himself on a northern motif, with the Virgin holding in her arms the Christ child's body after it had been removed from the cross; but the work was very distant from the rigid, angular German representations. Michelangelo has created a fluid image, over which the eye runs smoothly, attracted by the gentleness of the gestures, the suppressed sorrow, and the miracle of the celestial vision. As the artist himself explained, when replying to those who criticized the Virgin's excessive youth, her face is the pure face of a girl who has never known sin, while the body of Christ is exhausted by all the sins with which he sought to burden himself. The refinement of the draperies, the monumentality of the composition, the beauty of the faces, and the

anatomical perfection are all combined in a timeless, natural manner that has aroused the admiration of all those who have seen this marvelous work over the centuries.

The last important work that Michelangelo executed during his first stay in Rome was a panel painting commissioned by the friars of Sant'Agostino, in accordance with the will of the bishop Giovanni Ebu, for a chapel dedicated to piety. The work has been identified with the *Entombment*, now in London, the attribution of which has long been controversial; it was left unfinished when the artist returned to Florence in 1501. The Saint Peter's *Pietà* was, however, the masterpiece that brought fame to the twenty-four-year-old artist and, at the turn of the century, launched a totally new figurative style. The degree to which Michelangelo was aware and proud of this innovation is indicated by the gesture he made following rumors attributing the sculpture to a Lombard artist. This is, in fact, his only work bearing his signature, which is engraved on the sash crossing the Virgin's breast: MICHAELAN-GELUS BONAROTUS FLORENT[INUS] FACIEBAT.

After the arrest of Savonarola and the sentence condemning him to be hanged and then burnt in May 1498, Florence went through a period of chaotic euphoria. The nobility regained part of the power they had lost and the "snivelers" were persecuted, while luxury and worldly pleasures were once again allowed. Nevertheless, the incitement to oppose tyranny in Savonarola's sermons had left its mark. When the situation became more stable a number of artists returned to Florence, including Leonardo da Vinci in 1500, after eighteen years of absence, and, in May 1501, Michelangelo, after five years in Rome (in 1504 the young Raphael also arrived). Thanks to the fame he had acquired with the works he had executed in Rome, Michelangelo obtained new commissions. In June he signed the contract for the sculptural decoration of the Piccolomini altar in Siena; in August the one for a huge marble *David* intended for the cathedral; in 1502 the Signoria (the city's governing body) ordered a bronze *David* for Marshal Pierre de Rohan; in 1503 the Opera del Duomo (the cathedral

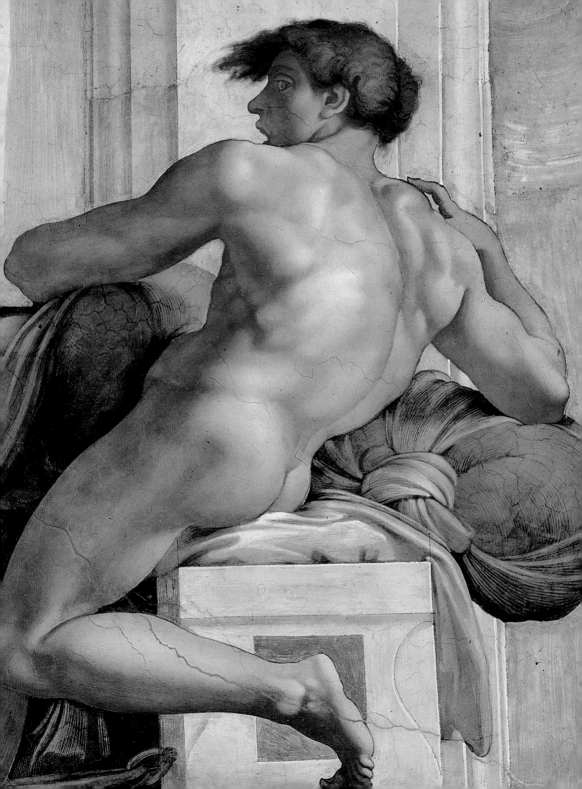

board of works) commissioned twelve statues of the apostles; there were also many works requested by Florentine families, such as the Doni, the Pitti and the Taddei.

These works indicated a notable progression in Michelangelo's career. Thus he obtained the Sienese commission thanks to his connections in Rome: the intermediary between the artist and Cardinal Todeschini Piccolomini (who became Pope Pius III in 1503, but reigned for only a month) was, once again, the banker Jacopo Galli. Michelangelo only made four of the fifteen statues ordered: *Saint Paul*, *Saint Peter*, *Saint Pius*, and *Saint Gregory*. The commission for the David for one of the buttresses of Florence Cathedral was a particularly challenging task. The artist was provided with a large block of marble, which had been clumsily carved, on which Agostino di Duccio and then Antonio Rossellino had previously worked. This presented Michelangelo with a wonderful opportunity: he studied the antique models, combining them with those of the Florentine tradition; he imitated the pose of Donatello's and Verrocchio's statues, but

changed their effete youths into a young man with powerful, taut musculature. After three years' work, the artist had overcome all the difficulties of the undertaking. The work was so representative of the heroic virtues of republican Florence that, after a committee, comprising a number of famous artists present in the city, had met, it was decided to locate it in front of the Palazzo Vecchio to replace Donatello's *Judith*, the just and chaste heroine who had become the symbol of the expulsion of the Medici.

Leonardo also expressed an opinion regarding the positioning of the *David*, suggesting that the statue should be located in the Loggia dei Lanzi in a large niche painted black. This opinion is in marked contrast with the view of Michelangelo, who wanted instead to set the sculpture in the open air, freely standing in space, with, in the background, not the enveloping form of a niche, but the rough surface of the palace's rusticated ashlar. Leonardo regarded the sculpture as a pictorial matter, the monumental plasticity of which needed to be attenuated. Michelangelo, on the

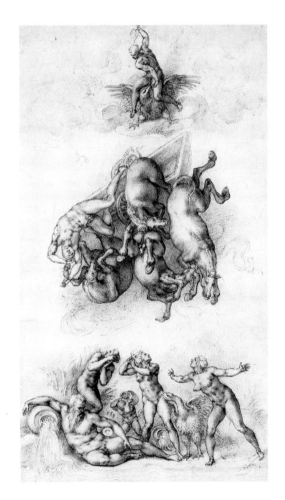

other hand, considered the work to be the statement of a new, heroic concept of man, whose moral solidity is reflected by the figure's restrained gestures, the intensity of his gaze, and the athletic beauty of his body, the perfection of which had not been reached since classical antiquity.

The two great artists were to meet again just a few months later when tackling the theme of history painting. In 1502, following the example of the Venetian doges, the Florentine aristocracy had elected for life a gonfalonier (chairman of the Signoria) whose task it would be to strengthen the central power, reduce the weight of the Consiglio Maggiore (Great Council), prevent the return of the Medici and thwart the ambitions of Cesare Borgia. No sooner had he been appointed than Piero Soderini initiated a policy based on military and cultural prestige. One of his closest assistants was Niccolò Machiavelli and he immediately started a war for the reconquest of Pisa. In March 1503 he summoned Leonardo back to the city—he had gone to give military advice to Cesare Borgia—putting him in charge of a

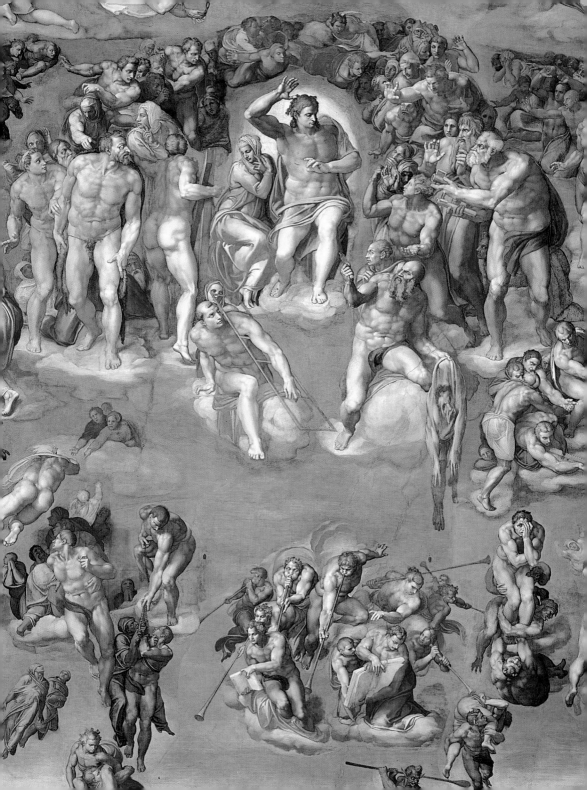

scheme for the diversion of the Arno and commissioning a great wall painting for the Sala del Consiglio in the Palazzo Vecchio. The subject of this was the Battle of Anghiari, in which, in 1440, the Florentines were victorious over the troops of the duke of Milan, Filippo Maria Visconti; its function was to give a psychological boost to the battles then being fought, supporting them through the power of the images. Meanwhile the war against Pisa was dragging on (the city only surrendered in 1509), as was the work of Leonardo, who experimented with a technique intended to produce the effects of oil painting. In the autumn of 1504 Piero Soderini decided to entrust the young Michelangelo, who had distinguished himself with his *David*, the new symbol of the republic, with a second wall painting, to be executed in competition with his rival, Leonardo. The subject in this referred in an even more explicit way to the war then in progress: the Battle of Cascina, which the Florentines won against the Pisans in 1364. Soderini hoped that the rivalry between the artists would not only stimulate their creativity but also speed up the execution of the paintings and their positive effects on the outcome of the war. Thus was born one of the great challenges in the history of art, although it turned out to be a failure: Leonardo only executed a small part of his work, using a technique similar to the encaustic of antiquity, which soon started to deteriorate; Michelangelo, on the other hand, did not get much beyond the preparatory cartoon. Despite their differing approaches to the subject of war, both works were in contrast with the harmonious vision of humanism and interpreted the mood of pessimism of this period of crisis.

At the same time as his great public undertakings of the *David* and the *Battle of Anghiari*, Michelangelo also received a number of private commissions in which he investigated ways of arranging a number of figures in a circular space: a panel painting, the *Doni Tondo*, and two reliefs, the *Pitti Tondo* and the *Taddei Tondo* (the first two in Florence, in the Uffizi and Bargello respectively, the last in the Royal Academy, London). The comparison was with the latest work of Leonardo, who in 1501

caused a sensation with his famous cartoon of the *Virgin and Child with Saint Anne*, which Michelangelo saw and reworked in a drawing now in Oxford. The two reliefs, both depicting the Virgin and child and the infant Saint John the Baptist, were intended for the private meditation of the patrons, Taddeo Taddei and Bartolomeo Pitti, displaying themes of the Incarnation and the Passion. In the *Pitti Tondo* Christ is portrayed as a funerary genius leaning pensively on the book foretelling his death, while Mary, with a seraph on her headband, gazes into the distance, aware of her son's fate. In the *Taddei Tondo*, Saint John holds out a goldfinch—the Italian word for which (*cardellino*) recalls the thistle (*cardo*) and thus the crown of thorns—to the Christ child, who recoils in fear, clinging to his mother, who is dressed as a sibyl. The expressive power that Michelangelo imparts to the marble, deliberately leaving large parts rough and others unfinished, creates a break with the devotional tradition that tried to arouse emotion through the outpouring of affection and the compassion of the narration; it is a new classicism that seeks

the essence of the sacred and the continuous materialization of the prophecy.

Regarding the *Doni Tondo*, which is closely related to the two reliefs, Vasari told an anecdote that aimed, above all, to draw attention to the artist's character: the patron, Agnolo Doni, wanted a work by Michelangelo; when it was delivered the artist asked for seventy ducats, but Agnolo thought the sum was excessive. Michelangelo replied that he wanted a hundred ducats, or else he wanted the painting back; Agnolo then agreed to pay him seventy, but "Michelangelo was not satisfied, and indeed, because of Agnolo's lack of good faith, he wanted twice as much as he had originally asked; so that, as Agnolo wanted to keep the painting, he was obliged to send him a hundred and forty ducats." Aside from this tale, it is probable that the work was executed on the occasion of the wedding of Agnolo Doni and Maddalena Strozzi in 1503. The subject of the *Doni Tondo* is more complex than those of the two reliefs: of the many interpretations, the most favored regards the succession of the eras. The nude youths in the background represent

following pages
*Angels with the Instruments
of the Passion* (detail of the
Last Judgment), 1536–1537
Vatican City, Sistine Chapel

the time "before the Mosaic dispensation," the infant Baptist symbolizes the passage to the "age of the Law" in which the encounter between Mary and Joseph takes place, while Christ inaugurates the "age of Grace" and, for this reason, is held aloft in triumph. The hairband worn by the Christ child appears to allude to the victorious athletes, but, in reality, both Saint John and the nude youths are wearing the same hairband, and this suggests continuity between them rather than contrast. It is probable that the choice of the Holy Family as the subject was related to the patron's wedding: the cooperation of Mary and Joseph in holding the Christ child may allude to the encounter of the two Florentine families, while the semicircular space containing the Baptist and the nudes may be a sort of baptismal font, from which Saint John, the patron saint of Florence, gives his blessing to the union. An integral part of the work is the frame, one of the few surviving originals, with five carved heads: at the top is Christ, at the sides are two prophets, or perhaps two patron saints and at the bottom two sibyls who seem to be two angels, perhaps

a reference to the patron's name. Although some of the iconographic elements are derived from a panel by Luca Signorelli (*Madonna and Child*) in the Uffizi, Michelangelo devised a series of compositional and coloristic innovations that make this work one of the great masterpieces of Western painting. The young Raphael, who worked for the same patrons (he painted portraits of Agnolo Doni and his wife and the *Madonna of the Meadow* for Taddeo Taddei), imitated the torsion of the Virgin in the figure of young woman in the *Entombment* (Galleria Borghese, Rome), the central panel of the *Baglioni Altarpiece*. However, the greatest influence of the *Doni Tondo* was on the first generation of Mannerist painters, such as Pontormo and Rosso Fiorentino, also through the development of its ideas that Michelangelo carried out on the ceiling of the Sistine Chapel.

In October 1503 Giuliano Della Rovere, Sixtus IV's nephew, was elected pope with the title Julius II. In the conclave he was supported by Cesare Borgia, who did not want to lose the territories he had conquered by

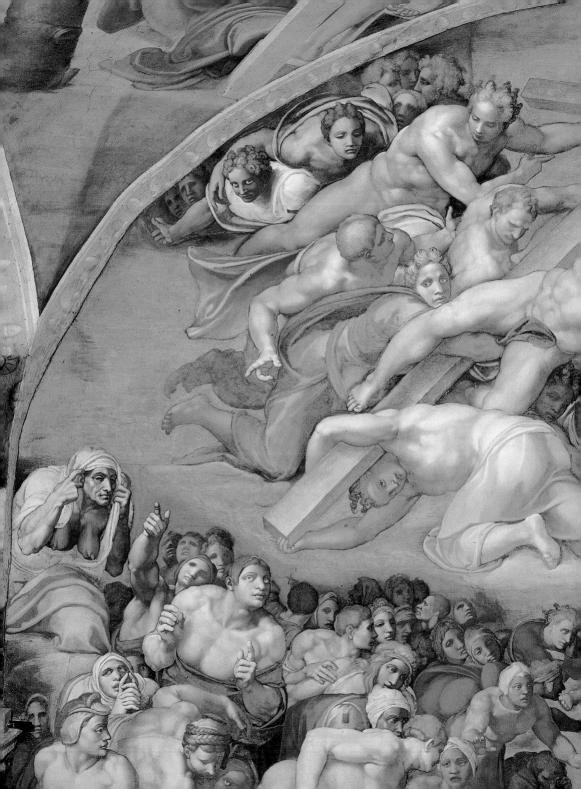

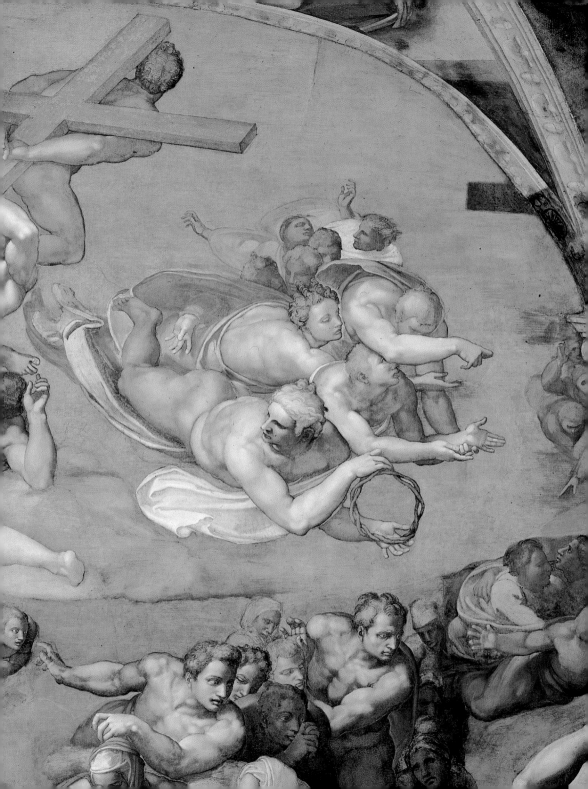

force and trickery, but once on the papal throne, Julius II abandoned him, leading to his downfall. He did this not only through fear of Borgia but also because he had a bold plan in mind: that of giving the church temporal power that would be embodied in a large state, limiting the expansion of Venice's mainland possessions, and expelling the foreigners from the Italian territories. In order to realize this project he laid all scruples aside: he created and changed alliances, and, dressed as a warrior, led the papal troops through Italy. Also the great urban planning schemes, architectural projects and commissions for fresco cycles were intended to transform Rome into the capital of the new papal state, giving concrete form to the ideas of the pope, who wanted the monumentality of the ancient city to be reborn. Employing the leading artists of his day, he was particularly attracted by the audacity of their projects and the innovative and persuasive character of their styles; he did not hesitate to dismiss painters, even famous ones, to give the maximum freedom to the young Michelangelo and Raphael, or to demolish the old basilica of Saint Peter's in order to realize Bramante's new project.

Michelangelo's fame in Rome was still linked to the statues of *Bacchus* and the *Pietà*. When, in March 1505, Julius II commissioned the artist to design and execute a huge tomb for him, he was seeking someone who could express his political and military aspirations. The warrior pope was not interested in Bacchus's drunkenness or the Virgin's grief, but rather the strength of the *David* and the heroes of the *Battle of Cascina*. Perhaps Michelangelo never got on so well with anybody as he did with the ambitious Julius II: they were both proud and irascible, their relationship was often difficult, and, at times, they were close to breaking point, with the pope refusing to grant him an audience and the artist fleeing from Rome, but, in the end, they managed to come to an agreement. Although the first project for the tomb had been shelved, giving rise to what the artist himself described as the "tragedy of the tomb," their encounter produced one of the remarkable creations of Western civilization: the painting of the ceiling

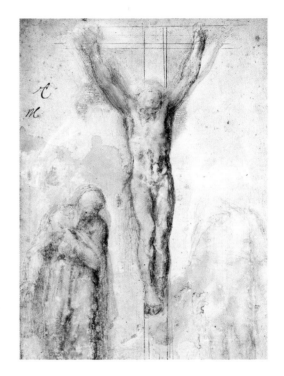

Christ Crucified between the Virgin and Nicodemus, c. 1552–1554
Paris, Musée du Louvre,
Cabinet des dessins

of the Sistine Chapel. Although Neoplatonic and theological interpretations of the significance of this undertaking have been put forward and are certainly relevant, it also served to celebrate the new golden age of Julius II's pontificate. In the Romantic Age it was believed that Michelangelo was isolated from his contemporaries, a misunderstood genius who worked only for himself; on the contrary, he was deeply affected by the glories and dramas of his day.

After his first project for Julius II's tomb had been approved, Michelangelo spent a long period in Carrara choosing the marble, then he returned to Rome, but the pope was preoccupied with the new Saint Peter's and did not want to receive him. The artist returned to Florence in a fury, and it was only after receiving three letters from the pope and the intervention of Piero Soderini that he agreed to meet Julius II in Bologna, where the pope had gone to conquer the city. This military triumph needed to be celebrated and, in order to pacify Michelangelo, Julius commissioned a bronze statue of himself: the pope was

portrayed holding a sword as a warning to the rebels (it was angrily destroyed by the Bolognese in 1511 when they obtained their independence). The artist remained in Bologna until February 1508 to conclude the casting of the statue; then, after a brief stay in Florence, he returned to Rome in May to start the frescoes in the Sistine Chapel.

The papal chapel posed serious problems due to the instability of its structure. In 1504 forged iron rods were installed above the vault, damaging the existing decoration of gold stars on a blue ground. For this reason Julius II decided to entrust Michelangelo with the execution of a new decorative scheme comprising the figures of the twelve apostles. His name had been suggested by Bramante, who wanted to make things difficult for him by obliging him to undertake a major pictorial cycle; nevertheless, the artist transformed what was to have been a stopgap into a new challenge. The original idea was abandoned in favor of a more ambitious project. Michelangelo himself stated that he was given carte blanche: scholars, on the other hand, have hypothesized the direct intervention of the pope or his assistants, or a link with a specific written source. In any case, Michelangelo drew on a wide variety of models: antique low reliefs and statues, the first panels of Lorenzo Ghiberti's "Gates of Paradise" for the Baptistery in Florence, Masaccio's frescoes, and Jacopo della Quercia's reliefs (which he saw again in Bologna while he was making the statue of Julius II); it has also been noted that the artist derived many of his images from woodcuts in late fifteenth-century editions of the Bible.

Realizing that the great project for the tomb of Julius II was in danger of foundering, he reused a number of his inventions for it, especially those having celebratory and allegorical meanings. The four seated figures representing the active life, the contemplative life, Moses and Saint Paul were replaced by prophets and sibyls. The bronze reliefs on the tomb, showing the pope's exploits, take the form of gilded medallions depicting incidents from the Bible presaging military victories. The bound prisoners, representing the provinces captured by the pope, become bronze *ignudi*

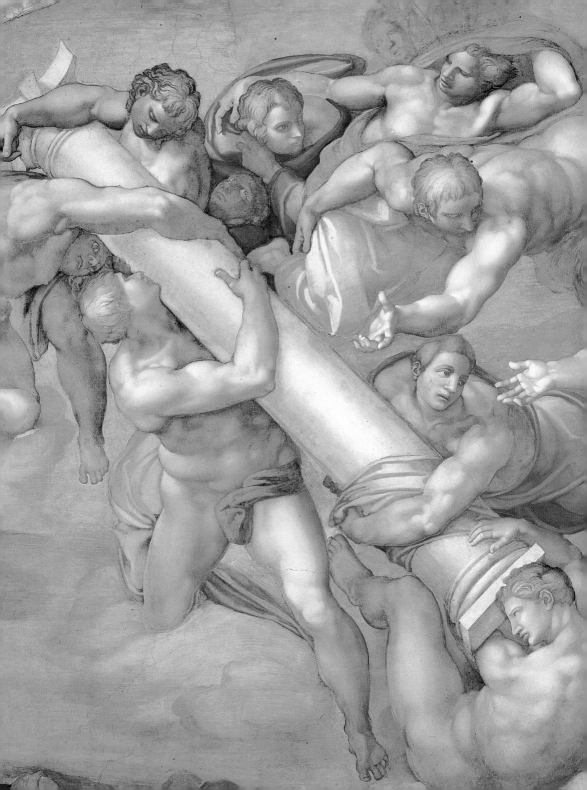

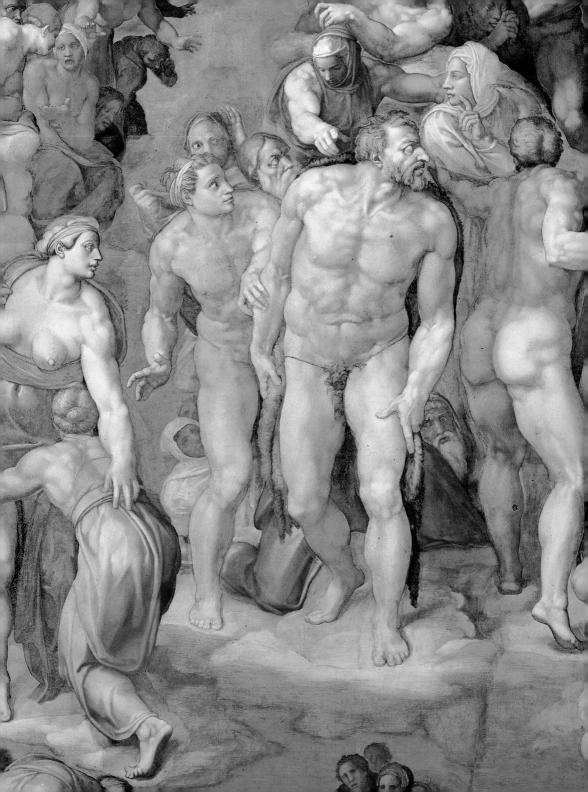

(nude male figures) symbolizing imprisoned souls or war trophies. The Victories are replaced by *ignudi* bearing festoons of oak leaves and acorns, heraldic devices of the Della Rovere, but also symbols of the golden age.

In addition to introducing the bible stories prefiguring the advent of the Messiah, the Seers high on the ceiling foretell a domain of the spirit that may be identified with the greatness—also of a temporal nature—of the Church. Bearing in mind the character and ambitions of Julius II, it is inconceivable that he should not have paid close attention to the underlying significance of this very expensive undertaking. According to one account, the pope told Michelangelo to add more gold: although it was misconstrued as a sign of bad taste, this request reasserted the theme of the new golden age that his pontificate aspired to represent.

The whole ceiling is conceived as a series of five enormous triumphal arches, which refer explicitly—with the medallions corresponding to its roundels—to the Arch of Constantine, which appears a number of times in the fres-

coes below painted for Sixtus IV, whose nephew Julius II, after the difficult interlude of the hated Borgia, continued the work of renewal. After entering the Sistine Chapel, the papal procession passes under the arches in order to reach the altar, going over the whole story of Salvation from the scene of the Creation to the "histories" of Noah, whose sons were the progenitors of all the races of humankind. The ancestors of Christ are painted in the spandrels and lunettes, from Noah's son Shem to Abraham, and from the latter, through the forty generations described by the evangelist Mathew, up to Joseph, the father of Jesus. The story continues in the fresco cycle on the walls, with the lives of Moses and Christ, in the fresco on the altar wall, the *Assumption of the Virgin* (later replaced by the *Last Judgment*), the image of the church triumphant, and in the series of the early popes.

Linked indissolubly to the pope's glory, Michelangelo thus finally obtained the recognition for his art that he deserved. However, in addition to prophesying greatness, the Sistine ceiling is also a bitter reflection on the history

of humankind: this is why the artist portrays himself in the melancholy pose of the prophet Jeremiah. The new golden age is but a subtle fiction concealing the deceit and violence of the perennial iron age.

In 1512 Julius II's campaign against the French had immediate consequences for Florence. With the withdrawal of the French troops, in fact, Piero Soderini fled and the republic fell. In September, a month before Michelangelo finished painting the ceiling, supported by the pope and the Spaniards, the Medici were able to return to the city. Lorenzo the Magnificent's eldest son, Piero the Unlucky had died by drowning; his brothers Giovanni and Giuliano remained, the former a cardinal and the latter duke of Nemours. At the beginning of 1513 Julius II died and Giovanni de' Medici was elected pope, taking the title of Leo X. Although Michelangelo had known Giovanni since Lorenzo had invited him, when he was still a boy, to live in his household, the tastes of the pope were closer to the style of Raphael. The latter, having been appointed architect of Saint Peter's and superintendent of Roman antiquities, received the commissions for the decoration of the Vatican apartments and the cartoons for the tapestries of the Sistine Chapel. From 1513 to 1516 the now elderly Leonardo lived in the Vatican, where he carried out research into the natural sciences and atmospheric cataclysms. The first modest commission that the pope gave to Michelangelo was for an architectural work, a marble façade for the chapel in Castel Sant'Angelo.

After he had completed the Sistine ceiling and following the death of Julius II, Michelangelo had to fulfill his contractual obligations regarding the pope's tomb. The original project was modified and reduced, so that it was no longer freestanding but attached to the wall, with fewer statues, which the artist undertook to finish within seven years; in reality, it took more him than thirty years to produce the makeshift solution—"patched up and redone," in his biographer Ascanio Condivi's words— of the tomb in San Pietro dei Vincoli. In these months he finished the statue of *Moses* and those of the two *Slaves*, which were later

discarded and are now in the Louvre. In 1516 the project was further reduced, perhaps because of the plans of Leo X, who wanted Michelangelo to design the façade of the church of San Lorenzo in Florence. As far as the pope was concerned, this commission had priority over the other ones the artist had received, especially because of its political significance: he wanted to create an axis between Rome and Florence, leaving Michelangelo with the task of transforming the Medicean capital and Raphael that of remodeling the papal one.

San Lorenzo was the Medici family church and Michelangelo conceived the façade as a gallery of statues. In his early drawings the artist had been inspired by Masaccio, in his first sculptures by Donatello, and now he completed his investigation of the first generation of the Florentine Renaissance by designing the façade of Brunelleschi's church. This encounter with Brunelleschi's work stimulated him. In order to choose the marble he went to Carrara and Pietrasanta; he worked incessantly, at the same time going ahead with the tomb for Julius II. Then in March 1520

the pope changed his mind and the project was abandoned; the artist was furious, but he had to succumb to the decision. In April Raphael died. In June Leo X issued the bull excommunicating Luther, who burned it publicly, thus starting the Reformation.

The suspension of the work on the façade of San Lorenzo was compensated for by the commission for the construction, in the same church, of the New Sacristy, a pendent to the Old Sacristy designed by Brunelleschi. The idea originated as a result of the deaths of a number of members of the Medici family. In 1516 the pope's brother Giuliano, duke of Nemours, died, as did, three years later, Lorenzo, duke of Urbino and son of Piero the Unlucky. The city was now ruled by Cardinal Giulio de' Medici. Functioning as a funerary chapel, the New Sacristy was to contain, according to the first designs, four tombs: that of Lorenzo the Magnificent, that of his brother Giuliano (killed in 1478 in the plot of the Pazzi and father of Cardinal Giulio), and those of the two dukes who had died prematurely, Lorenzo and Giuliano.

This work was also suspended. At the end of 1521 Leo X died and the new pope was a Netherlandish cardinal, formerly tutor to Emperor Charles V, who took the title of Adrian VI. His moralizing campaign with regard to the Curia and clergy curbed the glories of the church and aroused hopes that the rift with Luther would be healed; his scornful opinions on both the antique statues and Michelangelo's frescoes give an idea of the censorious attitude of this pope. The effects of his pontificate were, however, short-lived: he died in 1523, when, once again, a member of the Medici family was elected as pope—this was Cardinal Giulio, who took the name of Clement VII. Michelangelo was able to start work again on the Medici tombs; indeed, the project was enlarged to include the construction of the adjacent Laurentian Library. He was also entrusted with the designs of the ciborium (not realized) and the reliquary tribune in San Lorenzo.

Despite being unfinished, the New Sacristy (Medici Chapel) is a wonderful fusion of architecture and sculpture. The forms conduct a dialogue from one wall to another following an ascendant movement, concluding in the dome covered with coffering inspired by the Pantheon. The two Medici tombs, with the statues of the dukes Lorenzo and Giuliano, emerge from the wall like the promise of resurrection. The four figures of *Day* and *Night*, and *Twilight* and *Dawn* recline in unstable poses on the curved surfaces of the sarcophagi. The finish of the surfaces passes from polished smoothness to rough *non-finito*, with consequent accentuation of the light effects. In the Laurentian Library, on other hand, there are no figures; or rather, the human bodies are sublimated into the pure forms of the architectural elements. In the reading-room the wooden desks, designed according to the proportions of the human body, become bodies themselves; the rhythm of steps in the long corridor is reflected in the harmonious sequence of the windows. In the *ricetto* (vestibule) giving access to the library the columns are recessed into the wall like statues, the functionless tabernacles project like reliefs; in the center of the space is the splendid staircase, which is like a ship in a port berthed alongside the wall, creating a

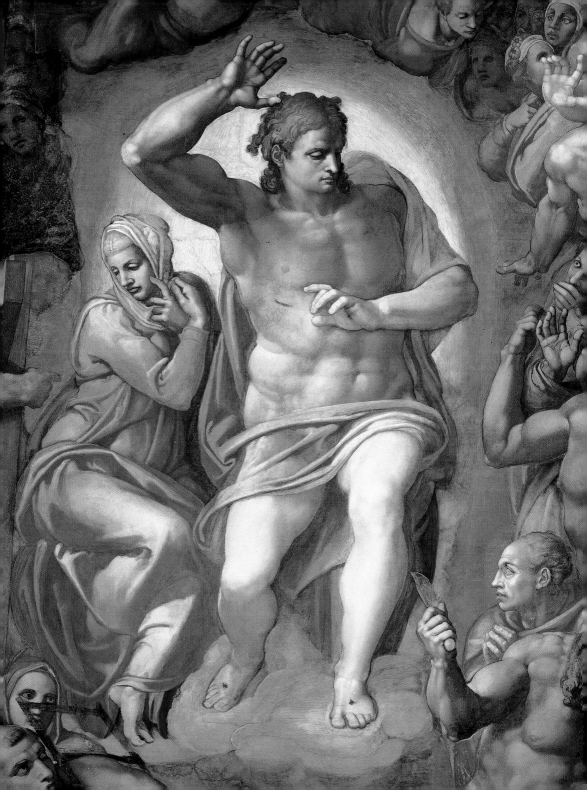

wavelike form that reverberates through the articulation of concave and convex lines.

In 1521 the Italian states, with Clement VII in the front line, allied with France, Milan, Venice and Florence to form the League of Cognac against Charles V and the threat from the huge empire he ruled, which originated from the fusion of the Spanish crown and the Habsburg one. The emperor's reaction, however, was ruthless: in May 1527 Rome was invaded and sacked by the lansquenet, the Medici were again expelled from Florence and the republic was restored. Thus the Medici commissions were suspended and Michelangelo was given the task of making a colossal statue of Hercules, or Samson, for Piazza della Signoria: close to the image of astuteness represented by his *David* one of strength was required so that the Florentines would have the courage to make a stand against both the pope and the emperor, who had now made peace.

Michelangelo, whose "virtue and discipline [...] love and affection for his homeland" were recognized, assumed an important role in the defense of Florence. In January 1529 he was elected a member of the "Nove della Milizia" and in April was appointed head of the "Dieci della Guerra" with the title of governor-general of the fortifications. He spent the summer inspecting defensive positions and visiting the most up-to-date fortifications, such as those of Ferrara, where he was a guest at the court of Alfonso d'Este. By nature proud and ambitious, yet apprehensive, Michelangelo changed his mind on various occasions: on September 9 he returned to Florence, then, ten days later, he fled to Venice with the idea of accepting Francis I's invitation to move to France. The Florentine Republic banished him as a rebel, but, in mid-November, when the city was already under siege, he was allowed to return. Tormented by the idea of being considered a traitor and inspired by his solid republican ideals deriving from Savonarola and Plato's *Republic*, he chose to throw in his lot with the Florentines at this time of great difficulty when the hopes of resistance were fading. The siege lasted ten months and Michelangelo did his best to ensure the walls would withstand enemy attack as long as possible, but in the end, after the betrayal of

the commander-in-chief Malatesta Baglioni and the defeat at Gavinana, on August 12, 1530 Florence was obliged to surrender on unfavorable terms, which, however, allowed it to avoid being sacked by the lansquenet.

Upon the return of the Medici, Michelangelo remained in hiding, then, having obtained a pardon from Clement VII, he started work again on the New Sacristy and the Laurentian Library. He was also required to sculpt a statue and design a house for the papal governor of Florence, Baccio Valori, and, for Alfonso d'Avalos, marquis of Vasto, to draw a cartoon for the *Noli me tangere* later executed by Pontormo. But the bitter experience of the siege had left its mark on him. After spending another four years in Florence, where he executed numerous commissions and underwent a deep religious crisis, in 1534 he settled permanently in Rome.

In April 1532 Michelangelo went to Rome for yet more negotiations linked to the completion of the tomb of Julius II, which still had not been completed twenty years after the pope's death. Now that work on the commissions for the Medici in Florence was well underway, nothing could prevent the artist from going ahead with the assignment for the Della Rovere. In the new contract it was decided to erect the tomb in the church of San Pietro in Vincoli, where it was to be built as a shallow construction against the wall, so that it became, to all intents and purposes, a grandiose high relief. In Florence Michelangelo set to work again, executing four *Slaves*, finished to different degrees and full of brute force agitating the bodies imprisoned in the marble blocks. They were to have supported the cornice like telamones and, between them, two figures of *Victories* were to have been placed, but both the *Slaves* and the one finished *Victory* were not included in the final project (they are now in the Galleria dell'Accademia and the Palazzo Vecchio in Florence). Work on the tomb was suspended for a long period from 1535 to 1541 because Michelangelo was busy painting the *Last Judgment*. In fact, the monument was only completed in 1545, after the

Group of the Blessed on the Right
(detail of the *Last Judgment*),
1537–1539
Vatican City, Sistine Chapel

artist had allowed a number of the statues to be sculpted by assistants.

One of the reasons behind Michelangelo's move to Rome in 1534 was his dislike of the new government in Florence, which was now ruled tyrannically by Alessandro de' Medici, who was assassinated by Lorenzino de' Medici in 1537. This tragic event is recalled by the bust of *Brutus* (now in the Bargello), which the artist executed in defense of tyrannicide. In Rome he associated, above all, with Florentine exiles who had fled from persecution in their city. Thus, in the following years he rejected the repeated invitations of Duke Cosimo to return to Florence, making the excuse that he was getting old or that he had too many commitments in Rome; in reality, he did not want to become a court artist whose main function would be to celebrate the greatness of the prince. As a result of his religious crisis of this period he chose to work almost exclusively for the pope: for Michelangelo this meant he was working for the whole of mankind.

Another reason why the artist preferred to live in Rome his close friendship with the handsome young Tommaso de' Cavalieri. Michelangelo dedicated to him a series of love sonnets with a Neoplatonic color to them in which the contemplation of beauty is one and the same thing as the vision of God: "I see in your beautiful face, my lord, / That which it is difficult to recount in this life: / Your soul, still clothed in its flesh, / Has ascended with it many times to God." Michelangelo increased his output of poetry in the 1530s because he intended to publish a book of poems, although this idea was abandoned in 1546. In the same period he managed to overcome his deep religious crisis thanks to his friendship with Vittoria Colonna, herself a poet and muse of the arts, a friend of figures linked to the new reformed religiousness. He took part with her in discussions on grace and works—that is, the ways in which the individual could obtain salvation. Increasingly frequent in the sonnets he wrote in his old age is the theme of the beneficence of Christ, who, with his blood, cleansed the sins of humanity and is alone able to obtain salvation: "no attempt of mine / can allow me to attain bliss without your blood."

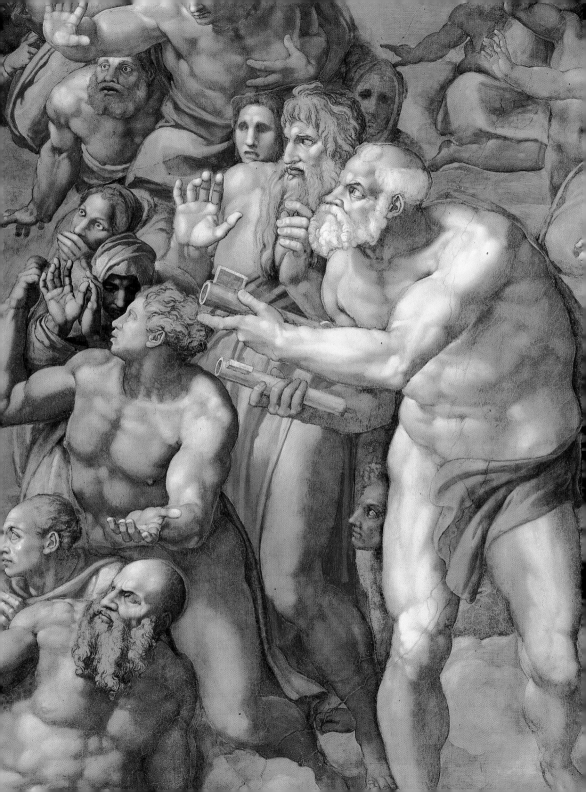

The immediate reason for Michelangelo's move to Rome was, however, to be found in the prestigious commission for the *Last Judgment*, which marked his return to painting after many years. It is plausible that the idea for a new fresco in the Sistine Chapel came to Clement VII as a result of his bitter experience during the Sack of Rome in 1527, when he remained isolated and besieged in Castel Sant'Angelo. The pope and the artist met in 1533 and perhaps agreed on the first scheme, but Clement died and the project seemed to have been abandoned; however, the new pope, Paul III, a cultured man who was determined to reform the church, confirmed the commission.

In a way, the decision to fresco the altar wall of the Sistine Chapel represented a conversion. It should not be forgotten that it involved the destruction of the pre-existing frescoes: a scene from the life of Moses and one from that of Christ, four figures of popes, two lunettes previously painted by Michelangelo and, above all, Perugino's altarpiece of the *Assumption of the Virgin*. In the first project an attempt was made to save the *Assumption* by only occu-

pying the surrounding areas, but in the end the whole wall was made available for the fresco, its edges coinciding with the cross-section of the chapel, without a frame or decorative border. This gesture was similar to that of Julius II when he decided to demolish Old Saint Peter's, but its underlying meaning was the contrary: it was an affirmation that Rome was willing to reflect on its sins and to cancel the celebrations in order to mirror itself in the severe divine judgment.

The structure of the fresco is based on the division of the walls into four parts. At the top, corresponding to the lunettes, are angels carrying the instruments of the Passion. In the band below—where the figures of popes had been—is Christ with the Virgin and the blessed. Further down—at the level of the scenes from the lives of Moses and Christ—are the angels blowing trumpets with the righteous rising toward heaven and the damned driven toward the underworld. Lastly, in the bottom zone, where the painted curtains had been, the dead emerge from their graves and the damned are led to hell. This division, based on the tradi-

tional use of registers placed one above the other is counterbalanced by the strong sense of unity linking the different parts of the fresco, thanks also to the sky painted with lapis lazuli, which gives the scene a timeless dimension, like the gold ground in Byzantine painting. It is not true that there is a clockwise motion in the fresco: in the left, lower, and middle zones the figures rise, but also the corresponding ones on the right have an ascending movement, although this is blocked by demons and angels and then by the wall of martyred saints. In the whole of the upper zone, moreover, the figures converge from both left and right toward the center, forming two rings of the blessed around Christ. Thus the movement is one of expansion and contraction, like a beating heart.

Michelangelo's anguished religious experience is even more evident in the frescoes that the pope commissioned for the Paolina Chapel, which he painted from 1542 to 1550: "While the *Last Judgment* in the Sistine Chapel, which has an official function for the whole of Christianity closely linked to the pope's authority, is a sacred public oratory, the two

frescoes painted for Paul III's private chapel are pure religious lyricism" (Bruno Contardi). According to Vasari, together with the *Conversion of Saint Paul*, there was to have been *Christ Giving the Keys to Saint Peter*, the moment at which Christ appoints the apostle Peter as his successor. With the *Crucifixion of Saint Peter*, the subject was, however, changed from triumph to martyrdom. Thus the pope did not have the glory of power before his eyes, but rather the example of the perfect imitation of Christ. This allowed the two frescoes to comprise the beginning and the end of the Christian life. The artist probably felt the need to conform to the reformist aspirations of the Council of Trent, which was convened by Paul III and finally opened, after numerous delays, in 1545.

Michelangelo was totally involved in these works. In both frescoes he introduced innovations regarding the use of both color and composition. He confirmed his rejection of rigorous Renaissance perspective: at the bottom, the figures are cut off by the frame, the colors are toned down and the landscape is

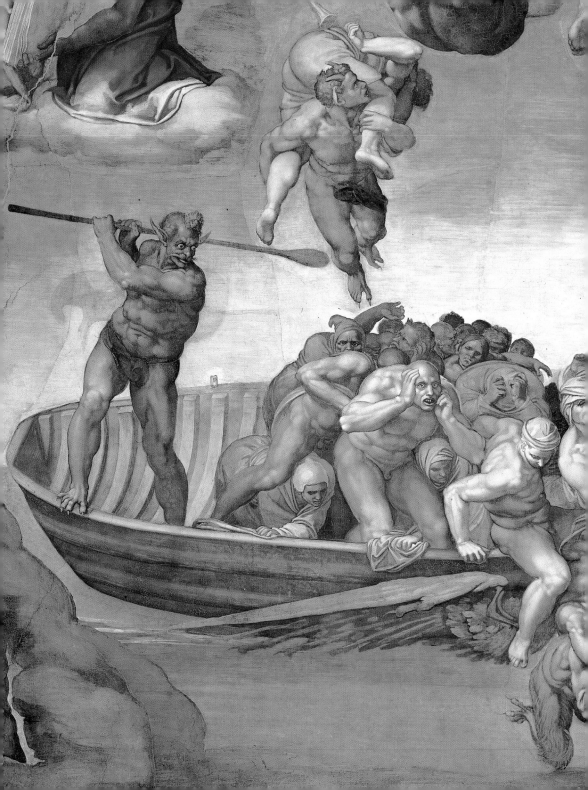

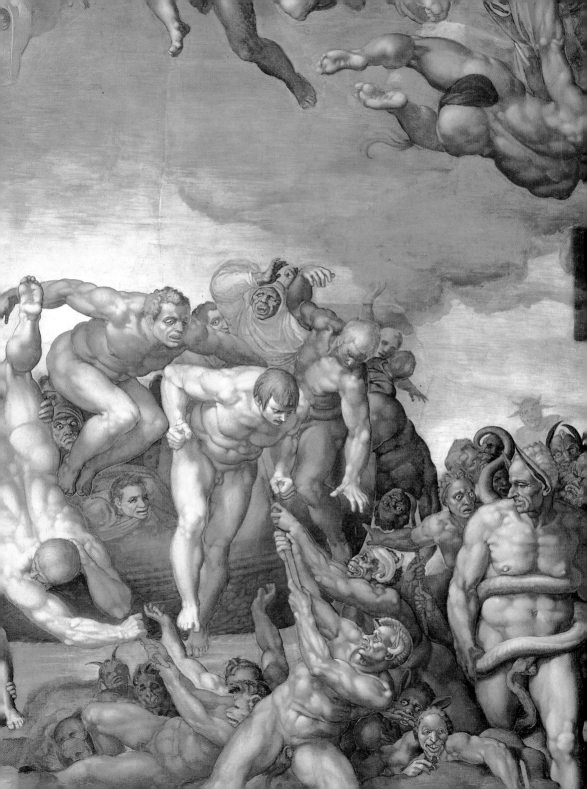

The Damned Driven towards the Underworld (detail of the *Last Judgment*), 1539–1540
Vatican City, Sistine Chapel

desolate. The artist portrays himself hooded like a Nicodemite with his arms crossed, symbol of his full adherence to the teachings of Christ. And it is in the role of Nicodemus, the evangelical figure who conceals his true faith, that he also represented himself in the *Pietà* in Florence, now in the Museo dell'Opera del Duomo, sculpted in the years 1550–1555, when the Council took its authoritarian and dogmatic stance, and, for many believers suspected of heresy, Nicodemism became the only way of cultivating their ideas by concealing themselves behind the practice of the official rites.

During the last years of Paul III's pontificate Michelangelo also received a series of architectural commissions. The first of these, in 1538, originated once again from a sculpture: the placing on the Campidoglio of the equestrian statue of Marcus Aurelius. Very reluctantly, Michelangelo designed its pedestal and then, from this, developed the project for the piazza, with the façades of the Palazzo dei Conservatori and the Palazzo Nuovo at a slight angle to each other, the double flight of steps leading to the Palazzo Senatorio, and the monu-

mental access ramp. His architectural activity became preponderant after the death of Antonio da Sangallo the Younger in 1546. Michelangelo inherited his role as architect in charge of Saint Peter's and other papal commissions such as the almost finished Palazzo Farnese, where he intervened with a few masterly touches to the façade and courtyard.

Paul III died in 1549 and his successors confirmed Michelangelo's absolute power over the construction of the new Saint Peter's. Thus he worked for Julius III, Paul IV, and Pius IV, with the very brief interval in 1555 of the reign of Marcellus II, who, under the pressure of the "Sangallo sect," wanted to oust him. The building of Saint Peter's was the obsession of his old age. Sangallo's project was based on a proportional system that subdivided and multiplied the elements. Michelangelo redesigned the structure as a series of lines in tension coming together in the dome and terminating in the lantern. He returned to the concept of the central plan, albeit on a smaller scale, in the designs for San Giovanni dei Fiorentini and the Cappella Sforza in Santa Maria Maggiore.

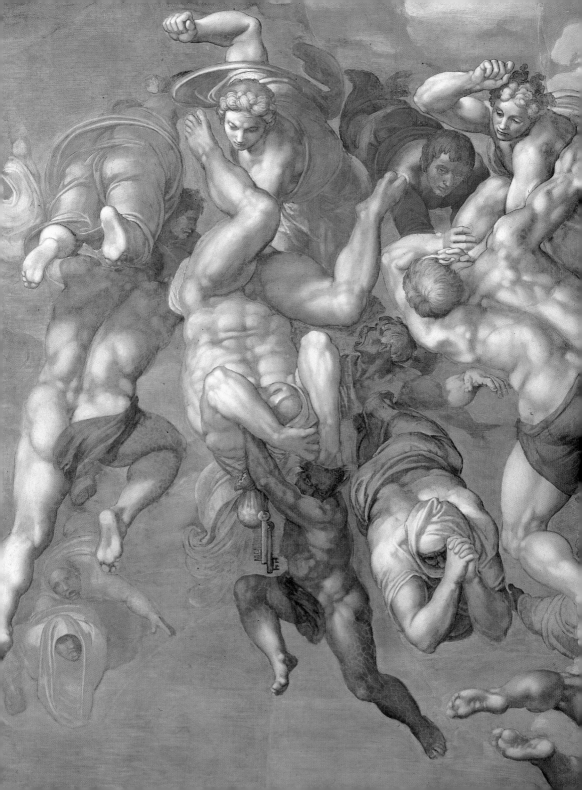

After he had renounced figurative representation, his last commissions were the negation of architecture: Porta Pia was formed by fitting together decorative elements; Santa Maria degli Angeli was the adaptation of the Baths of Diocletian as a church. One was a gesture of welcome, the other a conversion.

Michelangelo's last years were characterized by his recurrent thoughts about death. This is attested by the fifty epitaphs in memory of Cecchino Bracci, a boy who died prematurely and for whom he designed his tomb in Santa Maria in Aracoeli, and the poems and letters in which he remembers Vittoria Colonna, his friend Luigi del Riccio, and his faithful assistant Urbino. A mirror of this inner torment is his last work, the *Rondanini Pietà*, from which he detached a finished part, which was found many years ago; he began on various occasions to carve the marble, leaving it in an unfinished state, full of pain and consternation, the negation of his early *Pietà* in Saint Peter's. After these last blows of the chisel there was only silence: on February 18, 1564, at the age of eighty-nine, Michelangelo died.

Michelangelo left a whole host of imitators and followers, but no pupil as such. His works were what counted. For almost all of the Cinquecento the debate on the arts regarded the contrast between or the combination of the Raphaelesque and Michelangelesque styles. Although Michelangelo's work was one of the points of reference for European art, and was studied and copied by all the great artists, the Raphaelesque model won the day, at least until the early nineteenth century, in the same way that, in the field of literature, Petrarchism vied with Dantism. Then, beginning with the poetics of the sublime in the second half of the eighteenth century, with the Romantic generation right up to his influence on Rodin, Michelangelo became a model for the modern artist: indomitable, independent, expressive, sincere, ingenious and misunderstood.

Subsequently, critics have put this image in perspective, but art historians, like artists, have put their heart into their reconstructions. Almost all the leading European critics and scholars have concerned themselves with

Michelangelo, so that, thanks to the opinions expressed regarding his work, it is possible to reconstruct a history of art criticism from Vasari up to the present day. After the long contrast between a purely formalistic interpretation, a philosophico-iconological one, and a biographical and psychological one, recently attention has focused, above all, on two aspects. On the one hand, thanks to the conservation work of the last twenty years, many discoveries have been made with regard to the vicissitudes and techniques of the works: the new colors of the Sistine ceiling, the compositional integrity of the *Last Judgment*, the diagnostic analysis of the *Pietà* in Florence and the recent attribution of the statue of Julius II resulting from the conservation of the tomb in San Pietro in Vincoli. On the other hand, there have been in-depth studies of the artist's training, freeing it from the myth of absolute independence, the personalities of some of his friends and assistants, the financial and material aspects of Michelangelo's work, his influence on his contemporaries, and his posthumous reputation. In addition there is the confirmation of existing attributions or

the making of new ones: two panels in London, the *Young Archer* in New York, a number of drawings up for auction, and the first version of the *Christ of the Minerva* recently identified as a statue in Bassano Romano.

Others examples of the attitude to the artist after his death may be seen in the fate of his works, starting with the draperies added to cover the nudity of the *Last Judgment*, or the sculptures that remained in his workshops in Rome and Florence: for instance, the *Pietà*, formerly in the Palazzo Rondanini in Rome and now in the Castello Sforzesco in Milan, where it is displayed in a Rationalist installation designed by the BBPR partnership; and the *Victory* and four *Slaves* that remained in his Florentine workshop and were given to Duke Cosimo I. The *Victory* ended up in the Sala del Cinquecento and, for a brief period, in the Bargello; the *Slaves* were inserted, to the detriment of their dramatic force, in a grotto in the Boboli Gardens, where they stayed until 1908, when they were taken to the Galleria dell'Accademia, where they were displayed in the Tribune, which had been specially built to

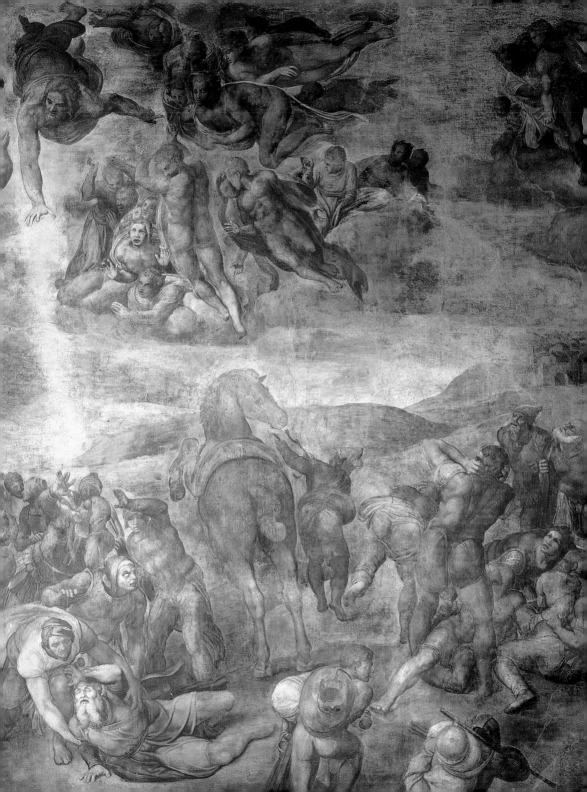

house the colossal statue of the *David* after it had been moved there from Piazza della Signoria in 1873, two years before the celebrations of the four-hundredth anniversary of Michelangelo's birth. Also in the Galleria is *Saint Matthew*, until 1834 in the Museo dell'Opera del Duomo, and the *Pietà of Palestrina*, an undocumented work removed in 1939 from an unsuitable location. Together with the cases of the forgotten works, there are the contrary cases of an excess of attention, as for the Saint Peter's *Pietà* and the *David*, which have become modern-day fetishes, attracting the wrath of deranged visitors wielding hammers. By the time of his death Michelangelo had already become a legend, which facilitated the preservation of many materials (drawings, documents and letters), thanks also to the care of his nephew, Lionardo, and the latter's son, Michelangelo the Younger, who spent a fortune on decorating—with a cycle celebrating the artist—his house, now the Casa Buonarroti museum.

Michelangelo's importance derives not only from his works, but also from the whole of his life. This celebrated artist, who was able to stand up to popes and princes, was, in reality, a very lonely man, full of irresolvable conflicts, which are not so different from the conflicts and loneliness of people today. Although it has recently been suggested that the artist was avaricious and even dishonest, allowing him to become one of the richest men of his day, what counts now is the difficult quest for consistency in his life, the radical nature of his choices, and the emotion that his works arouse, which certainly make him one of the most outstanding figures in the history of European culture. Michelangelo continues both to raise questions and command admiration, like his favorite poet, Dante, whose works he knew by heart and whom he certainly felt was worthy of emulation. Although expressing both the anguish and the hopes of his age, Michelangelo transcends his times to speak to us today of earthly love and salvation, melancholy and Titanism, sin and eternity, perfection and incompleteness, tormented vitality and a bitter, disconsolate reflection on the passing of time and the end of all things.

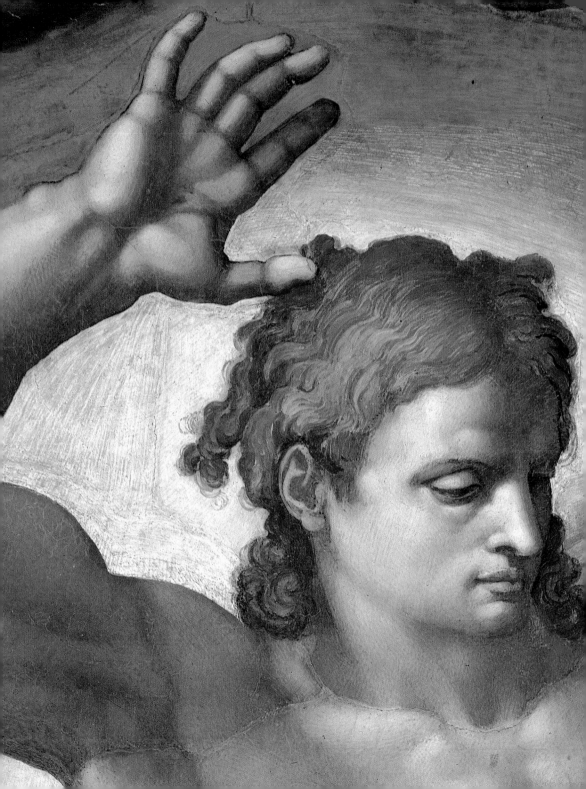

The Masterpieces

Christ the Judge (detail
from the *Last Judgment*),
1537–1538
Vatican City, Sistine Chapel

Virgin and Child with the Infant Saint John the Baptist and Four Angels (Manchester Madonna)

c. 1495–1497
Tempera on panel,
104.5 × 77 cm
London, National Gallery

The attribution of this work has long been debated. After the affinities with the *Entombment* (also in the National Gallery) had been noticed, the existence of "The Master of the Manchester Madonna" was hypothesized; the name was derived from the city where the work was exhibited in 1857. From the time when it was believed to be contemporary or subsequent to the *Doni Tondo*, the only certain panel painting by Michelangelo, differences and incompatibilities, but also important similarities, have been noted. It was supposed that the anonymous painter had used drawings by Michelangelo, but the most likely hypothesis is that the panel was by the artist himself and was among his first works as an independent painter, perhaps executed during his return to Florence while it was under Savonarola's sway in 1495–1496. The work is, in fact, based on a number of types that were common in Florentine painting at the end of the Quattrocento, in particular Botticelli's Madonnas with angels and the groups by the Della Robbia in glazed terra-cotta. Its provenance from the Borghese collections suggests that it may have been painted about 1497, shortly after Michelangelo's arrival in Rome.

The painting contains the traditional references to the future of Christ. Mary, portrayed with a bare breast (in accordance with the type of the Madonna of Humility) is reading in a book about the fate of her son, who is leaning forward to read it, while his Mother solicitously moves it away. The infant Saint John's conventional attribute, a reed cross, has been replaced by his crossed arms; his scroll announcing the Passion (the inscription "Ecce Agnus Dei" is implicit) has also been moved away from Christ and given to the angels, who read it with sad expressions. Their nature is stressed by the feathers sprouting from the shoulder of the angel on the right. The work is unfinished: the angels on the left are only outlined and Mary's mantle lacks the final coat of blue paint. The position of the Virgin and child, inserted in an elongated cylindrical form, was also used in the *Bruges Madonna*, which Michelangelo sculpted in 1504.

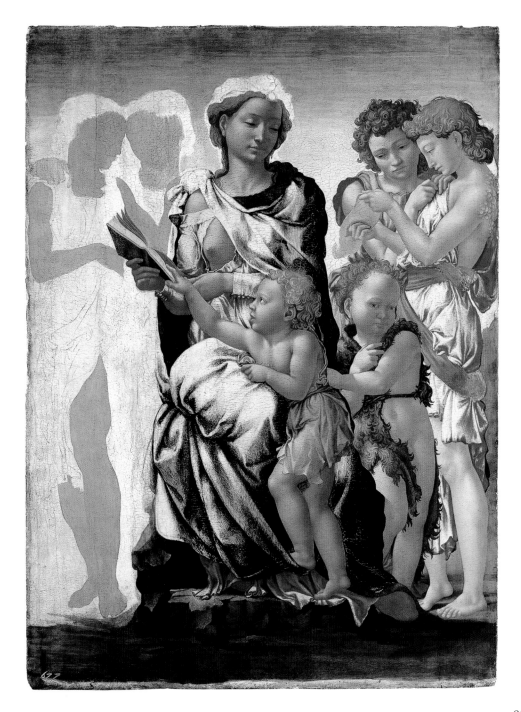

91

The Entombment

1500–1501
Oil on panel,
161.7 × 149.9 cm
London, National Gallery

Formerly in the Farnese Collection, this painting was for a long time assigned to the hypothetical Master of the Manchester Madonna and dated to about 1510. Although doubts remain about the use of oils for some passages, a technique to which the artist later declared himself to be contrary, the attribution to Michelangelo found many supporters in the past and has recently obtained general approval, also because it is difficult to believe that another artist would have used his drawings and would have been so familiar with his works. The figure of Christ, in fact, resembles that in the Saint Peter's *Pietà*, but seen from above. The woman seated lower left, probably the Magdalene is derived from a drawing by Michelangelo in which she is holding the crown of thorns. Wearing a red robe and supporting Christ's body, Saint John is the mirror image of a drawing in the Louvre linked to the design of the *David*. Lastly the face of the elderly man behind Christ (Joseph of Arimathea or, less probably, Nicodemus) resembles that of Joseph in the *Doni Tondo*. The figure of the Virgin, in the right corner, has been left as an empty outline. The other two female figures are part of the group of the Three Maries: one, helping to carry Christ's body, is in an agile pose reflecting that of John, but turned through 180 degrees; the other, with an expression of grief, holds out the palm of her unfinished hand, probably to show the nails of the Crucifixion. It has been suggested that the work was intended for the cella of the tomb of Julius II, according to the first design of 1505, and that Michelangelo abandoned it when he started on the frescoes in the Sistine Chapel. More convincing, also for stylistic reasons, is the hypothesis advanced by Michael Hirst, who has identified the work with an altarpiece commissioned from Michelangelo in 1500 by the friars of Sant'Agostino in Rome, in accordance with the will of Bishop Giovanni Ebu, whose chapel was dedicated to piety. The artist refunded his fee when he returned to Florence, leaving the work unfinished.

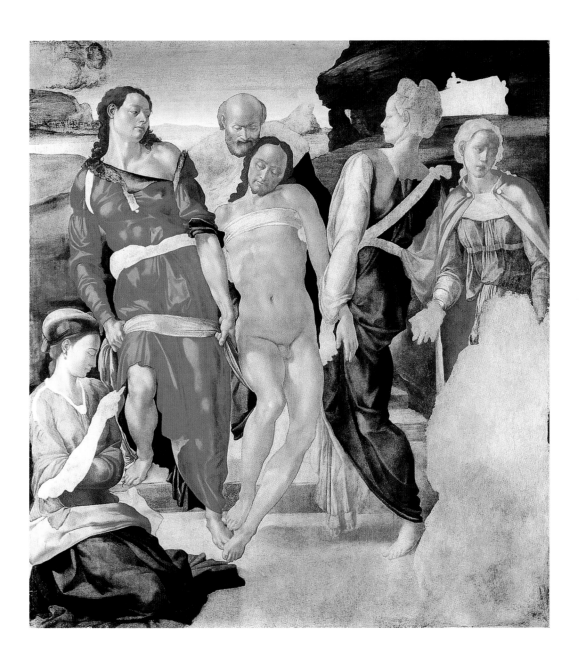

The Holy Family with the Infant Saint John and Ignudi (Doni Tondo)

1503–1504 or 1506–1507
Tempera on panel,
diameter 120 cm
Florence, Galleria degli Uffizi

This work is the only panel painting attributed with certainty to Michelangelo. The frame is the original one and may have been designed by the artist himself (the motif of the profiles of the fauns recalls the one sculpted for Lorenzo the Magnificent). The date is, however, uncertain: some scholars ascribe it to 1506–1507, when the artist returned to Florence and immediately before he started the Sistine frescoes—to which it is linked because of the evident affinities of form and color—although the more likely dating is that of 1503–1504, when the patron, Agnolo Doni, married Maddalena Strozzi. In fact, the crescent moons of the Strozzi arms appear in the top left quarter of the frame, and the work was recorded in Doni's house in 1537. The typically Florentine circular form allowed the artist to create a carefully organized composition in which the figures dominate the space. The chromatic range is limited to a few bright colors, with a result similar to that of the painting of ceramics.

In the foreground is the group with the Christ child held by Joseph, who is passing him to Mary; this refers to the merging of the line of David into the new humanity of the universal church, represented by the Virgin. The gesture of the latter, who attempts to cover the Christ child's genitals, thereby stressing their presence, alludes to the circumcision through which Christ was confirmed as a member of the people of Israel, but which also prefigures the blood spilled on the cross. The awareness of Mary with regard to her son's fate is highlighted by the closed book on her lap. The holy space is separated from the rest of the composition, forming a *Hortus conclusus* (enclosed garden) in which a number of clumps of clover allude to the Trinity. Observing the scene from the right is the infant Saint John, easily recognizable thanks to his tunic of camel's hair and small cross. In the background are five figures of nude youths, perhaps a reference to humanity before grace, awaiting baptism.

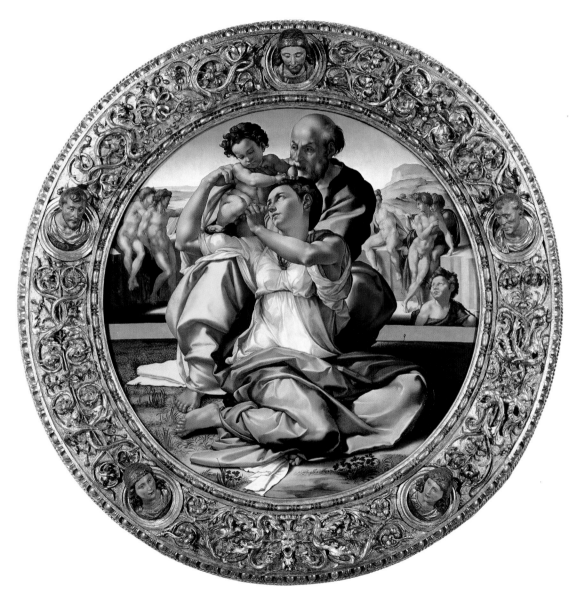

95

Battle of Cascina
(copy by Aristotele da Sangallo)

c. 1542
Copy of the cartoon by
Michelangelo (1504–1506)
Oil on canvas, 75.5 × 130 cm
Norfolk, Holkham Hall,
Collection the Earl
of Leicester

This work was commissioned by the gonfalonier Piero Soderini in the fall of 1504, at the height of the war for the reconquest of Pisa, and was intended for the Sala del Consiglio of the Palazzo Vecchio in Florence. Michelangelo executed the preparatory cartoon in competition with Leonardo, but it was interrupted by his journey to Rome in 1505 and restarted in 1506, before he left for Bologna. The subject, drawn from Filippo Villani's *Cronica*, is an episode of the previous war against Pisa: on July 29, 1364 Galeotto Malatesta halted with his troops near Cascina. Here, because of the heat, the soldiers bathe, disarmed and naked, in the Arno until one of the warriors, Manno Donati, burst into the camp, crying out, "We're lost!"; after dressing in great haste, the soldiers confronted the Pisans, defeating them. The sound of the trumpet and the shout of the old man in the center of the scene arouse the heroic virtues and combative fury that simultaneously animate the figures.

It was probably Michelangelo himself who chose to represent this particular moment, because it allowed innumerable variations of the theme of the nude figure in movement. Leonardo, who was entrusted with the *Battle of Anghiari*, had instead prepared drawings of horses, armor and weapons, studying, above all, the atmospheric effects caused by the pounding of the horses' hooves and the general commotion. After making numerous preparatory drawings, Michelangelo produced the large cartoon serving to transfer the design onto the wall. It is probable that he did not get very far with the wall painting, interrupting it in order to start, in 1508, the Sistine ceiling: in any case, after June 1509, with the final conquest of Pisa by the Florentines, the subject became anachronistic. The cartoon, which was moved from one place to another, became, as Benvenuto Cellini said, the "school of the world"; studied and copied until it was worn out, it was divided into a number of parts and then lost. The copy of the central group, executed by Aristotele da Sangallo, is one of the most complete and accurate.

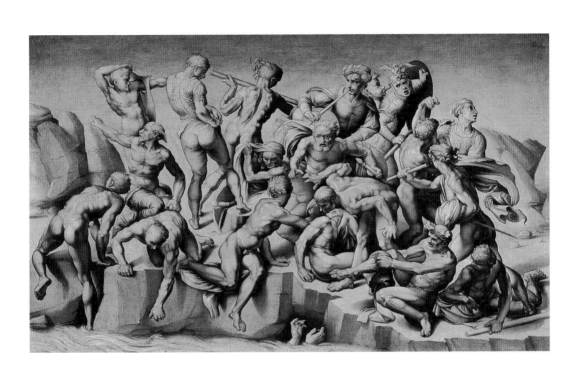

Ceiling of the Sistine Chapel

1508–1512
Fresco, approx. 13 × 36 m
Vatican City, Sistine Chapel

In 1477, on the orders of Sixtus IV, work was started on the Sistine Chapel, which incorporated the pre-existing papal chapel. The building, which is based on the form of Solomon's Temple, must have been finished in 1481, when Pietro Perugino, Sandro Botticelli, Domenico del Ghirlandaio and Cosimo Rosselli, assisted by Pinturicchio, Luca Signorelli, Piero di Cosimo, and others, signed the contract for the execution of the frescoes on the walls. The chapel was inaugurated on August 15, 1483, the feast of the Assumption of the Virgin, to which it was dedicated. In 1504 serious problems regarding the stability of the structure due to the drainage of groundwater made reinforcement work necessary; iron rods were placed over the vault—decorated with gold stars on a blue ground by Pier Matteo d'Amelia—with filling in of the cracks that damaged the existing decoration. Thus Julius II decided to give Michelangelo the task of painting the new frescoes for the ceiling.

The first project, figures of apostles inserted in a geometric framework, was transformed into a complex program comprising scenes from Genesis, prophets and sibyls, the ancestors of Christ, and various other figures having a heraldic or allegorical function. Thus the ceiling recounted the events leading up to the fifteenth-century cycle on the walls depicting scenes from the lives of Moses and Christ, and the series of popes. The artist installed a scaffolding bridge, fixed to the walls, and started work in May 1508, firstly with a number of assistants from Florence, and then almost alone: he finished the titanic undertaking in 1512. Like Botticelli, who in his last years was influenced by Savonarola, Michelangelo abandoned the perspective construction of the Quattrocento and carried out a deliberately archaistic reduction, arranging the monumental figures according to a dimensional and expressive hierarchy. The separate parts of this new heroic humanity are unified by a series of triumphal arches under which the papal procession passes in order to arrive at the altar.

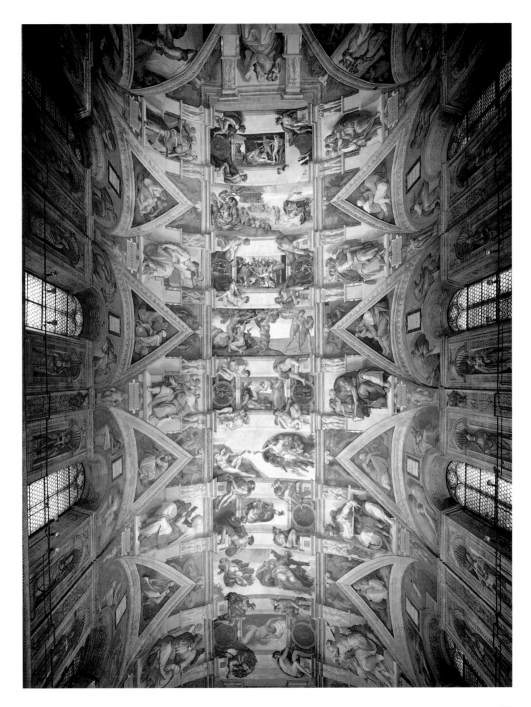

Prophet Zechariah

1508–1509

Fresco, 360 × 390 cm
Vatican City, Sistine Chapel
With the inscription
"ZACHERIAS" on the plaque

The figures of the prophets and sibyls are larger than the others, not only because it was necessary to "weigh down" the corbels from which the curve of the vault springs, but also to affirm the order in which the frescoes should be observed. The projecting figures of the seers form the beginning of the narrative. From their meditations and wisdom are derived the images—that is, the vision of the scenes and characters, interpreted with regard to the coming of the Messiah, and also of the future that is identified with the reign of Julius II. The events of the Creation and the history of the people of Israel become the prefiguration of the subsequent events, continuing the dialogue between the Old and New Testaments on which all the Quattrocento decorations were based. The seven prophets and five sibyls are arranged alternately: the former begin above the entrance doorway with Zechariah and continue on the right with Joel; in the following bay, on the left, with Isaiah; then, on the right, Ezekiel and, on the left, Daniel; lastly, on the right, Jeremiah and, above the altar wall, Jonah. In the remaining spaces are the sibyls: the Delphic, the Erythraean, the Cumaean, the Persian, and the Libyan.

The figure of Zechariah is seen in profile, seated on a marble throne, leafing through a book or perhaps about to read out its contents. The colors are those of the Florentine tradition, which Michelangelo had assimilated in Ghirlandaio's workshop, and the prophet's stocky, solid forms wrapped in drapery are derived directly from Giotto, Masaccio, and Donatello. The light falls from the left, bathing the naked rotundity of the nape of his neck and the pages of the book, and leaving his absorbed face in shadow. The complex prophecies in the Book of Zechariah were interpreted as prefigurations of the whole story of the Redemption; the placing of the prophet above the entrance to the chapel not only reflects his prediction of the entry of Christ into Jerusalem, but is also a call for conversion, with the humility and meekness necessary for entry into the kingdom of God.

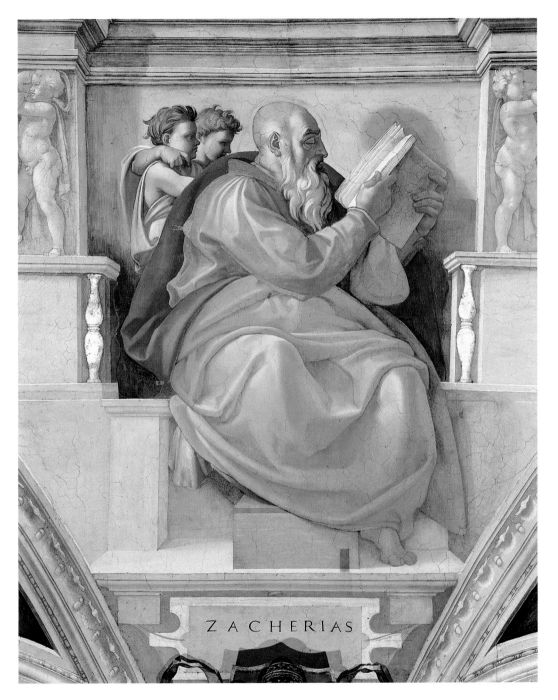

ZACHERIAS

Cumaean Sibyl

1510
Fresco, 375 × 380 cm
Vatican City, Sistine Chapel
With the inscription "CVMAEA"
on the plaque

The pagan-Christian syncretism of humanism, with which Michelangelo, too, was imbued, appears evident in the placing of the sibyls alternately with the prophets. While the latter appear as the authors of the books of the Old Testament, thus linking them directly to the biblical scenes on the ceiling, the presence of the sibyls is accounted for by the fact that their predictions, deriving from Greek and Roman divinatory rituals, are reinterpreted from a Christian point of view. The sibylline oracles are assimilated to Apollo and, thus, through the traditional analogy between Christ and the sun, to the predictions of the coming of the Messiah. In the context of Julius II's pontificate, their presence assumed a particular politico-military significance, as it was associated with the setting up of a large and powerful papal state legitimated by the inseparability of temporal and spiritual power. Just as the prophets foretold the kingdom of Christ, the sibyls predicted the fate of the Roman Empire, but both had the task of announcing the approach of Julius II's reign, during which the new Christian Rome would be reborn from the ancient city, inheriting its magnificence and coming to pass in the light of the Revelation.

The Cumaean Sibyl exemplifies this dual political and religious significance. In his fourth *Eclogue*, Virgil gives her the task of foretelling the new golden age inaugurated by a child conceived by a virgin (the prophecy, like Isaiah's similar one, is seen in relation to the coming of Christ); in the *Aeneid* he has her announce the triumph of the gens Iulia and the end of disorder with the Pax Augusta (which refers not only to the Pax Christi, but also to the political plans of Julius II, the Vicar of Christ and the new Augustus). Michelangelo has depicted a woman who, despite her age, is remarkably vigorous: she has muscular arms and powerful legs, and a firm grip on the book, toward which her grumpy face is turned. Also the restrained colors of the drapery, with its metallic tones, evoke the militaristic force of Cumaea's character.

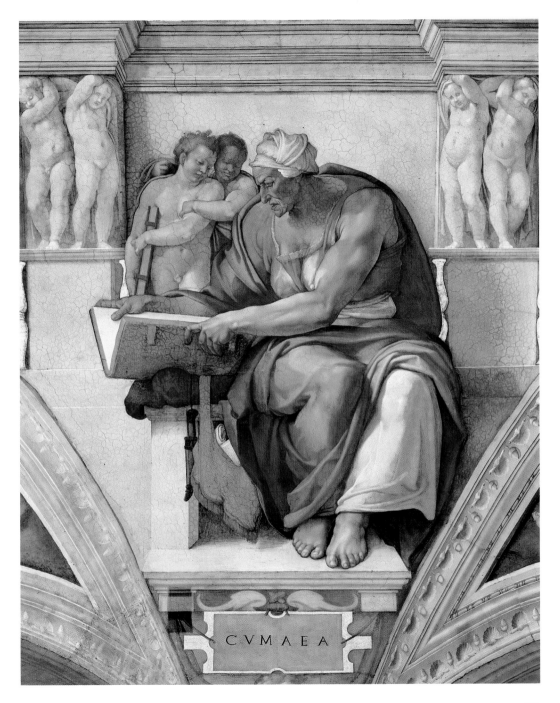

CVMAEA

103

Prophet Jeremiah

1511
Fresco, 390 × 380 cm
Vatican City, Sistine Chapel
With the inscription
"HIEREMIAS" on the plaque

Among the various attitudes and temperaments of the seers, Jeremiah belongs to the melancholy type, with his legs crossed, his head leaning forward and propped on his hand, and his elbow transmitting the weight to his knee. This figure, which displays its "bitterness," as Vasari described it, has been interpreted as a veiled self-portrait of Michelangelo; his posture is the same as that given to him by Raphael when he portrayed him as Heraclitus in the *School of Athens*. It is interesting to note that both figures wear leather boots, which Vasari said was characteristic of Michelangelo. In the series of the seers, the use of footwear is an exception (apart from Jeremiah, only the adjacent Persian Sibyl appears to have shod feet); the bare feet of the others recall the gesture of Moses when he was in the presence of God. The mournful meditation of Jeremiah even seems to cast doubt on hope in the Almighty: the author of the *Lamentations*, the prophet was persecuted and imprisoned. His prophecies were read during Lent as prefigurations of Christ's Passion.

Each seer is sitting on a throne consisting of a marble seat placed between two pilasters, each of which is flanked by two small gilded balusters that imitate the shape and corner position of those invented by Donatello for the base of his *Judith and Holofernes*, which Michelangelo perhaps copied because he did not approve of the way Bramante used them to crown the peristyle of his Tempietto. Pairs of caryatid putti surmounting the pilasters are depicted in fictive relief, which is generally executed using the same cartoon reversed on both sides of each throne; each pair is formed by a male and female, stressing that the prophecy is addressed to the whole of humanity. Below each throne, a plaque bears the name of the seer in large letters; lower down, where the corbels narrows, a putto supporting the plaque forms a link between the walls and the vault, its size contrasting notably with the smaller figures in the Quattrocento decoration.

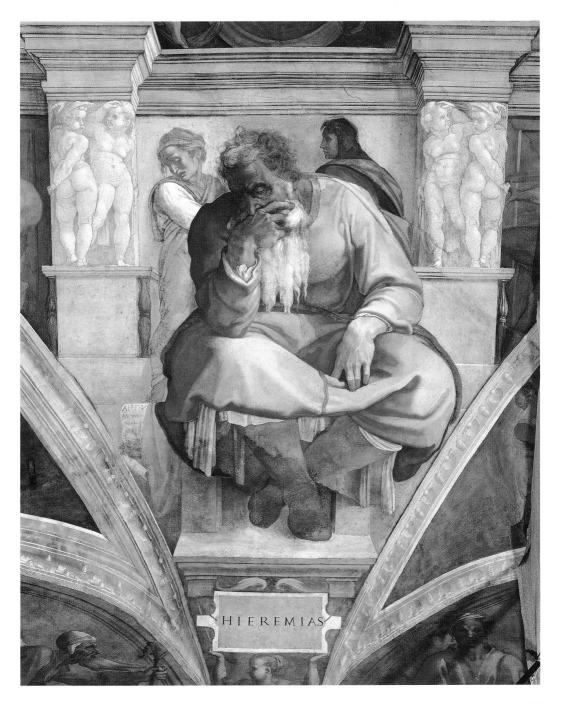

HIEREMIAS

Libyan Sibyl

1511
Fresco, 395 × 380 cm
Vatican City, Sistine Chapel
With the inscription "LIBICA"
on the plaque

The different geographical origins of the sibyls underscore the universal relevance of the Evangelical message: Delphica evokes Greece; Erythraea, Asia; Cumaea, Italy; Persica, the Holy Land; and Libyca, Africa. With her bare shoulders, neat hairstyle and supple and twisted pose, her bodice undone and held in place only by her girdle, the Libyca is certainly the most sensual of the sibyls. The pose has been carefully studied in a preparatory drawing, now in New York, where the figure, which is naked, displays all her muscles in action. In contrast to the contemplative Jeremiah, who faces her on the opposite side of the ceiling, the active Libyca is lifting a book, but, before turning with the weighty volume, she is looking at her right foot to ensure that she has a hold on the stone slab below, while she rests her other foot on a wooden box on its edge. Like all the other seers, the figure is accompanied by two young attendants or genii, one of whom indicates the book, thus drawing attention to the sibyl's gesture.

When Michelangelo started to paint the second half of the ceiling, toward the altar, he made stylistic modifications, increased the scale of the figures, and broke the rigid symmetry of the parts already painted. Although they are well harmonized, there is an evident change in the last five seers (the Persian and Libyan sibyls, and the prophets Daniel, Jeremiah and Jonah): the slab on which their thrones rest has been lowered and, since the space between the spandrels is reduced, it becomes narrower and is seen from a higher viewpoint; in this way the size of the figures could be increased, culminating in the huge figure of Jonah, which the artist could only fit in the space of the throne by depicting him leaning backwards. This increase in size serves to reduce the foreshortening effect when the whole ceiling is viewed, which is only possible—in order not to see the central scenes upside down—from near the old entrance.

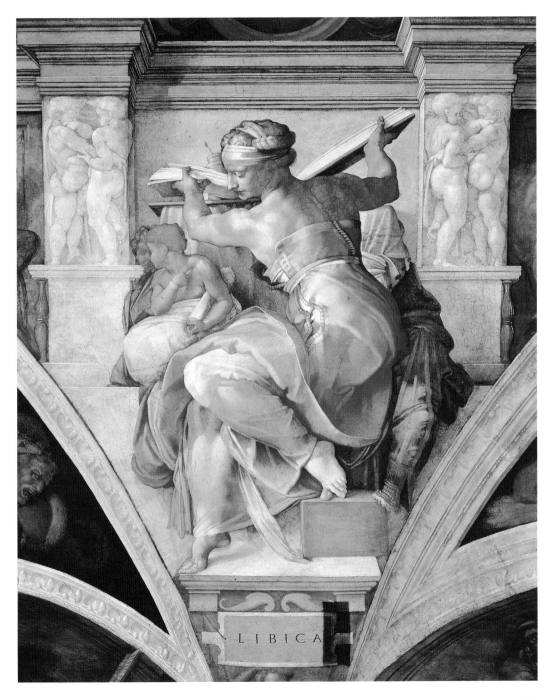

LIBICA

Prophet Jonah

1511
Fresco, 400 × 380 cm
Vatican City, Sistine Chapel
With the inscription "IONAS"
on the plaque

The prophet Jonah is unlike all the other seers, not only due to his posture, which is dynamic and more articulated in space, but also for his gestures and gaze, allowing him to interact with the adjacent scenes. His body is bent backwards and his arms meet at his right side to allow his hands to make the same gesture, pointing to the pendentive below showing the *Punishment of Haman*; by contrast, the foreshortened head, deriving from that of Mary in the *Doni Tondo*, faces upwards toward the panel where God is separating light from darkness. Thus, rather than being a figure enclosed in the limited space of the throne, Jonah is located at the point where the series of seers and biblical scenes converge if the ceiling is viewed looking toward the altar wall.

The way in which Jonah carries out his task as prophet is different too. While the prophets and seers are portrayed while they are immersed in reading or engaged in a discussion with their attendants, Jonah has neither books nor scrolls, but rather the attributes associated with his story: a whale and a gourd plant. His prophetic vocation only becomes evident after he had disobeyed God, who saves him from drowning at sea by having him swallowed by a whale, which then casts him up on the shore. In the gospel according to Matthew, Christ refers to the three days spent by Jonah in "the belly of the whale" as the prefiguration of the three days that he was to spend "in the heart of the earth" after his death and before the Resurrection. The way that Jonah presaged the Messiah was not, however, through prediction, but rather through his own life, and this is why this subject is placed above the altar, where the Eucharistic sacrifice takes place. The gourd plant in the background, representing the one that God caused to grow to shelter Jonah from the sun, is a symbol of the mercy of God, who will save whosoever calls upon his name.

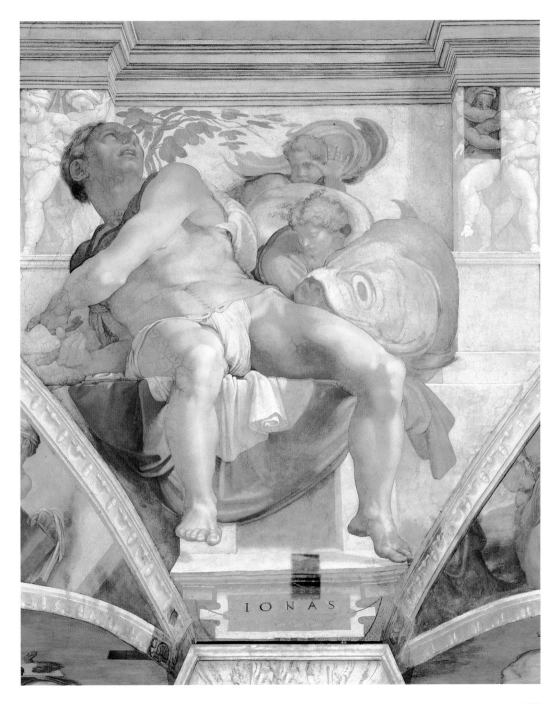

IONAS

Drunkenness of Noah

1508–1509
Fresco, 170 × 260 cm
Vatican City, Sistine Chapel

In central panels of the ceiling Michelangelo painted nine scenes from the book of Genesis. The three ones in which the figure of God stands out alone are followed by the three scenes from the story of Adam and Eve and three scenes from that of Noah. The order in which the artist intended them to be viewed is backwards in time, from Noah to the first day of the Creation—from the entrance door to the altar—and corresponds more or less to the order in which they were executed. From the altar wall, in fact—which is where visitors enter the chapel today—these frescoes are seen upside down. The scene of the *Drunkenness of Noah* interrupts the narrative of the central zone, which continues in the spandrels and the lunettes with the ancestors of Christ.

The subject of the first scene is dual: after the Flood the old patriarch plants vines (he can be seen working on the left), from which he obtains the wine contained in the large vat in the center; Noah gets drunk (in the foreground is a jug and cup) and then falls asleep naked. One of his three sons, Ham, sees him and mocks him, calling his brothers Shem and Japheth, who approach Noah so as not to see him and cover their father's nakedness. Michelangelo represents one of them trying to persuade his brother to come away and the other, with his head turned, covering Noah (this is probably Shem, from whom Abraham was descended). Noah then laid a curse on his ungrateful son, Ham, and his offspring, while he blessed those of the other two. The theme is not so much that of the drunkenness of Noah, condemned as a sin by the Fathers of the church, as that of the patriarch who, for the first time, produces wine, the prefiguration of the Eucharistic blood, and his mocking as the prefiguration of the mocking of Christ by the scoundrels. The tendency of part of humanity, which had just been redeemed by the Flood, to seek evil gave rise to the long journey of the chosen people in search of a new covenant with God. That is why this scene terminates the central zone and starts that of the expectation of the Messiah in the rest of the ceiling.

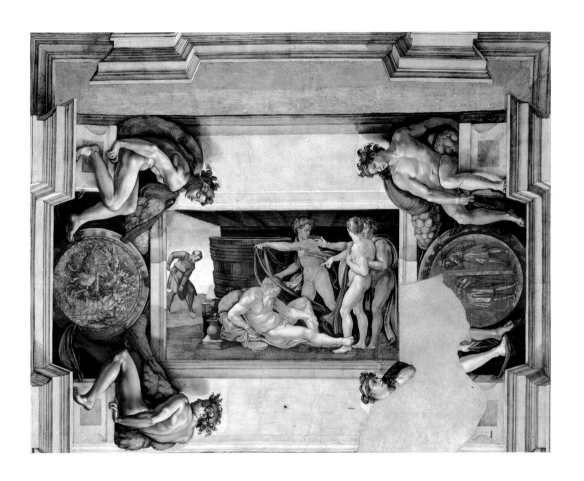

Flood

1508–1509

Fresco, 280 × 570 cm

Vatican City, Sistine Chapel

The first of the scenes painted by Michelangelo in the Sistine Chapel, this was one of those that posed the most problems, firstly because of his difficult relationship with his assistants, whose work did not satisfy him; then as a result of the formation of mold on the fresco, which obliged him to redo a number of parts; and lastly, due to the complexity of the subject and the large number of figures. The scene must be read from left to right, continuing toward the center and finishing with the ark. A number of family groups have taken refuge on the high ground on the left: in the foreground is a woman resigned to her fate, with her child in tears; beyond her is an old man and his wife, child, and ass; two youths are depicted from behind and a third climbs a tree; a woman is shown with her two children, one in her arms, the other clinging to her leg. A column of people struggles up the hill: a woman carries a small table with various objects on her head; a young man has a large pan, another a heavy sack on his back; a man is carrying an exhausted woman piggyback. On the right of the fresco the desperation increases. A group has climbed onto a rocky outcrop, where they shelter from the strong wind in a tent, but the water continues to rise and some of them look down at it despondently. In the center a man is carrying the body of his drowned son, knowing only too well that the same fate awaits him. Further away, on a boat, despair has turned into bestial fury. A number of men try to climb onto the boat, which risks capsizing and the reaction of the occupants is merciless: using a club and their fists two of them make the intruders get back into the sea, while the others act as counterweights. In the background a number of people have swum to the ark and are trying to enter it, some with a ladder and others by making a hole with an ax, while Noah looks out, apparently unconcerned. At the top, in the central opening, a dove heralds the moment when, as the earth reemerges, it will return with an olive leaf in its beak, but it also symbolizes the Holy Spirit descending for the purifying rite of the baptism, sanctioning with water the new covenant in Christ.

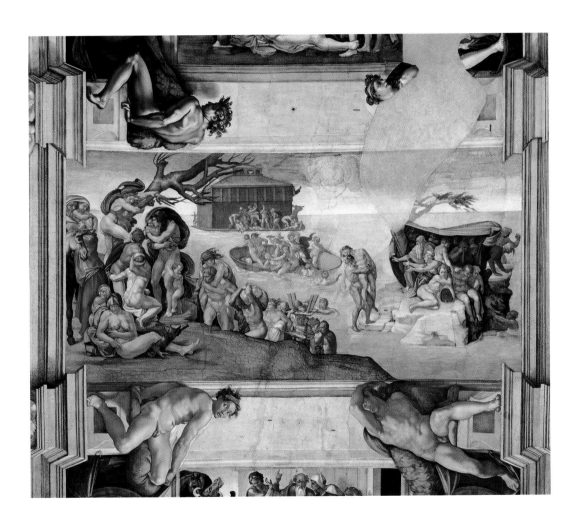

113

Sacrifice of Noah

1508–1509
Fresco, 170 × 260 cm
Vatican City, Sistine Chapel

Although it is in itself fairly clear, the definition of this subject presents the problem of the chronological order of the events; it is likely that the three scenes from the life of Noah should be viewed together in a single block. The sacrifice is made, in fact, as a thanksgiving to God when, at the end of the Flood, Noah and his family step off the ark, while here the scene is placed before that of the Flood, which, because of its complexity, had to occupy one of the large panels in the ceiling. Michelangelo's biographers, Vasari and Condivi, because of the narrative order, identified the subject as the sacrifices made by the sons of Adam and Eve, Cain and Abel: the former brings the fruit of the ground, which is not welcomed by God; the latter sacrifices the first lamb of the season, and is appreciated for this. There are, however, numerous elements that suggest this was not the subject of this fresco. In the background is one of the sides of the ark and, on the left, four animals representing those saved from the Flood: an ox, an ass, a horse and an elephant, chosen for their symbolic value—the first two refer to the Nativity, the second two are emblems of the church and wisdom.

In the center, next to his wife, is Noah, who is pointing toward the sky from where the rain came and where the smoke from the sacrifice will rise. In the foreground, in their heroic nudity, are the patriarch's three sons: the first is holding the ram that has yet to be sacrificed, the second is blowing into the oven, and the third is handing over the entrails of the animal that has just been slaughtered. The other three figures have been interpreted as the wives of Noah's sons, but the young man on the right, carrying the wood for the fire, could hardly be confused with a woman. It must also be remembered that the fresco was severely damaged by the cracks caused by the settling of the building and already in the sixteenth century the two figures on the left had been repainted by Domenico Carnevali (about 1568), probably according to the original drawing on the lost intonaco.

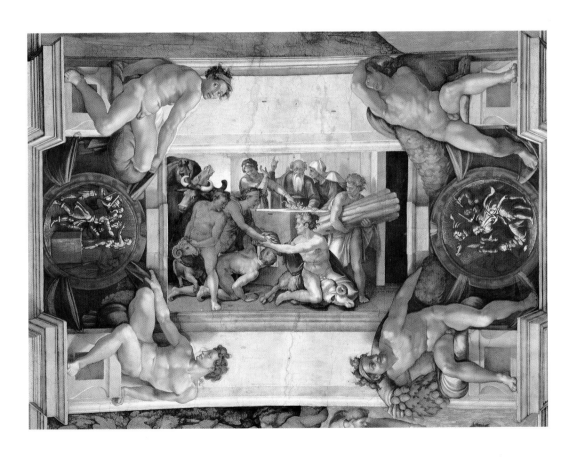

115

Temptation and Expulsion of Adam and Eve

1509–1510
Fresco, 280 × 570 cm
Vatican City, Sistine Chapel

The three scenes from the story of Noah are followed by those from the story of Adam and Eve set in the Garden of Eden. From the expulsion, the narrative sequence goes backwards to the Creation of Adam. The first scene is divided into two parts by the tree of the knowledge of good and evil that, according to the biblical account, stood in the midst of the garden. The Temptation is depicted in the left half: the figure of the serpent—Satan in disguise, which Masaccio had given a female head—becomes the body of a woman whose legs turn into two serpents that wind around the trunk of the tree. The latter is a figtree, which alludes to the fact that, as soon as they had eaten the forbidden fruit and discovered that they were naked, Adam and Eve covered themselves with fig-leaves. Although it has been said that Michelangelo omitted the forbidden fruit, the serpent is, in fact, handing Eve two figs so she can eat one and give the other to Adam, who, with a parallel movement in the opposite direction, is pointing to a third fig near the serpent's head (since they are the same color as the leaves, the fruit are not easily distinguishable). Eve's posture, resembling that of the Virgin in the *Doni Tondo* in reverse, highlights her sensuality, her seductiveness, and her guiltiness; the sterility of her action is symbolically represented by the dead tree trunk next to her, the form of which echoes the position of Eve's body and arm.

The right half of the fresco represents the subsequent phase of the Expulsion: the posture of the angel is symmetrical to that of the serpent, but inverse in its positive value. Adam and Eve, previously proud of their bodies and indifferent to their nudity, attempt to hide themselves from the severe gaze of the angel, who threatens them with a sword. The two figures, referring back to the precedents of Masaccio and Jacopo della Quercia, are already weighed down by their mortal state and the despair resulting from their sinful act.

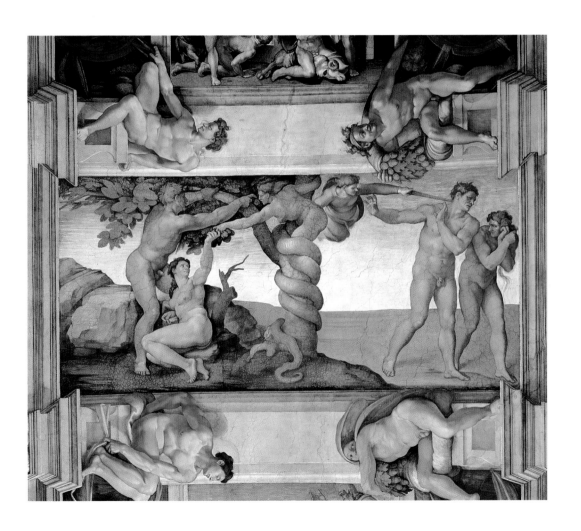

117

Creation of Eve

1509–1510
Fresco, 170 × 260 cm
Vatican City, Sistine Chapel

This is the first scene containing the figure of God the Father, which appears in all the following ones. This reflects the division of the space in the Sistine Chapel into two parts by the *cancellata* (screen) that was originally exactly halfway along it, but was later moved. Thus the division between the space reserved for the pope and the clergy and the area for the congregation corresponded to that between the presence and the absence of God on the ceiling, or rather, to the transition from the cosmic immanence of the Creator to his historic presence through the church (Noah's ark prefigures the church, as does Eve, who also foreshadows the Virgin). Even Eve's posture, as she rises to her feet and approaches God, may be interpreted as a reference to the dedication of the Sistine Chapel to the Assumption of the Virgin. Below, Adam is sleeping, propped against a dead tree trunk with a projecting branch, the form of which echoes that of Eve; she emerges from Adam's side to go toward God, whose figure is derived from a drawing Michelangelo made in his youth after Masaccio. But the moment of Eve's creation has already passed and the dialogue consisting of gestures shows that she submits to the will of the Lord, who appears to be telling her what is allowed or forbidden in the Garden of Eden.

The scene is practically devoid of any superfluous element; even the Garden of Eden, which ought to be full of plants and animals, is depicted as a tract of bare, rugged land. The composition is constructed with a system of intersecting directional axes: Eve is in line with Adam's arm and perpendicular to his body, forming a triangle with the figure of God; Eve holds her hands together immediately under those of the Lord, and Adam's feet are in line with God's massive foot emerging from his cloak; the three heads are aligned on a single axis. Everything is concatenated and harmonious in the brief period preceding the original sin.

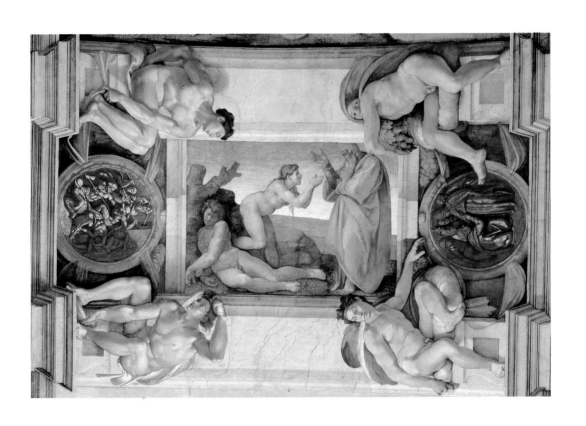

119

Creation of Adam

1510
Fresco, 280 × 570 cm
Vatican City, Sistine Chapel

This scene represents the moment when God created the first man, or rather, endowed him with life and a soul. The whole composition is constructed along oblique lines, which, parallel to or intersecting each other, produce the effect of the attraction between the two bodies. The figure of Adam is represented lying on the ground, from which the clay modeled by God has been obtained; his body is without energy, his left arm raised with difficulty, his right arm and left leg are bent in order to thrust his body forward, his head is inclined and his eyes follow the movement of his arm, which seeks contact with God as their forefingers approach each other (Adam's fingers, lost due the formation of a crack, were repainted by Carnevali). Michelangelo creates here a type of man of remarkable beauty and physical presence, made, as the bible says, in the image and likeness of God, but not in the likeness of the Father, but rather that of his Son, not yet incarnate, but already with his Father. The creation of Adam is that of the perfect man who, after falling into sin, could only be redeemed by Christ, the new Adam. The breath of life of the creation was also construed as the prefiguration of Pentecost, when the Holy Spirit descended on the disciples. Thus this scene may allude to the Trinity, the Godhead conceived as the Father, the Son, and the Holy Spirit. Around the figure of God are clustered twelve wingless angels, who could be interpreted symbolically (the months, the tribes of Israel) were it not for the fact that among them is a female figure who, it has been conjectured, could be Eve or, even better, the Virgin, from the beginning of time chosen to be the vessel of Christ's Incarnation and preserved from the original sin. In this case the child clinging to her leg would prefigure Christ; his posture is similar to that of Adam, and God's fingers touch his shoulder just as the priest holds the host during mass.

The beauty and universality of this scene have made it extremely popular; it has become the symbol of the perfect harmony at the height of the Renaissance that, as soon as it had been reached, was abandoned.

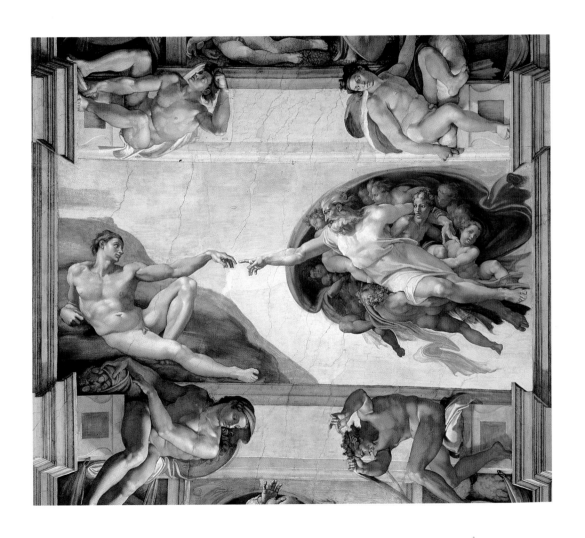

Separation of the Earth from the Waters

1511
Fresco, 155 × 260 cm
Vatican City, Sistine Chapel

Proceeding toward the altar, one arrives at the last three scenes in which God is depicted as the Creator of the Universe. These scenes may be regarded as a single composition in the form of a rhombus, with, at the corners, the four images of God facing in different directions: towards the right, toward the left, from the bottom forwards, from below upwards. This repetition of God the Father does not give the impression of the succession of events, but rather of their simultaneity, and these magnificent foreshortened views suggest the omnipresence of God and his capacity for movement according to his will. It is possible, however, that these panels, in which the first five days of the Creation are recounted, do not follow the narrative order exactly, as is also the case with the scenes from the story of Noah (where the sacrifice as a thanksgiving precedes the Flood). It has, therefore, been hypothesized that this scene, the third starting from the altar wall, represents the separation of the waters (second day)—that is, the creation of the firmament, which divides the waters above the heavens from those below. This is a controversial interpretation, also because it is possible to respect the order of the narrative: in the first scene is the *Separation of Light from Darkness* (first day), in the second the *Creation of Plants* (third day) *and of the Sun and Moon* (fourth day) and in the third scene the *Creation of the Fishes and the Birds* (fifth day), a subject suggested by the biographer Condivi. The following scenes represented the *Creation of the Progenitors* (sixth day). The double gesture of God's hands may be interpreted as the simultaneous creation of the fish in the water and the birds in the sky, but it is also possible that Michelangelo has assimilated the two acts regarding the waters of the second and fifth days. The gesture of blessing the water is linked to that of baptism and the three angels accompanying the Creator may allude to the three theological virtues infused into the sacrament. Already in the sixteenth century, due to the cracks that had formed in the ceiling, there was loss of intonaco and God's left hand was entirely repainted by Carnevali.

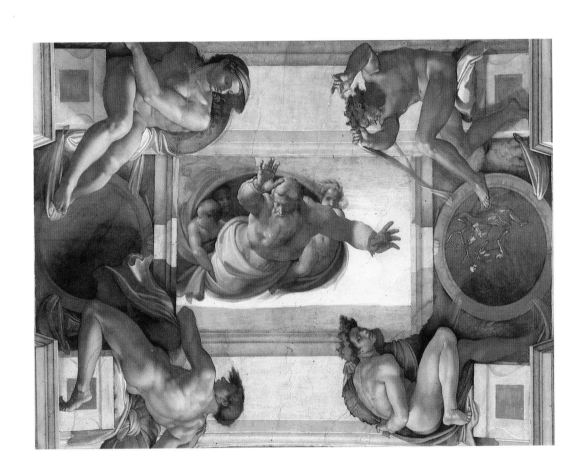

Creation of the Plants
and of the Sun and Moon

1511
Fresco, 280 × 570 cm
Vatican City, Sistine Chapel

As in the *Temptation and Expulsion of Adam and Eve*, Michelangelo has divided this scene into two parts representing the third and fourth days of the Creation. Thus God appears twice: on the left he creates the plants, on the right the sun and the moon. With regard to the splendid foreshortening from behind, Michelangelo's contemporaries, including Paolo Giovio and Vasari, praised the illusionistic effect that made it seem to follow the spectator to different points of the chapel. The artifice does not merely have virtuosic value, but rather is intended to represent the infinite mobility of God, which is emphasized by the way the figure moves transversally to the open arms of the second image of God on the right.

Michelangelo isolates from the fourth day of the Creation the moment at which the Lord makes two lights appear, the greater one to rule the day, the lesser to rule the night: the sun and the moon, which refer to the parallel between Christ and the church, which only shines with his reflected light (Michelangelo used the same analogy to explain the superiority of sculpture over painting). In the context of the pontificate of Julius II, however, there is probably also a reference to the medieval dispute between the papacy and the Holy Roman Empire, where the former is compared to the sun and the latter to the moon, which appears here in a subordinate position. The four figures of putti flanking God may allude to the four temperaments of man—influenced by the celestial bodies—or to the four seasons, which are linked to the cycle of time, like the alternation of night and day, or even to the four elements, the separation of which was often associated with the events of the Creation. Thus the figures are open to various interpretations: the putto shading himself from the sun could be fire or summer; the one pointing to the plants, the earth or spring; the hidden, evanescent one, air or autumn; the one drying himself with a cloth, water or winter. The audacity of the artist's painting technique is clearly visible in God's hair: Michelangelo increases its volume with black lines painted with the tip of the brush.

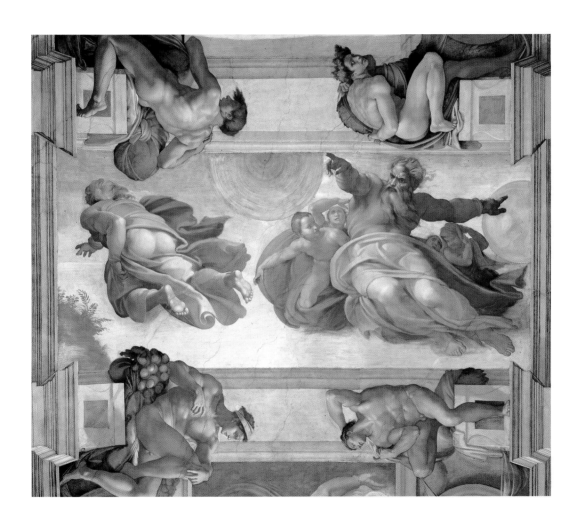

125

Separation of Light from Darkness

1511
Fresco, 180 × 260 cm
Vatican City, Sistine Chapel

In the beginning of the book of Genesis, this is, in fact, the last scene painted by Michelangelo in the central zone and concludes the journey back through time, from the dispersal of Noah's descendants to the first day of the Creation. The *Separation of the Light from Darkness* is the first act in the creation of the universe, but is also, in the Neoplatonic conception, the beginning of the eternal struggle between good and evil. The figure of God fills almost the whole of the composition and is partially outside the frame, as if to say that, before this act, only the infinite corporeity of God existed, but then, in the following scenes, it gradually becomes smaller.

Reaching out towards the indistinct gaseous cloud, his arms held above his head, God separates the dark masses from the light ones, his thought and his act becoming simultaneous ("And God said, Let there be light: and there was light"). The figure seems to be rotating in order to thrust its head forwards into the realm of the light, leaving the darkness to the rebel demons. God's body, with its powerful muscles, is sheathed in a pink robe, which billows out around his waist and gradually fades away into the cloud. His head has the same position, strongly foreshortened, that must be assumed in order to look at the ceiling. The spectators' viewpoint is identified with that of God, so that they are drawn into the miracle of universal existence.

But the Creator's pose is also the one adopted for four years by Michelangelo, who, according to the sources, when he finished working on the ceiling could only read books or letters by holding them up high. God's creative posture is the same as the artist's: both with their arms raised towards the vault—of the chapel or the universe—give concrete form to the idea that is in their mind, molding the image in accordance with the principle that is the hyperuranian matrix of all the corrupt worldly forms.

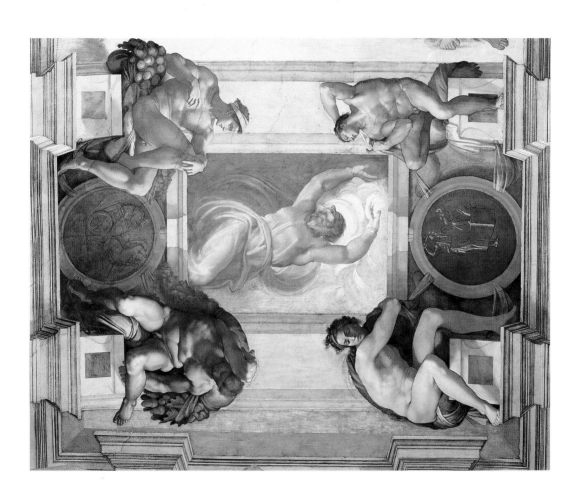

David and Goliath

1509
Fresco, 570 × 970 cm
Vatican City, Sistine Chapel

In the pendentives at the corners of the ceiling there are four scenes linked to the salvation of the Israelites, which appear to be evoked by the readings of the seers. The prophetic vision foretold the deliverance that was to take place with the advent of Moses. The first two scenes executed are those on the entrance wall and they treat the cases of a youth and a widow, David and Judith, who defeat the enemy with their faith and their cunning, instead of physical force. They are symbols of divine justice used also with political undertones in order to legitimize God's declared support (in Florence the two characters became republican symbols in Donatello's and Michelangelo's statues). Above all, however, with their humility, wisdom, and fortitude, David and Judith have the function—together with the prophet Zechariah, who separates the two pendentives—of providing a salutary warning to those entering the chapel.

In this scene the young David kills the giant Goliath (Samuel 1:17). Michelangelo does not portray, as he had done in the huge statue in the Piazza della Signoria, the moment of reflection preceding the action, but rather the conclusive one of the victory: the stone from his sling has already struck Goliath, who lies in the center foreground, while David has grabbed his sword and is about to deal the death blow by cutting off his head. Thus this subject creates a parallel with that in the other pendentive, where Judith is covering Holofernes' severed head. In both scenes the artist had to resolve a structural problem: the difficult form of the elongated triangle and the curvature of the vault, which at the meetingpoint between its end and side creates a sharp corner in the center of the pendentive. The problem was overcome by making the deepest area of the corner the lightest. The compositional axis passes through David's shoulder and that of Goliath; thanks to their brightness, the figures emerge from the shadows. In this way the scene acquires a convex form, reinforced by the rotundity of the tent, which offsets and disguises the real concavity.

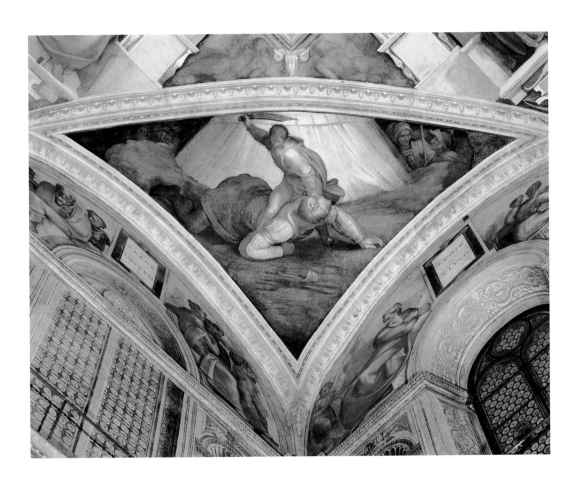

Judith and Holofernes

1509
Fresco, 570 × 970 cm
Vatican City, Sistine Chapel

This biblical subject is drawn from the book of Judith in the Apocrypha. In the period of the Assyrian domination, King Nebuchadnezzar charged his general, Holofernes, with the punishment of the rebellious Israelites and destruction of the city of Bethulia; during the siege, when the weary inhabitants were ready to surrender, Judith, a beautiful, but chaste and pious widow, promised she would be able to save them. In the night Judith set out with her maid to the Assyrian camp, allowed Holofernes to fall in love with her, then encouraged him to drink and, when he fell asleep, cut off his head; she gave it to her maid and, together, they went back to the city. The following morning, the terrified Assyrians fled and the Jews of Bethulia were saved. Michelangelo has chosen the moment at which the heroine has already beheaded the general and is about to leave the camp. On the left, a guard, unaware of what is happening, sleeps propped on his shield; on the right, the naked body of Holofernes is lying lifeless on the bed, the unbecoming posture symbolizing the vice and the drunkenness that seem to have remained with the general even after his death. As in the neighboring pendentive, Michelangelo resolves the problem of the triangular surface with a sharp corner in the center by the skillful use of lighting effects. The wall of the building represented in the fresco starts in the background and, with its light surface, is projected forward into the pictorial space. Placed to left of the central axis, Judith is seen from behind, her robe brightly lit, thus conveying a sense of the movement with which she is about to put Holofernes' head, which is lying on a tray on the maid's head, into a bag. Iridescent colors appear for the first time in an evident manner on the Sistine ceiling in the figures of these two women. Judith's robe is a roseate white that becomes emerald green in the shadows; the maid has a yellow dress in the lighted parts that turns to green in the folds.

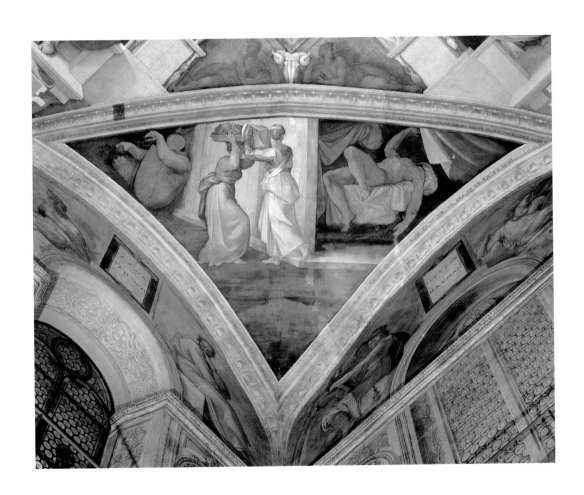

Punishment of Haman

1511
Fresco, 585 × 985 cm
Vatican City, Sistine Chapel

In the last two pendentives further stylistic experimentation is evident: the scale of the figures has been increased; the musculature and the foreshortening have greater prominence; the iridescence of colors is even more noticeable; the composition is no longer constructed on successive planes, but rather along diagonals that cut across the scene and project the figures into space. Furthermore, Michelangelo has eliminated the internal fascia of the fictive marble frame surrounding the two pendentives, thus giving the impression that the image goes beyond the edge of the fresco. All this accentuation of the forms is linked in part to the way the ceiling appears in perspective when it is viewed from the old entrance.

The story of the punishment of Haman, who wanted to exterminate the Jews of Persia, is drawn from the book of Esther, a figure who, like Judith, prefigures the Virgin and the church. The scene is divided into three episodes set in the palace of King Ahasuerus, Esther's husband. On the right, the king, lying on his bed, listens to the reading of the chronicles and orders his chief minister Haman, sitting in front of the door, to honor the loyalty of Mordecai, Esther's uncle; in reality, Haman had come to hang him. On the left, Esther has invited Ahasuerus and Haman to a banquet so she can reveal to the king that she is Jewish and ask him to revoke the decree of extermination issued by the minister, who reacts with a gesture of terror, foreseeing his end. In the center, in fact, Haman has been crucified on the gallows he had prepared for Mordecai. Although the Bible states he was hanged, this rendering of the story prefigures Christ, who "nailed" evil to his cross. One of Michelangelo's most audacious inventions, the figure of Haman was realized after a careful study of the foreshortening. The disposition of the figure in the form of an X, from right to left, corresponds to the crosswise arrangement of the space seen in depth: the right leg and the left arm are projected forwards, while the other two limbs are thrown backwards, indicating that he is doing his utmost in a vain attempt to free himself or relieve the pain.

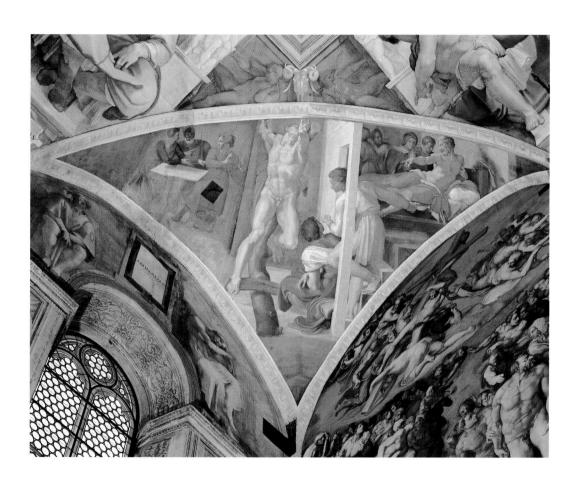

Brazen Serpent

1511
Fresco, 585 × 985 cm
Vatican City, Sistine Chapel

This subject, drawn from the book of Numbers, regards the punishment inflicted by God on the people of Israel during the exodus and his subsequent salvific intervention. Disheartened by their long march, the Israelites spoke against God and Moses because they had left them to suffer in the desert without food or water; the Lord sent poisonous snakes against the ungrateful people and many died. Having repented, they asked Moses to intercede with God, who, moved to pity by his entreaties, ordered him to make a serpent and put it on a pole: by looking at the serpent of brass, those bitten by the snakes would be saved. In the Gospel according to Saint John the story is cited as the prefiguration of the salvation through the cross: "And as Moses lifted up the serpent in the wilderness, even so must the Son of man be lifted up: That whosoever believeth may in him have eternal life" (John 3.14–15). With the parallel scene of the crucifixion of Haman and that of the prophet Jonah, this scene heralds the coming of Christ, who will free man from the slavery of sin through his death and Resurrection. The three scenes are, in fact, located above the altar, where the Eucharistic bread and wine are consecrated. The principal axis of the composition, which coincides with the pole supporting the serpent, has been shifted to the left, where, in the corner, there are the figures staring at the symbol of salvation; among these, a man holds the snake-bitten arm of a woman who, not by chance, adopts a posture similar to that of Eve, when she was tempted by the serpent. The central and right areas of the fresco are, on the other hand, occupied by the tangle of figures writhing in pain and desperation as they are crushed in the serpents' coils, an evident reference to the famous *Laocoön*, which had been discovered a few years before. Counterbalancing the concavity of the pendentive, the central figures adopt monumental foreshortened postures that burst through the pictureplane and seem to be about to fling themselves below, a visual metaphor for the moral precipice over which those who despair of Divine Grace will fall.

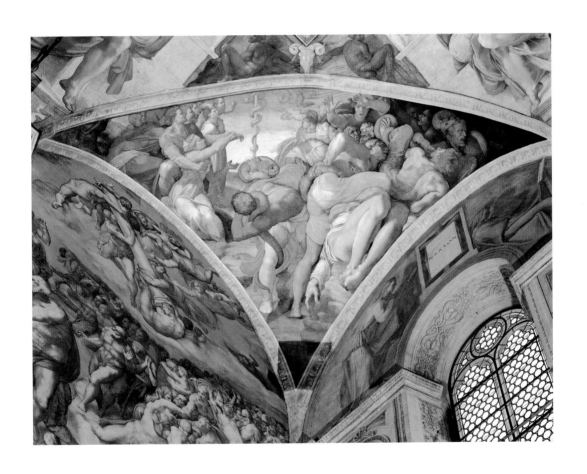

Ancestors of Christ

1509
Spandrel above the Josiah-
Jechoniah-Shealtiel lunette
Fresco, 245 × 340 cm
Vatican City, Sistine Chapel

The last of the central narrative panels is the scene representing the sons of Noah, but the story of Genesis continues with the different lineages descending from them: it is from that of Shem that the Semites, Abraham, and the entire people of Israel are descended. The attention of the observer must, therefore, shift to the spandrels and lunettes where the Jewish lineage right up to Christ is depicted. From the vision of the prophets, whose task it is to foretell the coming of the Messiah, derive the images of the *Ancestors of Christ*—that is, the list of the forty generations, from Abraham to Joseph, found at the beginning of the Gospel according to Saint Matthew, with which the prophecy of salvation is fulfilled and the wait for the Messiah comes to an end. And the family groups representing the continuity of the chosen descendents wait in a state of melancholy depression. The eight spandrels have been interpreted as being independent of the lunettes, which is where the tablets bearing the names of the ancestors appear, but the most convincing hypothesis is that the first of the names in each tablet refers to the spandrel above (the tablets of the lunettes in the corners only have, in fact, one or two names).

It is also possible, however, that the frescoes in the spandrels depict the eight generations between Shem and Abraham (Arpachshad, Shelah, Eber, Peleg, Reu, Serug, Nahor and Terah). In any case, the spandrels should seen in the same order as the lunettes, which started from the altar wall (the first two were destroyed by Michelangelo to make way for the *Last Judgment*), then proceeded zigzag fashion from one side to the other until the entrance wall, where the last lunette represents Joseph with the Virgin and child. The series then effectively continues in the fifteenth-century frescoes below, with the figures of popes, Christ's successors, also disposed in a zigzag manner. Thus, the pope, after having admired the seers and the scenes of the Creation as he entered the chapel, on his way out could observe the parallel between his predecessors and those of Christ.

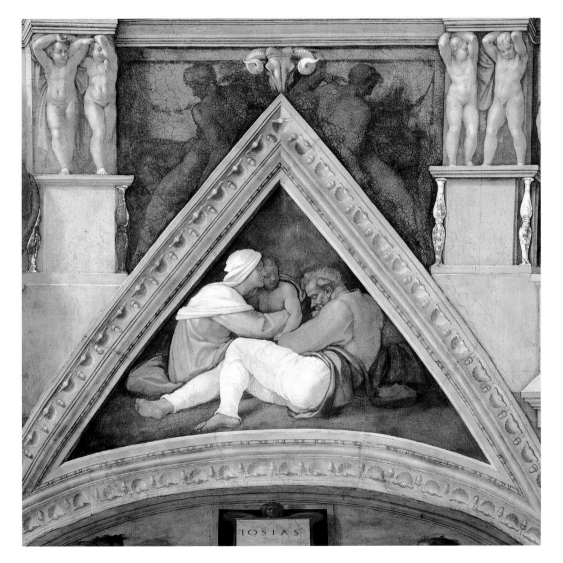

IOSIAS

137

Ancestors of Christ

1510
Spandrel above the Hezekiah-
Manasseh-Amon lunette
Fresco, 245 × 340 cm
Vatican City, Sistine Chapel

There were few iconographical precedents for the theme of the Ancestors of Christ, so that it was not possible to characterize the individual characters through significant attributes, but only through generic elements associated with distant peoples: hairstyles, clothes and headwear. This allowed Michelangelo to concentrate on the continuous variations of the poses, the gestures, and the way he could fit the figures into the very limited space of the triangle. In each spandrel are depicted family groups comprising a man, often elderly and bearded, a woman, almost always in the foreground, and a young child (in a couple of cases there are two children). Not by chance, the groups recall the traditional representations of the Holy Family, with the occasional addition of the infant Saint John the Baptist. According to Matthew's genealogy, Joseph, the husband of Mary, the mother of Jesus, was descended directly from this lineage; the generations that follow one another reproduce the structure of the family of Christ, foreshadowing his coming. Michelangelo resumed his experimentation with composition that he had started with the theme of the Virgin and child in the *Taddei Tondo* and *Pitti Tondo*, and that of the Holy Family in the *Doni Tondo*. The artist placed the figures in the triangle so as to leave the corners empty, concentrating the bodies in an ellipse, sometimes disposed horizontally, sometimes along the vertical axis; the bodies are bent in order to increase the effect of solitude of these chosen, but nonetheless unaware, ancestors lying on the bare ground with a gray sky behind. Each spandrel is surrounded by an architectural frame with fictive relief where the symbolic elements of the acorns—drawn from the family arms of the two Della Rovere popes who commissioned the building and decoration of the Sistine Chapel—alternate with shells, an evident allusion to the dedication of the chapel to the Virgin (Mary conceived Christ without fecundation, as the shell receives the pearl). More generally, acorns and shells are symbols of rebirth heralding the new golden age inaugurated by Julius II.

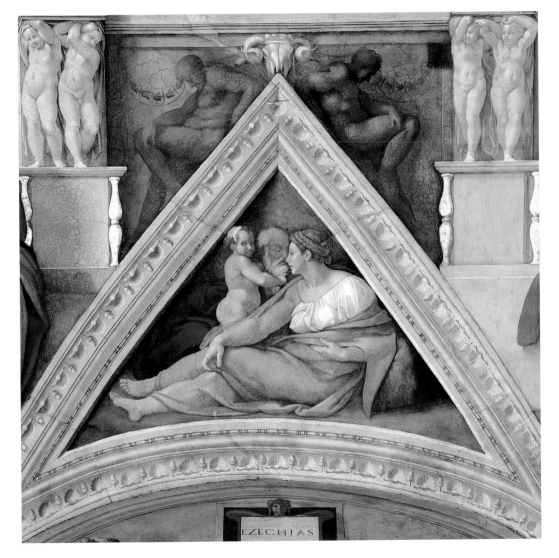

EZECHIAS

Ancestors of Christ

1511–1512
Nahshon lunette
Fresco, 215 × 430 cm
Vatican City, Sistine Chapel
With an inscription on the
plaque

After completing the frescoes in the first half of the ceiling, Michelangelo painted the corresponding eight lunettes on the walls; having moved the scaffolding, he tackled the second half of the ceiling and the remaining eight lunettes, which, compared to the others, therefore, display greater maturity. Each scene is divided into two parts, with, in the center, a tablet—or an open scroll on a lectern—where the names of the ancestors, from Abraham to Joseph, are written. Only in a few cases has it been possible to link the name to the person portrayed or explain the reason for the various objects and attitudes. If the spandrels really do form part of a separate series depicting the eight generations preceding Abraham, it is necessary to regard the figures in the lunettes as examples rather than simply illustrating the names on the tablets.

The figures are sitting on blocks of stone leaning against the semicircular frame surrounding the opening of the windows. All possible postures of the bodies in space were tried: thus they were shown frontally, in profile, and, above all, turning round, creating, with this rotation, the greatest possible number of variants in the positions of the arms and legs. The figures have various objects (a walking stick, a cradle, a spindle, a stool . . .) and a great variety of temperaments, thus distinguishing them from the greater monotony characterizing the groups in the spandrels above. In the Nahshon lunette, one of the last to be executed, there are two figures seen in profile facing the entrance, but neither looks up from the object they are contemplating. On the left, a woman with long hair tied up in a ponytail and wearing a pink and green dress is looking at herself in a small mirror; on the right, the young Nahshon, with blond curls and wrapped in a red cloak, is looking indolently at a book on a lectern. The posture of the woman—the only standing figure in the lunettes—is perhaps based on an antique sculpture; the youth is stretched out with one leg resting on a stool, although, in reality, his pose, turned through ninety degrees, echoes that of the woman.

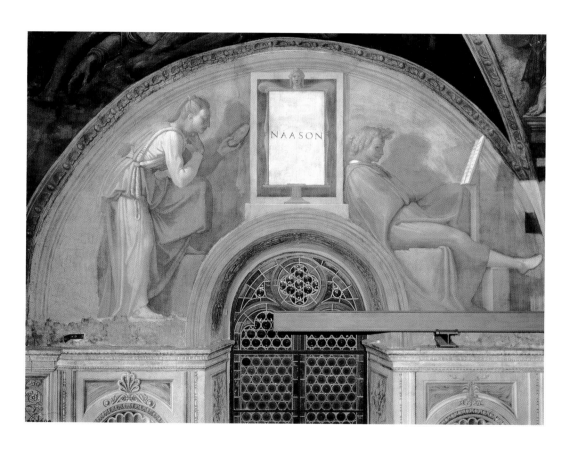

Ancestors of Christ

1511–1512
Amminadab lunette
Fresco, 215 × 430 cm
Vatican City, Sistine Chapel
With an inscription on the
plaque

The two figures portrayed in this lunette are very different from each other: while the man, Amminadab, is hieratic, with his immobile frontal pose, his eyes gazing out into space, and his hair tousled, the woman, perhaps his wife, is sinuous and in an unstable posture as she brushes her long hair, with her legs crossed, her bust and head inclined, her seductive face turned toward the observer. A sense of boredom and expectancy imbues these figures, whose only task is to await the coming of the Messiah. As in all the lunettes, the light appears to come from the direction of the altar. Their bodies stand out from the neutral background with minimum relief and the shadows cast by the figures are indistinct, especially if compared with the very clear ones in the opposite lunette, that of Nahshon. While the woman's close-fitting tunic highlights her beauty, showing her limbs as if they were naked, the man's cloak, with its variegated colors, seems to symbolize his restless, mutable character.

In the Sistine Chapel, Michelangelo gradually developed the use of iridescent colors, which, instead of tending toward black or white, according to the strength of the light, become their complementary color, or at least a contrasting one. In the first half of the ceiling this technique is limited to a number of figures in the central panels, in the spandrels, and, above all, in the first two pendentives, where the artist uses iridescent colors in the clothes. But it is in the entire second half of the ceiling that this practice becomes systematic. The greatest innovations are in the lunettes, which owe their fascination not only to the juxtapositions of colors but also to the remarkable freedom with which the artist worked, and the confidence and spontaneity with which he painted without preparatory cartoons. The technique of the fresco has become succinct and very rapid, to the point that the artist required only two *giornate* to complete an entire lunette (a *giornata* is the area of new plaster that can be painted in one day).

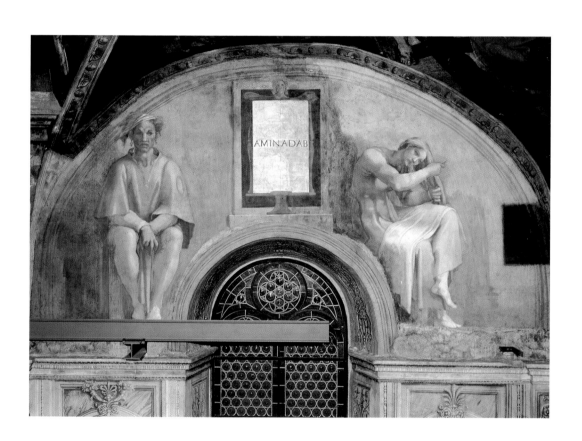

143

Ignudi with bronze medallion

1511

Pair of *ignudi* above the
Persian Sibyl
Fresco, 200 × 395 cm
Vatican City, Sistine Chapel

Above the seers Michelangelo placed ten pairs of *ignudi*, who have poses that are mirror images of each other in the first three bays, while in the following ones they adopt asymmetrical and increasingly audacious postures; in the center of each pair, a bronze medallion is hoisted with bands of cloth passing through rings in the cubic bases on which the *ignudi* are seated as they pull the strips with their hands and feet. The twenty youths also have the function of supporting the festoons of oak-leaves and large acorns that not only allude to the heraldic arms of the Della Rovere popes (Sixtus IV and Julius II), but are also symbols of the golden age and an emblem of the Roman Empire. The ten medallions (or shields), painted *a secco* with gold leaf (partially or wholly lost in the last four), contain stories from the Old Testament—inspired by the woodcuts in the bible translated by the Venetian friar Niccolò Malerbi—which may be interpreted as prophecies of the military and political deeds of Julius II (battle scenes, punitive expeditions, episodes of divine justice).

The architectural structure of the ceiling comprises five large fictive stone arches, alluding to Roman triumphs, but the presence of the medallions is a reference to the Arch of Constantine—represented no less than three times in the fifteenth-century cycle on the wall below—as a symbol of the origins of the pope's temporal power in the Roman Empire. Not by chance, an episode not recounted in the bible also appears in the series of tondi: Alexander the Great submitting to the authority of the high priest of Jerusalem, symbolizing the submission of the Holy Roman Emperor to the power of the pope. The series of *ignudi* does not, therefore, represent the primordial world before the Grace, symbolized by the bronze *ignudi* with the wild aspect on the lowest—that is, the most distant—level of the ceiling. The flesh-and-blood *ignudi*, placed at the highest point, before all the other scenes, spring from the minds of the seers as the last of the prophetic predictions, the most distant in time, the present—that is, the new golden age of Julius II's pontificate.

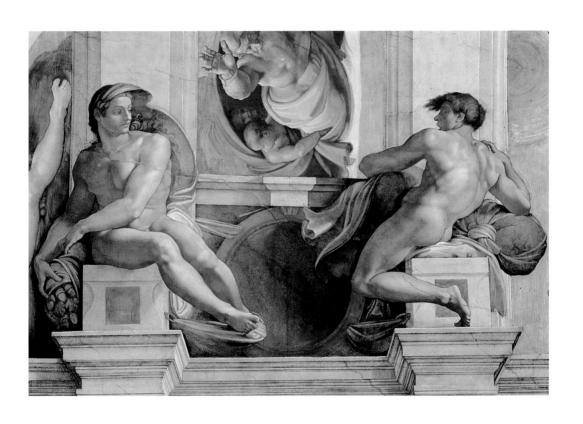

Bronze *Ignudi*

1511
Pair of *ignudi* between
the Prophet Ezekiel and
the Persian Sibyl
Fresco, 240 × 340 cm
Vatican City, Sistine Chapel

Above the spandrels and the pendentives are arranged twelve pairs of *ignudi* painted in bronze monochrome. Each pair was obtained from the recto and verso of the same drawing, which was by Michelangelo, while they were executed—almost always straight off, without a preparatory cartoon—by his assistants. The pairs of *ignudi* are divided by a ram's skull, a decorative motif derived from the sculpture of antiquity, where it was, above all, as an element used on sacrificial altars: together with the scene of the *Sacrifice of Noah*, where two rams are immolated, these skulls transform the whole ceiling into an enormous altar on which the prophecy of the sacrifice of Christ is fulfilled. Among the numerous interpretations of the bronze *ignudi* that have been put forward, there are those of a Neoplatonic or Christian nature. Perhaps the *ignudi* imprisoned in their triangular space represent the souls imprisoned in the matter awaiting their liberation, or perhaps souls waiting to become incarnate, or even the spirits of the dead waiting to join their resurrected bodies. These meanings have also been attributed to the *Slaves* sculpted for the tomb of Julius II, which are, however, referred to by the sources as personifications of the Papal States reconquered by the pope.

Like the *Slaves*, the *ignudi* may be interpreted from a political point of view, alluding to Julius II's projects. If the flesh-and-blood *ignudi* on the triumphal arches of the ceiling herald the new golden age and the gilded medallions foretell military victories, these bronze *ignudi* may be interpreted as trophies of war or the territories subjugated by the pope's reunifying mission. In any case, the different postures assumed by the bodies represent the diversity of the attitudes assumed by human beings when faced with the state of slavery: abandonment, repose, anger or rejection. The recent cleaning has revealed a pair of *ignudi* with faunlike pointed ears, which they themselves indicate with their forefingers, bearing out the theory that they are demoniac figures or rebel angels.

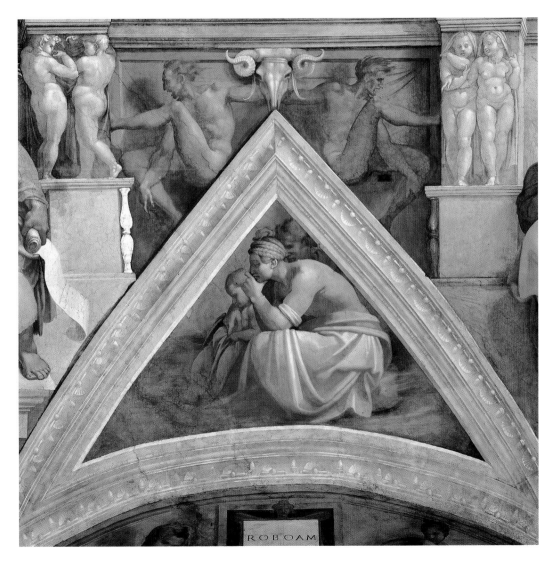

ROBOAM

147

Last Judgment

1535–1541
Fresco, 13.70 × 12.20 m
Vatican City, Sistine Chapel

It was Clement VII, who, in 1533, first had the idea of commissioning Michelangelo to paint the *Last Judgment* on the altar wall of the Sistine Chapel; after the pope's death the project was revived by his successor, Paul III. In June 1535 the artist had the scaffolding erected; the wall was cut back about 15 cm at the top, then cut progressively more deeply until a depth of about 60 cm was reached at the bottom, so that the surface became slightly inclined, probably to allow greater visibility. Work on the fresco started about a year later, with the lunettes: the upper part was completed in December 1540, while the whole wall was unveiled on October 31, 1541 for the celebration of Vespers on the eve of All Saints' Day. The *Last Judgment* appears as a unified scene divided into different zones linked to one another. At the top are the angels with the symbols of the Passion; below is Christ the Judge with the Virgin surrounded by the groups of the blessed and the saints. In the center of the middle zone are the angels with the trumpets of the Last Judgment, while, at the sides, the righteous rise towards heaven and the damned are driven back into the underworld. Finally, at the lowest level, is depicted the resurrection of the dead and the damned being led to hell.

In January 1564, a month before Michelangelo's death, the Council of Trent approved the demands coming from various quarters to conceal the nudity of the *Last Judgment*. One of the artist's pupils, Daniele da Volterra, was given this task; however, he died two years later, having realized only a part of the *braghettoni* (literally, breeches, in reality mainly draperies). Other censorious interventions followed, as well as conservation and restoration work. Nevertheless, the smoke from the candles and the glue added in order to increase the luminosity of the fresco ended up by forming a thick layer of dirt that prevented it from being seen properly. The conservation work carried out from 1990 to 1994 has allowed the brightness of the colors, the vigor of the forms, the definition of the details and the overall unity of the work to be restored.

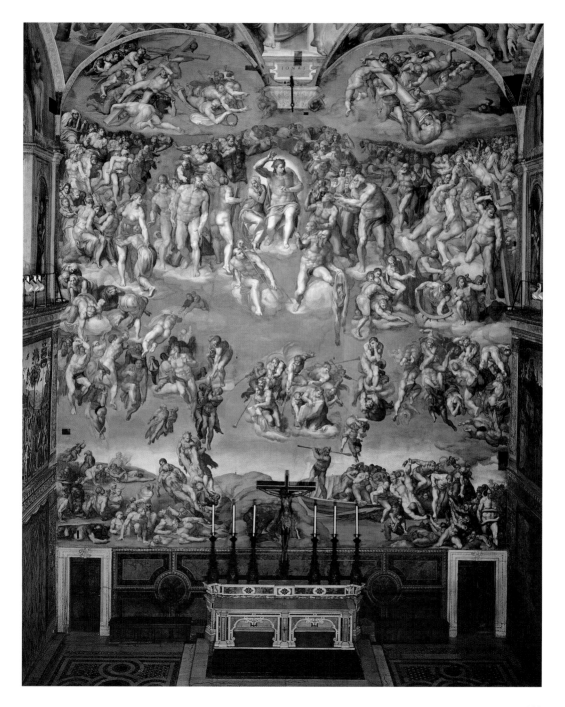

149

Angels with the Instruments of the Passion (left lunette)

1536–1537
Detail of the *Last Judgment*
Vatican City, Sistine Chapel

In the two lunettes at the top of the composition Michelangelo depicted groups of angels with the instruments of the Passion, in accordance with an iconographic tradition that was very common in northern European painting. The angels are all wingless, an anomaly that caused considerable controversy and even led to accusations of heresy. The left lunette was the first part of the fresco on the altar wall to be executed by the artist, and it replaced the lunette, painted in 1512 by Michelangelo himself, representing Abraham and his descendents. One group of angels is holding aloft the cross of Christ, assuming audacious and contorted poses ("in a wide variety of poses that were very difficult to execute," wrote Vasari). A figure in green, rather than holding up the cross, seems to be clinging to it while he looks towards us with a bewildered air. Immediately behind him a dialogue consisting of explicit gestures takes place: an angel points to the blessed below and another replies by showing him the cross, the means of salvation. Other angels throng behind them, creating an effect of greater depth. A group of figures on the right turns toward the lunette on the opposite side: one hold the crown of thorns, while his head is turned toward his companions on the left; the other gesticulating figures seem to be attempting to join up with the other heavenly hosts.

The scene was painted in thirty-three days, starting from the figures in the left background and proceeding towards the right; after he had completed the fresco, Michelangelo finished off many of the details with the *a secco* technique. The only *braghettone* added to this scene is the one covering the genitalia of the angel bending backwards before the cross.

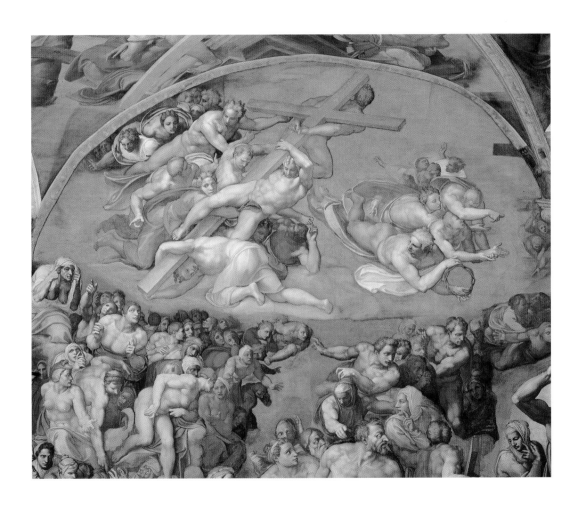

151

Angels with the Instruments of the Passion (right lunette)

1536–1537
Detail of the *Last Judgment*
Vatican City, Sistine Chapel

In the second lunette, other angels are bearing the instruments of the Passion in triumph: in the center is the column to which Christ was bound in order to be scourged; on the right, an angel with an orange cloak is carrying the reed with, at the top, the sponge soaked in vinegar that was offered to Christ on the cross. The function of this great representation of the symbols of the Passion is excellently summed up by Michelangelo's biographer, Condivi: "to remind the wicked of the benefits of God, for which they are ungrateful and with which they are discontent, and to comfort and give trust to the good." Although a large variety of symbols are traditionally associated with the Passion, Michelangelo has reduced them to just four (cross, crown of thorns, column and reed), eliminating all the others (lance, scourges, nails, Veronica's veil, soldiers' dice, tunic and tablet with the inscription "INRI"); when he had finished the fresco he added in the background, using the *a secco* technique, a number of angels in the shadow and almost invisible, bearing the ladder used during the Crucifixion.

This lunette is much more compact than the other one from a compositional point of view. The angels seem to be rotating the column rather than pushing it forward: this circular motion drags the bodies of the angels along with it and also seems to attract toward itself those still distant. Together with the other lunette, two main directional axes are defined, that of the cross and that of the column, which converge to form a point, like the sides of a pitched roof; the two lines are parallel to those of the left arm and the right forearm of Christ, thus amplifying his gestures so that the Last Judgment is reflected in the symbols of the evil wrought by man and in the mercy of God, who saves those who have followed Christ's example.

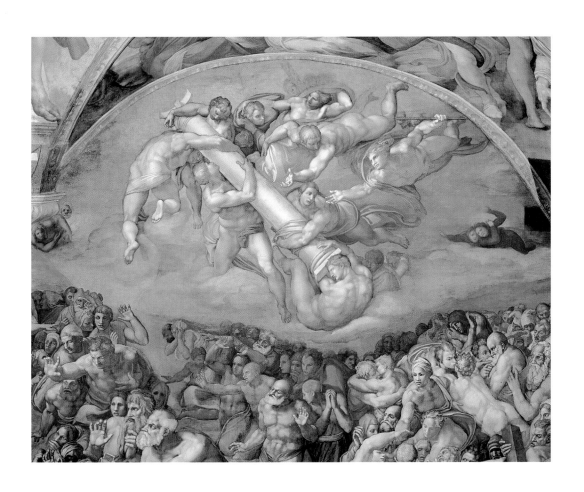

Christ the Judge and the Virgin

1537–1538
Detail of the *Last Judgment*
Vatican City, Sistine Chapel

Painted after the two lunettes, the central group, consisting of Christ and the Virgin in an aureole of light, is the motor of the whole composition. Michelangelo's contemporaries criticized the representation of Mary, the symbol of the church, who appears to assume a position of submission, without the role of intercession with her son that Marian devotion requires. It is not true, therefore, that Michelangelo's Christ only evokes implacable "awesome power," because his the double gesture has a double meaning: his right hand is lifted above his head, causing his bust and head to rotate to his left and he is looking downwards toward the damned and the mouth of hell; his gesture is one of condemnation and he seems to be gathering the strength necessary to drive the sinners toward the lower zone, rather than, as has been suggested, ready to hurl a justice-dealing thunderbolt like Jupiter. On the contrary, Christ's legs are seen frontally, or turned slightly to the left, and his left hand is extended delicately in front of him, inclined in the direction of the risen as they ascend toward the upper zone: it is a reassuring gesture that is linked to Mary's gaze turned in the same direction as her son's hand. The Virgin serenely confirms that the risen will have salvation by assuming the traditional pose with crossed arms and superimposed feet: those who imitate Christ right up to his sacrifice on the cross need not fear; they have a right to the eternal life. As some of his contemporaries, intent on discovering errors or licenses, did not fail to point out, Michelangelo represented the Redeemer beardless and without his traditional throne. Perhaps the choice was linked to a reference to the scene of the creation of Adam on the ceiling: Christ is the new Adam who saves humanity from the original sin. The comparison of Christ to Apollo is also not to be ruled out, but the heliocentric hypothesis, advanced by Charles de Tolnay, that Christ is the sun around which the bodies rotate like planets is unconvincing. There are also evident references to antiquity: Mary's pose echoes that of the Crouching Venus and Christ's that of the *Laocoön*.

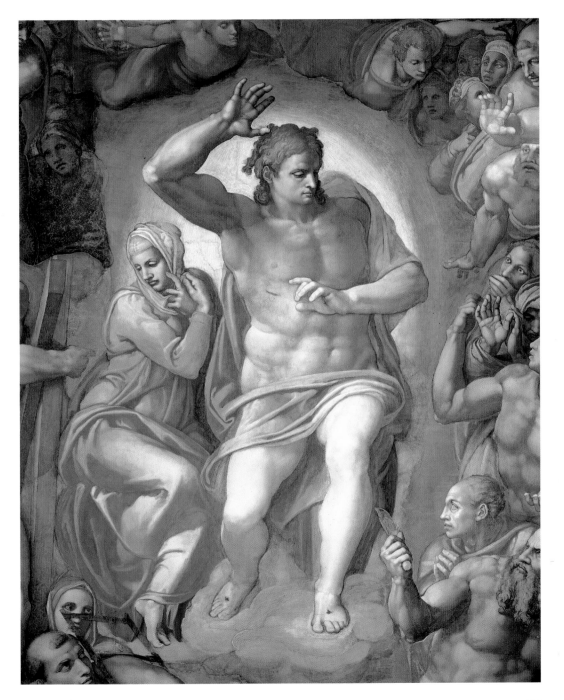

155

Group of the Blessed on the Left and Surrounding Christ

1537–1539
Detail of the *Last Judgment*
Vatican City, Sistine Chapel

In the highest zone are disposed the elect, the blessed and the saints, who are only distinguishable by their distance from the Redeemer (the absence of halos was harshly criticized during the Counter-Reformation). In effect, part of the figures form a ring in the center that is almost closed and evokes Dante's mystic rose; the remaining figures are divided into two wings, forming a broken semicircle.

At top left an old woman uncovers her ears and reveals her flaccid breasts; perhaps she is the sibyl who, in the text of the *Dies Irae*, opens the prophecy of the Judgment. Praying and awestricken, a crowd is thronging the area below her; the group further down seems intent on seeking physical contact without paying attention to Christ's gesture. Just to their right, in the foreground, a woman is clinging to the legs of a bare-breasted woman; although they are difficult to identify, the pose recalls the classical group of the Niobids. In the central ring various characters are recognizable: the muscular figure holding onto his animal skin cloak is John the Baptist (his genitalia were covered with a loincloth, also made of animal skin), and to his right is Andrew with his X-shaped cross; corresponding to them on the opposite side is Andrew's brother, Peter, who is returning the gold and silver keys to Christ, and, behind him, an apprehensive Paul wearing an orange cloak. In the foreground, the seated figure of Lawrence holds the gridiron on which he was roasted. Behind him, a female figure, wrapped in an orange mantle, has been identified as Vittoria Colonna, Michelangelo's muse; it is, however, more likely that she is a martyred saint, perhaps Lucy, on account of her squint, which is literally underscored by the top bar of the gridiron.

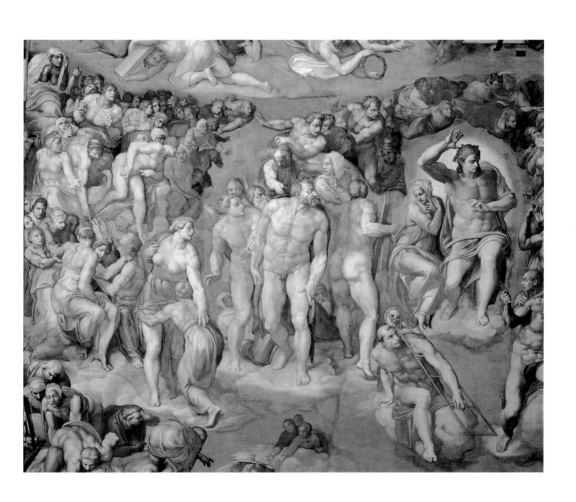

Group of the Blessed on the Right

1537–1539
Detail of the *Last Judgment*
Vatican City, Sistine Chapel

The different poses, gestures, and expressions are intended to demonstrate the varied nature of the state of beatitude and the complexity of the ways of achieving this. On the model of Dante's *Paradiso*, it is possible to identify, without clear distinctions, amorous, wise, militant, righteous and contemplative spirits: there are, in fact, figures embracing or kissing each other, pensive faces and gestures of eloquence, joined hands and imploring looks. But again there are a variety of interpretations: for example, the gestures of affection may represent the reunification of body and soul, or reunion after a long wait. The man carrying the large cross, on the far right, may be identified as Dismas, the good thief, or perhaps Simon the Cyrenian, who aided Christ on the way to Calvary; he himself is assisted by a bearded man, while, behind him, other hands reach out to help, suggesting the militant spirits, whom Dante had compose the image of the cross. On the left, Bartholomew holds in one hand the knife with which he was flayed and, in the other, his skin, the face of which is thought by some to be a self-portrait of Michelangelo.

The identification of the group of martyred saints is more certain: disposed on the cloud below and displaying the objects used to torture them, they include the apostle Simon Zelotes, with a saw; the apostle Philip, with a cross; Blaise, with iron combs; Catherine of Alexandria, with a spiked wheel; and Sebastian, with arrows. They are all leaning toward the group of the damned, who, underneath them, struggle to climb up, but in vain: the martyrs show them the instruments that are needed to reach to heaven. Originally Blaise also looked down threateningly, but his posture, regarded as indecent because he was leaning over Catherine's naked body, led to the censure of the Council of Trent. Daniele of Volterra chiseled the intonaco so he could paint a green dress over Catherine's body and turn the whole of Blaise's figure.

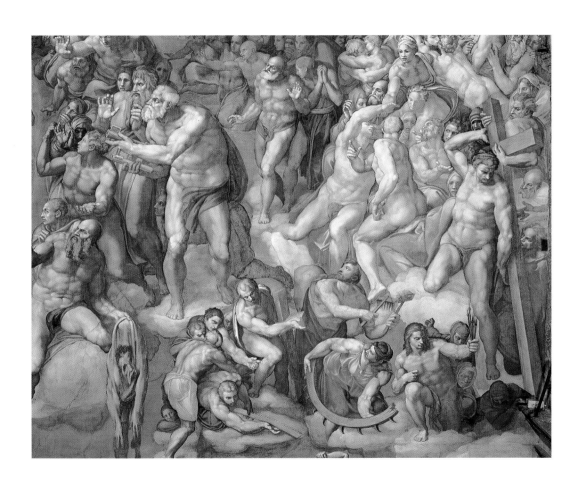

159

Angels with the Trumpets of the Judgment

1539–1540
Detail of the *Last Judgment*
Vatican City, Sistine Chapel

In the center of the middle zone, Michelangelo depicted a group of angels forming a circle and isolated from the flow of human beings. Like the other angels present in the *Last Judgment*, they are wingless and have the traditional effeminate aspect: their task is to awaken the dead with the sound of their trumpets. In reality, only four are facing the scene of the resurrection, while another, with his trumpet on his shoulder and pointing with his hand, seems to be correcting the angel below him, who had been blowing his instrument in the direction of the boat of the damned. In the foreground are the angels holding the books with the punishments, mentioned in the *Revelation of Saint John the Divine*. The "book of life" is turned to the left—that is, to the right of the Lord— toward the resurrection of the dead and the ascent of the blessed; the other book, containing the sentence that sends the damned to "the pool of fire," is turned to the right, toward Charon. While the first is a book of modest size, the other is a huge tome that has to be supported by two angels; this is because the number of sinners is far greater than that of the redeemed. The trumpet-blowing angels, their cheeks puffed out (a detail that was much criticized at the time), are based on the iconography of the winds blowing in all directions. The use of trumpets, however, refers to another prophecy of the *Revelation*, that of the seventh seal, in which seven angels, playing their seven trumpets, unleash the cataclysms and massacres preceding Christ's final victory. It should, however, be noted that this is only an allusion because here the trumpets are, in fact, eight, not seven, and overall the scene is based on the medieval text of the *Dies Irae*. This part of the wall was badly damaged because, during important ceremonies, a baldachin was erected here, attached to rings embedded in the wall just above the group of angels; the abrasions caused by this improper use, which lasted until the middle of the twentieth century, albeit irreversible, have been made less evident by the recent conservation work.

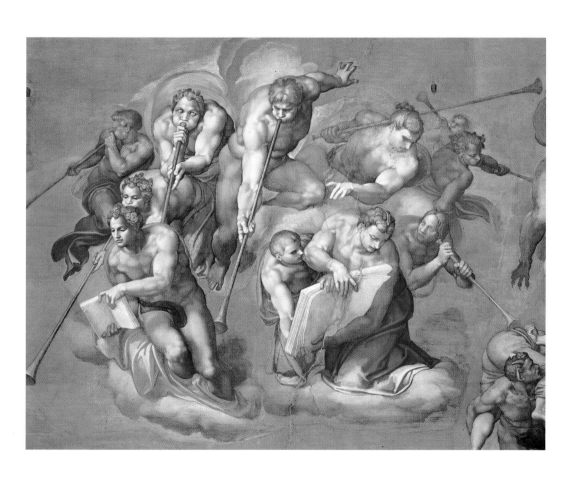

The Redeemed Rising to the Blessed

1539–1540
Detail of the *Last Judgment*
Vatican City, Sistine Chapel

A mysterious force slowly propels upwards the risen bodies of those whose names are written in the book of the righteous. This process seems to take place independently of the divine will: there are no angelic forces; the redeemed help each other or they cling to the clouds; many still have their eyes closed, or they seem to be blind; others are dragged upwards by the blessed in the higher zone; still others are perhaps moved by love, by the sight of friends or relatives that they have not seen since they died. On the right, two dark-skinned men are pulled upwards with a huge rosary, the symbol of the prayers that have led to the conversion of distant peoples and the salvific and universal power of faith. The expressions of the faces and the gestures range from fervent imploration to fear or indecision. Humanity redeemed does not seem to believe in its salvation, or it is not yet fully aware of it; rather than being happy, the redeemed almost seem to be dismayed because the design of Grace is clear only in the inscrutable mind of God.

In contrast to the scene placed symmetrically on the right, depicting the struggle between the angels and the damned, here Michelangelo has rendered the bodies in a more relaxed manner, which does not, however, deprive them of the accentuation of the musculature present in all the figures of the Last Judgment. Their disposition suggests a sort of circular and ascendant dance that stands out against the deep blue sky, painted with lapis lazuli pigments. To cover the most evident nudity, during the Counter-Reformation draperies were added to the principal figures, and these were left in place during the recent conservation work: the only *braghettone* that was removed was the one covering the buttocks of the foreshortened male figure seen from behind who is heading towards the two figures in green and red.

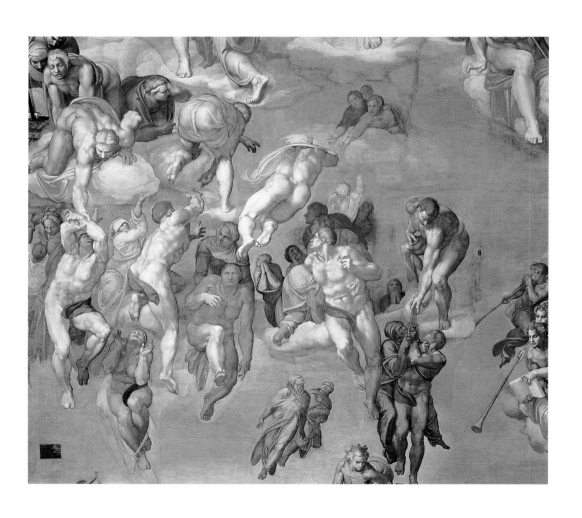

The Damned Driven toward the Underworld

1539–1540
Detail of the *Last Judgment*
Vatican City, Sistine Chapel

As happens in Dante's *Inferno*, some of the damned do not accept their punishment and they rebel; the angels, recognizable by their colored robes, have the task—in collaboration with the demons—of driving them back to the nether regions. This group of damned is generally associated with the types of the seven capital vices, some of them clearly identifiable, others only attributable by inference. On the right there is a lecher, whom a demon is pulling down by his genitals. The figure immediately above him is probably a proud person who is punished by being turned upside down. Between these two, in the shadow behind, a damned person with a dehydrated air, his hand on his throat and his mouth open, could be a glutton. The following figure, seen from behind, is probably an irascible person, who is struggling desperately with an angel in green, while one in red is coming to the latter's aid. Further down, one of the damned, wrapped in drapery and with his hands joined, seems to be hurtling down into the underworld without the intervention of the demons, almost through inertia: he might be a slothful person. The miser, driven back by an angel in orange while a demon pulls him down, is, however, easily recognizable by his moneybag and the keys of his coffers. The last one, seen from behind is likely to be an envious person, who, on seeing one of the risen ascending towards the upper zone, tries to follow him and is pursued by an angel in green. It has been suggested that the two diaphanous figures flying under him are Paolo and Francesca, the famous lovers in Dante's *Inferno*.

Lastly, isolated on the left, appears one of the damned to whom none of the angels pay any attention; although he is usually identified as a proud or desperate person, it is more likely that he represents the category of the wretched souls, described by Dante as "without infamy and without praise." In other words, he is undecided and cowardly, and, unable to react to the dragon's bite, he aspires neither to ascend nor descend, and not even the intervention of two demons can move him.

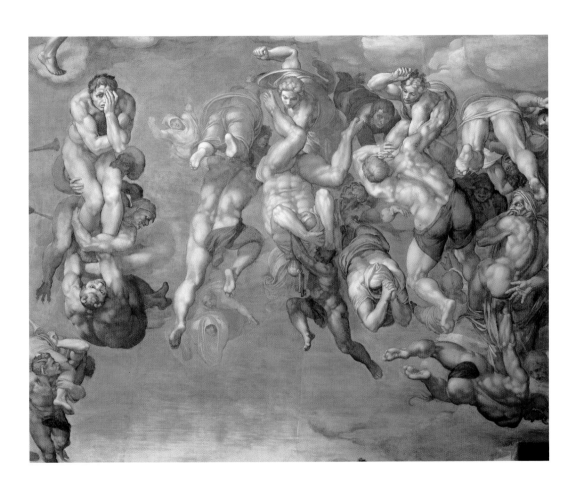

Resurrection of the Dead

1540–1541
Detail of the *Last Judgment*
Vatican City, Sistine Chapel

At the sound of the angels' trumpets, the dead are roused from their sleep. Michelangelo represents them in the various subsequent stages, during which the skeletons recover their flesh and, looking once again like human bodies, are reunited with their souls; the artist is inspired not only by the prophecy of the book of Ezekiel but also by the frescoes of the *Last Judgment* that Luca Signorelli had painted in the San Brizio Chapel in Orvieto Cathedral at the beginning of the Cinquecento. At bottom left, a number of dead emerge from a tomb by lifting up a stone slab; around them, instead, the bodies come out directly from the earth, in which they are buried on different levels: there are those who only appear with their heads, those with the whole of their busts, and those who have only a leg in the ground. Still weak and weary, the torpid bodies are mainly naked or else wrapped in shrouds. Some, now completely free, rise slowly and with an undulating motion towards the upper zone. The bearded figure standing on the far left of this scene, who is not one of the dead and seems to be blessing them, has been interpreted in a wide variety of ways. On the right there is a dispute between the angels and the demons over two bodies placed in inverse positions: the first, completely lifeless, is held down by a serpent pulled by a hand coming out of a rock; the second, which is upside down, is being helped by two angels who lift it upwards so as to free it from the demon who is pulling its hair.

The scene of the resurrection of the dead is, however, also a splendid allegory of the work of artists in general and especially of that of Michelangelo, who was obsessed by the study of the human figure and the investigation of its anatomy. The artist accomplishes the resurrection of the dead through painting. The painted bodies are the vision of a reality that has yet to come into being, but they are, at the same time, a reality that already exists and manifests itself before the observer's eyes: they bear witness to the veracity of the promise of salvation.

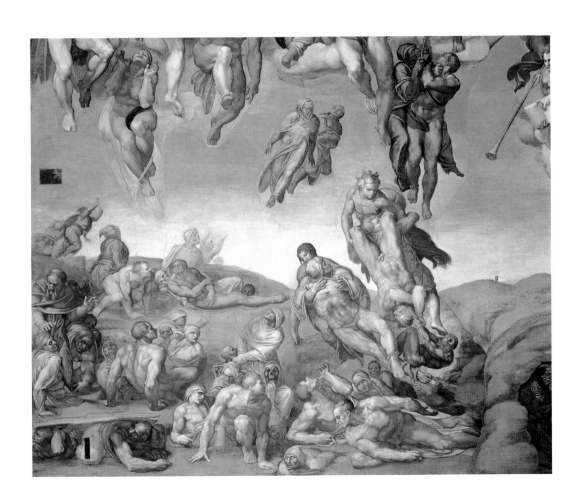

The Entrance of the Damned into the Underworld

1540–1541
Detail of the *Last Judgment*
Vatican City, Sistine Chapel

The last zone at bottom right contains the epilogue of the divine judgment: Charon's boat is ready to ferry the damned souls to the underworld, where a band of demons awaits them, some of them diabolically intent on their work, other making gestures and pulling faces at the observer. The artist's main source of inspiration is, of course, Dante's *Inferno*. The gesture with which Charon threatens the damned is drawn from this passage: "The demon Charon with eyes like burning coals / gives a sign and takes them all on board, / and strikes the laggards with his oar." The damned drop down, says Dante, as the leaves do in the autumn, and thus the artist paints them, overflowing from the boat as they fall over onto the demons, who, with long spears, draw out the most reluctant ones. Michelangelo's re-reading of Dante is also attested by the sonnets he dedicated to the poet after finishing the *Last Judgment*; composed in 1545–1546, they were intended for the printed edition of his *Rime*.

The far right of the scene is occupied by a line of waiting devils standing out against a fiery, smoke-streaked sky. Also drawn from Dante is the figure of Minos, with his donkey's ears, who has the task of assigning the damned to the appropriate circle of torment, indicating its number with the coils of a snake around his waist. According to Vasari, Michelangelo gave Minos's face the features of Biagio da Cesena, the pope's master of ceremonies, who, when he visited the Sistine Chapel while artist was working on the fresco, had criticized the excessive nudity of the figures. As a punishment, the serpent, with its mouth wide open, is about the bite his testicles. In this scene of the underworld, Michelangelo reaches an unparalleled peak of *terribilità*—that is, the effect of power mixed with awe and admiration that his contemporaries regarded as one of the great innovations of the artist's work.

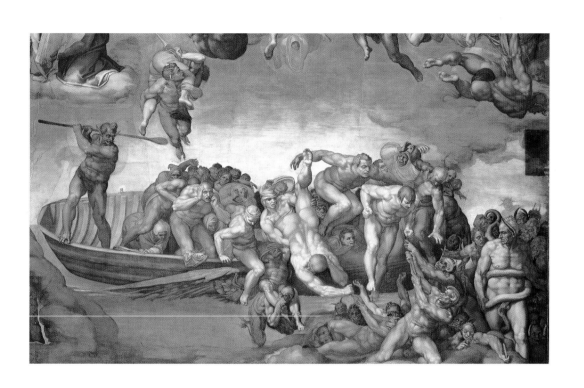

Conversion of Saul

1542–1545
Fresco, 625 × 661 cm
Vatican City, Paolina Chapel

The Paolina Chapel was designed by Antonio da Sangallo for Paul III and inaugurated in 1540. Shortly before the unveiling of the *Last Judgment*, in October 1541, the pope decided to entrust Michelangelo with the execution of the frescoes on the side walls. Work started a year later, but was interrupted on various occasions because of the artist's poor health and the damage caused by a fire that broke out in 1545, and was only completed in 1550. The subjects chosen related to themes relating to the mission of the pope himself: the vocation of the saint bearing his name and the martyrdom of the first head of the church.

The first fresco represents the conversion of Saul on the road to Damascus—the city is visible on the right—where he was going in order to persecute the Christians. Christ's double gesture, with one hand outstretched and the other pointing to the city, sums up the words he pronounced: "I am Jesus whom thou persecutest: But rise and enter into the city, and it shall be told thee what thou must do." (Acts 9:6) The composition is divided into two blocks separated by the horizon line: heaven and earth, grace and sin, and Christ with the angels and Paul with the soldiers. Above, the centripetal motion arranges the figures radially around the Redeemer, and the angels amplify his gestures by pointing downwards or showing the reverent attitude to assume in the presence of God: hands joined, arms raised and the gaze directed upwards, enraptured. In the lower zone, the centrifugal motion breaks up the order of the military column into frightened poses and contradictory directional axes. The sudden descent of Christ is accompanied by a beam of light that, continuing the opening made by his arm, arrives directly on Saul's face. His eyes closed—he remained blinded for three days—Saul, shortly to become the apostle Paul, stretches upwards, pushing himself away from the ground, in the pose of the river god the artist had studied for the Medici tombs, while, with his left hand he seems to be trying to cover his eyes and, at the same time, reach toward the light, which heralds the baptism he is to receive when he reaches Damascus.

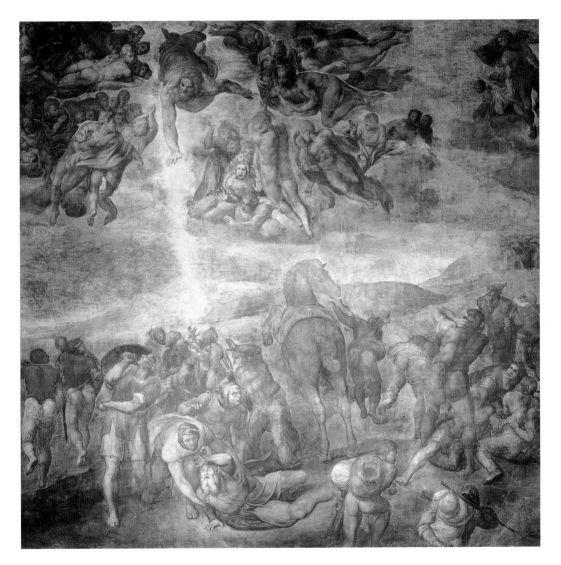

171

Crucifixion of Saint Peter

1546–1550
Fresco, 625 × 662 cm
Vatican City, Paolina Chapel

In the second fresco in the Paolina Chapel, Michelangelo represents the moment at which Saint Peter's cross is about to be thrust into the ground. The composition is constructed using two contrary concentric movements: the cross is about to be lifted in a counter-clockwise direction, while the surrounding crowd rises on the left and descends on the right. The dynamic and dramatic center of the scene is Peter's head, which twists round to stare directly at the observer, while his body already bends and begins to fall toward the ground; the pain has not yet reached the apostle, but he is fully aware of the need for martyrdom. In the group of onlookers in the center there is an eloquent dialogue of gestures: the man in green points with his right hand toward the horseman on the left —who, in his turn, indicates Peter to his companions—while, with his other hand, he points to the helmeted executioner, whose forefinger indicates the hole below. Further back, another spectator, dressed in red, signals to the one in green to keep quiet and points to the sky: they must contain their indignation because what is happening is God's will.

The dialogue of gestures continues with the group of women in the foreground, who show their consternation at being powerless spectators of the drama: the first also points toward the sky, the second turns toward the third, who is preparing a cloth with which to dry her tearful face; lastly, the fourth turns toward us with a puzzled expression, her mouth open. The bearded and hooded figure on the right refers to the martyrdom by the position of his arms echoing the arms of the cross; probably this is a self-portrait of Michelangelo, who thus testifies to his painful adhesion to the theme of salvation. In fact, neither God nor the angels are present in this scene: only the dawn light in the background perhaps heralds the Resurrection. But the solitude emanating from the bewildered figures and the desolation of the rugged landscape do not offer any certainties with regard to the hope of life after death.

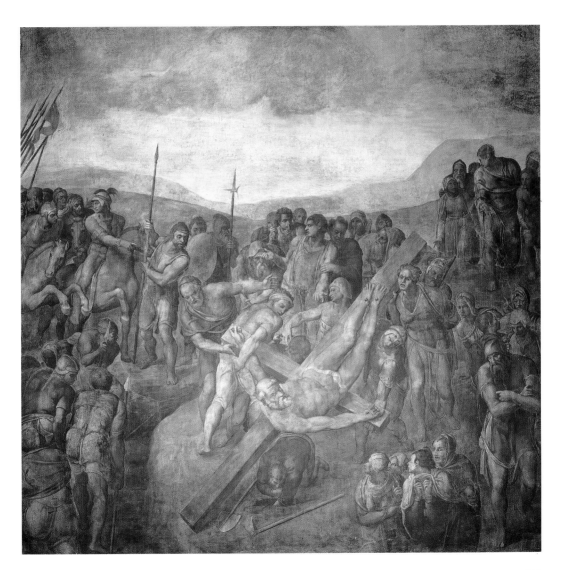

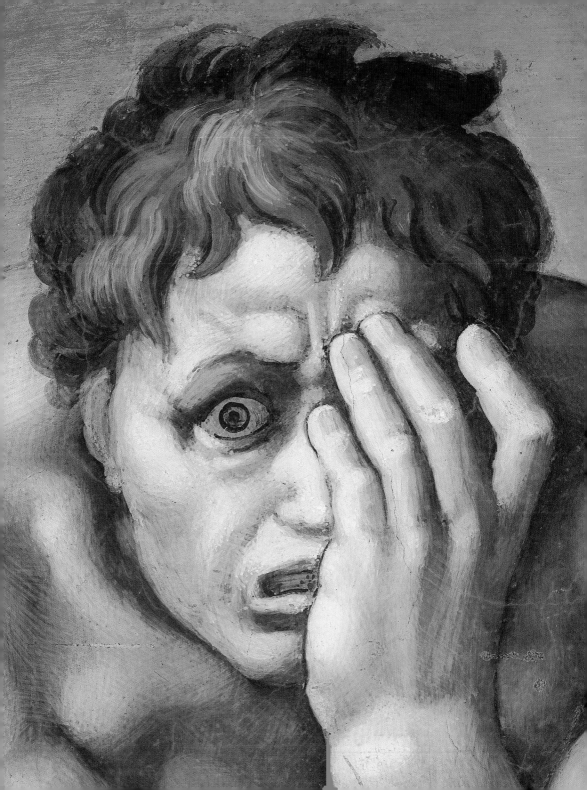

Appendix

Chronological Table

	Life of Michelangelo	Historical and Artistic Events
1475	On March 6 Michelangelo was born in Caprese, the second son of the *podestà* Lodovico di Lionardo di Buonarroto Simoni and Francesca di Neri di Miniato del Sera.	
1498	On August 27 made a contract with cardinal Jean Bilhères de Lagraulas for Saint Peter's *Pietà*: he undertook to finish the statue within a year and the agreed price was 450 ducats.	At the instigation of Alexander VI, Savonarola was tried and hanged, then burned. Antonio Pollaiuolo died in Rome.
1500	Contract for the execution of an altarpiece for Sant'Agostino in Rome; the work may be identified with the *Entombment* (National Gallery, London)	Louis XII invaded Italy. The Sforza were expelled from Milan. Leonardo da Vinci returned to Florence. Bramante was in Rome. Botticelli painted the *Mystic Nativity* (National Gallery, London).
1501	Returned to Florence. On August 16 signed the contract for the execution of the *David*, commissioned by the Florentine Republic.	Raphael undertook to execute the *Saint Nicholas of Tolentino Altarpiece* in Città del Castello.
1504	Received the commission for the wall painting of the *Battle of Cascina*. On September 8 the *David* was placed in Piazza della Signoria.	Raphael moved to Florence. Spain took over direct control of the Kingdom of Naples.
1505	In March Pope Julius II commissioned Michelangelo to design and execute his tomb; the artist went to Carrara to choose the marble.	Bramante started the Tempietto at San Pietro in Montorio and the Belvedere Court.
1506	Returned to Rome, but because the commission for Julius II's tomb was not confirmed, fled to Florence. On the 21st he was reconciled with Julius II in Bologna.	Julius II reconquered Bologna. The *Laocoön* was discovered in Rome. Bramante began construction of the new Saint Peter's. Leonardo left for Milan.
1508	Michelangelo returned to Florence. In April he was back in Rome. On May 10 signed contract to fresco the ceiling of the Sistine Chapel.	League of Cambrai: an alliance against Venice including Julius II, Emperor Maximilian I, Louis XII and Ferdinand of Aragon.
1512	On October 31 the Sistine Chapel was reopened: the frescoes had been completed twenty days previously.	The Medici returned to Florence. In Siena Beccafumi painted the triptych *Trinity and Saints*.
1515	In April returned to Florence, where he remained until 1534.	Francis I became king of France; with the victory of Marignano he reconquered Milan. Raphael began work on the cartoons for tapestries in the Sistine Chapel. Machiavelli completed *Il principe* (*The Prince*).

	Life of Michelangelo	Historical and Artistic Events
1519	Leo X commissioned him to construct the New Sacristy of San Lorenzo, Florence, intended to house the four Medici tombs.	The Habsburg king of Spain, Charles I, was elected Holy Roman Emperor. In Parma, Correggio painted the abbess's room in the convent of San Paolo.
1524	Started work on the Laurentian Library and on the tomb of Lorenzo de' Medici, duke of Urbino, with *Twilight* and *Dawn*.	Giulio Romano moved to Mantua, in the service of Federico Gonzaga. Parmigianino was in Rome.
1527	Following the expulsion of the Medici, work on the New Sacristy of San Lorenzo was suspended.	Sack of Rome: Peruzzi, Rosso Fiorentino, Jacopo Sansovino, Perino del Vaga, Giovanni da Udine and Parmigianino all fled from Rome.
1530	After the fall of the Florentine Republic on August 12, he went into hiding; pardoned by Clement VII, started work again on the Laurentian Library and the New Sacristy.	In Bologna, Charles V was crowned by Clement VII emperor and king of Italy. In exchange, he undertook to bring Florence back under Medici control.
1534	In September, although the sculptures for the New Sacristy had not been completed, he moved to Rome, perhaps with a view to starting work on the *Last Judgment*.	Alessandro Farnese became pope with the title of Paul III. Ignatius Loyola founded the Society of Jesus.
1536	On November 17 Paul III freed Michelangelo from any responsibility toward the heirs of Julius II, whose tomb he still had to finish.	Calvin's reform in Geneva. Paul III established a commission to lay the foundations of a reform of the church. Pietro Aretino's *Ragionamenti* were published, as were Vittoria Colonna's *Rime*.
1542	On August 20 the final contract for the tomb of Julius II was drawn up. Started the frescoes in the Paolina Chapel.	The Holy Office was established in Rome. Cardinal Contarini, protagonist of Catholic reformism, died. Giulio Romano died in Mantua.
1546	Appointed architect in charge of Saint Peter's after the death of Antonio da Sangallo the Younger.	Paul III died; he was succeeded by Julius III.
1550	Completed the *Crucifixion of Saint Peter* in the Paolina Chapel.	
1555	Paul IV confirmed his appointment as architect of Saint Peter's.	Julius II died; he was succeeded by Giovan Pietro Carafa, with the title of Paul IV. Charles V abdicated.
1564	On February 18 died in his house near Trajan's Forum in Rome.	On January 21 the Congregation of the Council of Trent decided to cover the parts of the *Last Judgment* considered obscene. Daniele da Volterra was commissioned to carry out this task.

Geographical Locations of the Paintings
(in public collections)

Italy		*The Holy Family with the Infant Saint John and Ignudi (Doni Tondo)* Tempera on panel, diameter 120 cm Firenze, Galleria degli Uffizi 1503–1504 or 1506–1507

Vatican City		*Ceiling of the Sistine Chapel* Fresco, approx.13 x 36 m Vatican City, Sistine Chapel 1508–1512	*Prophet Zechariah* Fresco, 360 x 390 cm Vatican City, Sistine Chapel 1508–1509
		Drunkenness of Noah Fresco, 170 x 260 cm Vatican City, Sistine Chapel 1508–1509	*Flood* Fresco, 280 x 570 cm Vatican City, Sistine Chapel 1508–1509
		Sacrifice of Noah Fresco, 170 x 260 cm Vatican City, Sistine Chapel 1508–1509	*David and Goliath Judith and Holofernes* Fresco, 570 x 970 cm Vatican City, Sistine Chapel 1509
		Ancestors of Christ (spandrel above the Josiah-Jechoniah-Shealtiel lunette) Fresco, 245 x 340 cm Vatican City, Sistine Chapel 1509	*Temptation and Expulsion of Adam and Eve* Fresco, 280 x 570 cm Vatican City, Sistine Chapel 1509–1510

Vatican City

Punishment of Haman
Brazen Serpent
Fresco, 585 x 985 cm
Vatican City, Sistine Chapel
1511

Ignudi *with Bronze Medallion*
(pair of *ignudi* above the
Persian Sibyl)
Fresco, 200 x 395 cm
Vatican City, Sistine Chapel
1511

Ignudi *with Bronze Medallion*
(pair of *ignudi* between
the Prophet Ezekiel
and the Persian Sibyl)
Fresco, 240 x 340 cm
Vatican City, Sistine Chapel
1511

Ancestors of Christ
Nahshon lunette
Fresco, 215 x 430 cm
Vatican City, Sistine Chapel
1511–1512

Ancestors of Christ
Amminadab lunette
Fresco, 215 x 430 cm
Vatican City, Sistine Chapel
1511–1512

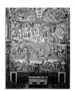

Last Judgment
Fresco, 13.70 x 12.20 m
Vatican City, Sistine Chapel
1535–1541

*Angels with the
Instruments of the Passion*
(detail of the *Last Judgment*,
left lunette)
Vatican City, Sistine Chapel
1536–1537

*Angels with the
Instruments of the Passion*
(detail of the *Last Judgment*,
right lunette)
Vatican City, Sistine Chapel
1536–1537

*Christ the Judge
and the Virgin*
(detail of the *Last Judgment*)
Vatican City, Sistine Chapel
1537–1538

*Group of the Blessed
on the Left and Surrounding
Christ*
(detail of the *Last Judgment*)
Vatican City, Sistine Chapel
1537–1539

Vatican City

*Group of the Blessed
on the Right*
(detail of the *Last Judgment*)
Vatican City, Sistine Chapel
1537–1539

*Angels with the Trumpets
of the Judgment*
(detail of the *Last Judgment*)
Vatican City, Sistine Chapel
1539–1540

*The Redeemed Rising
to the Blessed*
(detail of the *Last Judgment*)
Vatican City, Sistine Chapel
1539–1540

*The Damned Driven
toward the Underworld*
(detail of the *Last Judgment*)
Vatican City, Sistine Chapel
1539–1540

Resurrection of the Dead
(detail of the *Last Judgment*)
Vatican City, Sistine Chapel
1540–1541

*The Entrance of the Damned
into the Underworld*
(detail of the *Last Judgment*)
Vatican City, Sistine Chapel
1540–1541

Conversion of Saul
Fresco, 625 x 661 cm
Vatican City, Paolina Chapel
1542–1545

Crucifixion of Saint Peter
Fresco, 625 x 662 cm
Vatican City, Paolina Chapel
1546–1550

Great Britain

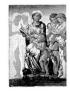

*Virgin and Child with the
Infant Saint John the
Baptist and Four Angels*
Tempera on panel,
104.5 x 77 cm
London, National Gallery
c. 1495–1497

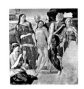

The Entombment
Oil on panel,
161.7 x 149.9 cm
London, National Gallery
1500–1501

Writings

The purpose of Michelangelo's art was religious—the unfolding of the basic tenets of the Christina faith: creation, redemption, damnation, and salvation. The means was the representation of beauty. In the doctrines of Plato, Dante and Ficino the artist found a metaphysical formulation of his mystical longing, of his unshakable faith, of his love of beauty, and of his artistic practice.

Beauty was given at my birth to serve
As my vocation's faithful exemplar,
The light and mirror of two sister arts:
Who otherwise beloved in judgment errs.
She alone lifts the eye up to that height
For which I strive, to sculpture and to paint.
O rash and blind the judgment that diverts
To sense the Beauty which in secret moves
 And raises each sound intellect to Heaven!
No eye infirm the interval may pass
From mortal to divine, nor thither rise
Where without grace to ascend the thought is vain.

Mine eyes that are enamored of things fair
 And this my soul that for salvation cries
May never heavenward rise
Unless the sight of beauty lifts them there.
Down from the loftiest star
A splendor falls on earth,
And draws desire afar
To that which gave it birth.
So love and heavenly fire and counsel wise
The noble heart finds most in starlike eyes.

Michelangelo sent the following sonnet to his great admirer Vasari in 1554, ten years before his death. He accompanied it with a letter declaring: "I would gladly rest my tired bones beside those of my father, but for the fear that my departure should cause injury to the building of St. Peter's, which would be a great shame as well as a great sin."

The course of my long life has reached at last,
In fragile bark o'er a tempestuous sea,

The common harbor, where must rendered be
Account of all the actions of the past.

The impassioned phantasy, that, vague and vast,
Made art an idol and a king to me,
 Was an illusion, and but vanity
Were the desires that lured me and harassed.

The dreams of love, that were so sweet of yore,
What are they now, when two deaths may be mine,–
One sure, and one forecasting its alarms?

Painting and sculpture satisfy no more
The soul now turning to the Love Divine,
That oped, to embrace us, on the cross its arms.

Francisco De Hollanda, a Portuguese miniaturist (1517-1584) lived for eight years in Italy, during which time he became acquainted with Michelangelo. He was present at some conversations between the sculptor, the Roman princess Vittoria Colonna, devoted friend of Michelangelo's old age, and some learned men, which he recorded in his De Pintura Antigua. *There is some question as to how far these quotations are historically accurate. It seems worth while, however, to quote a few pages that appear to express faithfully Michelangelo's sentiments as they are known to us from other sources.*

GENIUS AND SOCIABILITY

There are many who maintain a thousand lies, and one is that eminent painters are strange, harsh and unbearable in their manner, although they are really human and humane. And these fools, and not sensible persons, consider them fantastic and capricious and are loath to tolerate such characteristics in a painter. It is true that for such characteristics to exist the painter must exist; and him you will scarcely find outside of Italy, where things attain their perfection. But idle, unskilled persons are wrong to demand great ceremony from a busy, skillful man, since few persons excel in their work, and

certainly none of those who bring such accusations. For excellent painters are not unsociable from pride, but either because they find few minds capable of the art of painting or in order not to corrupt themselves with the vain conversations of idle persons and degrade their thoughts from the intense and lofty imaginings in which they are continually rapt. And I assure Your Excellency that even his Holiness sometimes annoys and wearies me when he speaks to me and insistently inquires why I do not go to see him; and I sometimes think I serve him better by not answering his summons, against my own interest, and working for him in my house; and I tell him that I serve him better then as Michelangelo than by standing all day before him, as others do [...].

I assure you that at times my grave concern for my art makes me so free that, as I stand talking to the Pope, I thoughtlessly put this old felt hat on my head and speak to him very freely. And they have not killed me for that, rather he has given me a livelihood [...].

Why seek to embarrass [the artist] with vanities foreign to his quietness? Know you not that certain sciences require the whole man, leaving no part of him at leisure for your trifles? When he has little to do as you have, then in good sooth he will observe your practices and ceremonies, better than you do yourselves. You only know this man and praise him in order to do yourselves honor, and are delighted if he be found worthy of the conversation of a pope or an emperor. And I would even venture to affirm that a man cannot attain excellence if he satisfy the ignorant and not those of his own craft, and if he be not "singular" or "distant," or whatever you like to call him. For as to those other meek and commonplace spirits, they may be found without the need of a candle in all the highways of the world.

NATURE AND FANCY

I shall be glad to tell you why it is the custom to paint things that have never existed and how rea-sonable is this license and how it accords with the truth; for some critics, not understanding the matter, are wont to say that Horace, the lyric poet, wrote these lines in dispraise of painters:

Pictoribus atque poetis
Quidlibet audendi semper fuit aequa potestas: Scimus,
et hanc veniam petimusque damusque vicissim.

An in this sentence he does in nowise blame painters but praises and favors them, since he says that poets and painters have license to dare—that is, to dare do what they choose. And this insight and power they have always had; for whenever (as very rarely happens) a great painter makes a work which seems to be artificial and false, this falseness is truth; and greater truth in that place would be a lie. For he will not paint anything that cannot exist according to its nature; he will not paint a man's head with ten fingers, nor paint a horse with the ears of a bull or a camel's hump . . . But if, in order to observe what is proper to a time and place, he exchange the parts of limbs (as in grotesque work which would otherwise be very false and insipid) and convert a griffin or a deer downwards into a dolphin or upwards into any shape he may choose, putting wings in place of arms, and cutting away the arms if wings are more suitable, this converted limb, of lion or horse or bird, will be most perfect according to its nature; and this may seem false but can really only be called ingenious or monstrous. And sometimes it is more in accordance with reason to paint a monstrosity (to vary and relax the senses and the object presented to men's eyes, since sometimes they desire to see what they have never seen and think cannot exist) rather than the ordinary figure, admirable though it may be, of man or animals.

THE HUMAN FIGURE THE NOBLEST THEME

To copy each one of those things after its kind seems to me to be indeed to imitate the work of

God; but that work of painting will be most noble and excellent which copies the noblest object and does so with most delicacy and skill. And who is so barbarous as not to understand that the food of a man is nobler than his shoe, and his skin nobler than that of the sheep with which he is clothed, and not to be able to estimate the worth and degree of each thing accordingly?

THE DIFFICULTY OF EASE

And I would tell you, Francisco de Hollanda, a very great excellence of this art of ours, an excellence which you perhaps already know of and will I think consider supreme: that what one must most toil and labor with hard work and study to attain in a painting, after much labor spent on it, it should seem to have been done almost rapidly and with no labor at all, although in fact it was not so. And this needs most excellent skill and art.

An excerpt from Giorgio Vasari's Lives of the Artists.

LIFE OF MICHELANGELO BUONARROTI
FLORENTINE PAINTER, SCULPTOR, AND ARCHITECT, 1475–1564

Enlightened by what had been achieved by the renowned Giotto and his school, all artists of energy and distinction were striving to give the world proof of the talents with which fortune and their own happy temperaments had endowed them. They were all anxious (though their efforts were in vain) to reflect in their work the glories of nature and to attain, as far as possible, perfect artistic discernment or understanding. Meanwhile, the benign ruler of heaven graciously looked down to earth, saw the worthlessness of what was being done, the intense but utterly fruitless studies, and the presumption of men who were farther from true art than night is from day, and resolved to save us from our errors. So he decided to send into the world an artist who

would be skilled in each and every craft, whose work alone would teach us how to attain perfection in design (by correcting drawing and by the use of contour and light and shadows, so as to obtain relief in painting) and how to use right judgement in sculpture and, in architecture, create buildings which would be comfortable and secure, healthy, pleasant to look at, well-proportioned and richly ornamented. Moreover, he determined to give this artist the knowledge of true moral philosophy and the gift of poetic expression, so that everyone might admire and follow him as their perfect example in life, work, and behaviour and in every endeavor, and he would be acclaimed as divine. He also saw that in the practice of these exalted disciplines and arts, namely, painting, sculpture, and architecture, the Tuscan genius has always been pre-eminent, for the Tuscans have devoted to all the various branches of art more labour and study than all the other Italian peoples. And therefore he chose to have Michelangelo born a Florentine, so that one of her own citizens might bring to absolute perfection the achievements for which Florence was already justly renowned.

So in the year 1474 in the Casentino, under a fateful and lucky star, the virtuous and noble wife of Lodovico di Leonardo Buonarroti gave birth to a baby son. That year Lodovico (who was said to be related to the most noble and ancient family of the counts of Canossa) was visiting magistrate at the township of Chiusi and Caprese near the Sasso della Vernia (where St Francis received the stigmata) in the diocese of Arezzo. The boy was born on Sunday, 6 March, about the eighth hour of the night; and without further thought his father decided to call him Michelangelo, being inspired by heaven and convinced that he saw in him something supernatural and beyond human experience. This was evident in the child's horoscope which showed Mercury and Venus in the house of Jupiter, peaceably disposed; in other words, his mind and hands were destined to fashion sublime and magnificent works of art. Now when he had served his term of office

Lodovico returned to Florence and settled in the village of Settignano, three miles from the city, where he had a family farm. That part of the country is very rich in stone, especially in quarries of greystone which are continuously worked by stone-cutters and sculptors, mostly local people; and Michelangelo was put out to nurse with the wife of one of the stone-cutters. That is why once, when he was talking to Vasari, he said jokingly: "Giorgio, if my brains are any good at all it's because I was born in the pure air of your Arezzo countryside, just as with my mothers' milk I sucked the hammer and chisels I use for my statues."

As time passed and Lodovico's family grew bigger he found himself, as he enjoyed only a modest income, in a very difficult circumstance and he had to place his sons in turn with the Wool and Silk Guilds. When Michelangelo was old enough he was sent to grammar school to be taught by Francesco of Urbino; but he was so obsessed by drawing that he used to be scolded and sometimes beaten by his father and the older members of the family, who most likely considered it unworthy of their ancient house for Michelangelo to give his time to an art that meant nothing to them. It was about this time that Michelangelo became friendly with the young Francesco Granacci, who had been sent as a boy to learn the art of painting from Domenico Ghirlandaio.[1] Francesco saw that Michelangelo had a great aptitude for drawing, and as he was very fond of him, he used to supply him every day with drawings by Ghirlandaio, who was then regarded, throughout all Italy let alone in Florence, as one of the finest living masters. As a result Michelangelo grew more ambitious with every day that passed, and when Lodovico realized that there was no hope of forcing him to give up drawing he resolved to put his son's aspirations to some use and make it possible for him to learn the art properly. So on the advice of friends he apprenticed him to Domenico Ghirlandaio.

When this happened Michelangelo was fourteen years old [...].

The way Michelangelo's talents and character developed astonished Domenico, who saw him doing things quite out of the ordinary for boys of his age and not only surpassed his many other pupils but also very often rivaling the achievements of the master himself [...].

Michelangelo's abilities were then clearly recognized by a Roman gentleman called Jacopo Galli, and this discerning person commissioned from him a marble life-size statue of Cupid and then a Bacchus, then spans high, holding a cup in his right hand and the skin of a tiger in his left, with a bunch of grapes which a little satyr is trying to nibble. In this figure it is clear that Michelangelo wanted to obtain a marvelous harmony of various elements, notably in giving it the slenderness of a youth combined with the fullness and roundness of the female form. This splendid achievement showed that Michelangelo could surpass every other sculptor of the modern age. Through the studies he undertook while in Rome he acquired such great skill that he was able to solve incredibly difficult problems and to express in a style of effortless facility the most elevated concepts, to the sheer amazement not only of those who lacked the experience to judge but also of men accustomed to excellent work. All the other works then being created were regarded as trivial compared with what Michelangelo was producing. As a result the French cardinal of Saint-Denis, called Cardinal Rouen,[2] became anxious to employ his rare talents to leave some suitable memorial of himself in the great city of Rome; and so he commissioned Michelangelo to make a Pietà of marble in the round, and this was placed, after it was finished, in the chapel of the Madonna della Febbre in St Peter's, where the temple of Mars once stood. It would be impossible for any craftsman or sculptor no matter how brilliant ever to surpass the grace or design of this work or try to cut and polish the marble with the skill that Michelangelo displayed. For then Pietà was a revelation of all the potentialities and force of the art of sculpture. Among the many beautiful fea-

tures (including the inspired draperies) this is notably demonstrated by the body of Christ itself. It would be impossible to find a body showing greater mastery of art and possessing more beautiful members, or a nude with more detail in the muscles, veins, and nerves stretched over their framework of bones, or a more deathly corpse. The lovely expression of the head, the harmony in the joints and attachments of the arms, legs, and trunk, and the fine tracery of pulses and veins are all so wonderful that is staggers belief that the hand of an artist could have executed this inspired and admirable work so perfectly and in so short a time. It is certainly a miracle that a formless block of stone could ever have been reduced to a perfection that nature is scarcely able to create in the flesh. Michelangelo put into this work so much love and effort that (something he never did again) he left his name written across the sash over Our Lady's breast. The reason for this was that one day he went along to where the statue was and found a crowd of strangers from Lombardy singing its praises; then one of them asked another who made it, only to be told: "Our Gobbo from Milan."[3]

Michelangelo stood there not saying a word, but thinking it very odd to have all his efforts attributed to someone else. Then one night, taking his chisels, he shut himself in with a light and carved his name on the statue . . .

Then some of his friends wrote to him from Florence urging him to return there as it seemed very probable that he would be able to obtain the block of marble that was standing in the Office of Works. Piero Soderini, who about that time was elected Gonfalonier for life,[4] had often talked of handing it over to Leonardo da Vinci, but he was then arranging to give it to Andrea Contucci of Monte Sansovino, an accomplished sculptor who was very keen to have it. Now, although it seemed impossible to carve from the block a complete figure (and only Michelangelo was bold enough to try this without adding fresh pieces) Buonarroti had felt the desire to work on it many years before; and he tried to obtain it when he came back to Florence. The marble was eighteen feet high, but unfortunately an artist called Simone da Fiesole had started to carve a giant figure, and had bungled the work so badly that he had hacked a hole between the legs and left the block completely botched and misshapen. So the wardens of Santa Maria del Fiore (who were in charge of the undertaking) threw the block aside and it stayed abandoned for many years and seemed likely to remain so indefinitely. However, Michelangelo measured it again and calculated whether he carve a satisfactory figure from the block by accommodating its attitude to the shape of the stone. Then he made up his mind to ask for it. Soderini and the wardens decided that they would let him have it, as being something of little value, and telling themselves that since the stone was of no use to their building, either botched as it was or broken up, whatever Michelangelo made would be worth wile. So Michelangelo made a wax model of the young David with a sling in his hand; this was intended as a symbol of liberty for the Palace, signifying that just as David had protected his people and governed them justly, so whoever ruled Florence should vigorously defend the city and govern it with justice. He began work on the statue in the Office of Works of Santa Maria del Fiore, erecting a partition of planks and trestles around the marble; and working on it continuously he brought it to perfect completion, without letting anyone else see it.

As I said, the marble had been flawed and distorted by Simone, and in some places Michelangelo could not work it as he wanted; so he allowed some of the original chisel marks made by Simone to remain on the edges of the marble, and these can still be seen today. And all things considered, Michelangelo worked a miracle in restoring to life something that had been left dead.

After the statue had been finished, its great size provoked endless disputes over the best way to

transport it to the Piazza della Signora. However, Giuliano da Sangallo, with his brother Antonio, constructed a very strong wooden framework and suspended the statue from it with ropes so that when moved it would sway gently without being broken; then they drew it along by means of winches over planks laid on the ground, and put it in place. In the rope which held the figure suspended he tied a slip-knot which tightened as the weight increased: a beautiful and ingenious arrangement. (I have a drawing by his own hand in my book showing this admirable, strong, and secure device for suspending weights.)

When he saw the David in place Piero Soderini was delighted; but while Michelangelo was retouching it he remarked that he thought the nose was too thick. Michelangelo noticing that the Gonfalonier was standing beneath the Giant and that from where he was he could not see the figure properly, to satisfy him he climbed on the scaffolding by the shoulders, seized hold of a chisel in his left hand, together with some of the marble dust lying on the planks, and as he tapped lightly with the chisel let the dust fall little by little, without altering anything. Then he looked down at the Gonfalonier, who had stopped to watch, and said:

"Now look at it."

"Ah, that's much better," replied Soderini. "Now you've really brought it to life." [...]

The David (for which Piero Soderini paid Michelangelo four hundred crowns) was put in position in the year 1504. It established Michelangelo's reputation as a sculptor and he went on to make for the Gonfalonier a very fine David in bronze, which Soderini sent to France . . .

Eventually [Michelangelo was asked by Pope Julius] to paint, as a memorial for his uncle Sixtus, the ceiling of the chapel that he had built in the Vatican. Michelangelo

[...] Considering the magnitude and difficulty of the task of painting the chapel, and his lack of experience, tried in every possible way to shake the burden off his shoulders. But the more he refused, the more determined he made the Pope, who was a willful man by nature [...].

However, seeing that his holiness was persevering, [he] resigned himself to doing what he was asked [...].

Michelangelo then started making the cartoons for the vaulting; and the Pope also decided that the walls that had been painted by previous artists in the time of Sixtus should be scraped clean and that Michelangelo should have fifteen thousand ducats for the cost of the work, the price being decided through Giuliano da Sangallo. Then being forced reluctantly, by the magnitude of the task, to take on some assistants, Michelangelo sent for help to Florence. He was anxious to show that his paintings would surpass the work done earlier, and he was determined to show modern artists how to draw and paint. Indeed, the circumstances of this undertaking encouraged Michelangelo to aim very high, for the sake both of his own reputation and the art of painting; and hi this mood he started and finished the cartoons. He was then ready to begin the frescoes, but he lacked the necessary experience. Meanwhile, some of his friends, who were painters, came to Rome from Florence in order to assist him and let him see their technique. Several of them were skilled painters in fresco, and they included Granaccio, Giuliano Bugiardini, Jacopo di Sandro, the elder Indaco, Angelo di Donnino, and Aristotile. Having started the work, Michelangelo asked them to produce some examples of what they could do. But when he saw that these were nothing like what he wanted he grew dissatisfied, and then one morning he made up his mind to scrap everything they had done. He shut himself up in the chapel, refused to let them in again, and would never let them see him even while he was at home. So, when they thought the joke was wearing thin, they accepted their dismissal and went back ashamed to Florence.

Thereupon, having arranged to do all the work himself, Michelangelo carried it well on the way to

completion; working with the utmost solicitude, labor, and study he refused to let anyone see him in case he would have to show what he was painting. As a result every day the people became more impatient.

Pope Julius himself was always keen to see whatever Michelangelo was doing, and so naturally he was ore anxious than ever to see what was being hidden from him. So one day he resolved to go and see the work but he was not allowed in, as Michelangelo would never have consented . . . Now when a third of the work was completed (as I found out from Michelangelo himself, to clear up any uncertainty) during the winter when the north wind was blowing several spots of mould started to appear on the surface. The reason for this was that the Roman lime, which is white in color and made of travertine, does not dry very quickly, and when mixed with pozzolana[5] which is a brownish color, forms a dark mixture which is very watery before it sets; then after the wall has been thoroughly soaked, it often effloresces when it is drying. When Michelangelo saw what was happening he despaired of the whole undertaking and was reluctant to go on. However, his holiness sent Giuliano da Sangallo to see him and explain the reason for the blemishes. Sangallo explained how to remove the moulds and encouraged him to continue.

[…] And so in twenty months Michelangelo brought the project to perfect completion without the assistance even of someone to grind his colors. Michelangelo at time complained that because of the haste the Pope imposed on him he was unable to finish it in the way he would have liked; for his holiness was always asking him importunately when it would be ready. On one of these occasions Michelangelo retorted that the ceiling would be finished "when it satisfies me as an artist."

And to this the Pope replied: "And we want to satisfy us and finish soon."

Finally the Pope threatened that if Michelandid not finish the ceiling quickly he would have him thrown down from the scaffolding. Then Michelangelo, who had good reason to fear the Pope's anger, lost no time in doing all that was wanted; and after taking down the rest of the scaffoldings he threw the ceiling open to the public on the morning of All Saint's Day, when the Pope went into the chapel to sing Mass, to the satisfaction o the entire city.

[1] Domenico Ghirlandaio (1449–1494), a competent painter, chiefly in fresco, who ran a large family studio in Florence.

[2] This was Jean Villier de la Grolaie, abbot of Saint-Denis and cardinal of Santa Sabina.

[3] Cristoforo Solari.

[4] Soderini was elected *Gonfaloniere di Justizia* for life (in effect, head of the Florentine Republic) in 1502.

[5] A volcanic dust found near Pozzuoli.

Concise Bibliography

Bull, George. *Michelangelo: A Biography*. New York: Viking, 1995.

Buonarroti, Michelangelo. *Complete Poems and Sacred Letters of Michelangelo*. Trans. Creighton E. Gilbert. Princeton: Princeton University Press, 1980.

Feller, Robert L. *Artists' Pigments: A Handbook of Their History and Characteristics*. Reprint, National Gallery of Art, 1993.

Goldwater, Robert, and Marco Treves, eds. *Artists on Art from the XIV to the XX Century*. New York: Pantheon Books, 1945.

Merrifield, Mary. *The Art of Fresco Painting*. 1846. Reprint, London: Alec Tiranti, 1966.

Partridge, Loren. *Michelangelo: The Sistine Chapel Ceiling, Rome*. New York: George Braziller, Inc., 1996.

Reeves, Marjorie, ed. *Prophetic Rome in the High Renaissance Period: Essays*. New York: Oxford University Press, 1992.

Ryan, Christopher. *The Poetry of Michelangelo: An Introduction*. London: Athlone, 1998.

Summers, David. *Michelangelo and the Language of Art*. Princeton: Princeton University Press, 1981.

Tolnay, Charles de. *The Art and Thought of Michelangelo*. New York: Pantheon Books, 1964.

Vasari, Giorgio. *Lives of the Artists (Volume I)*. Trans. George Bull. London: Penguin Books Ltd., 1987.

Wallace, William E. *Michelangelo: The Complete Sculpture, Painting, Architecture*. New York: Hugh Lauter Levin Associates, 1998.

Welch, Evelyn. *Art in Renaissance Italy*. Oxford: Oxford University Press, 1974.

Vatican City

Creation of Eve
Fresco, 170 x 260 cm
Vatican City, Sistine Chapel
1509–1510

Cumaean Sibyl
Fresco, 375 x 380 cm
Vatican City, Sistine Chapel
1510

Creation of Adam
Fresco, 280 x 570 cm
Vatican City, Sistine Chapel
1510

Ancestors of Christ
(spandrel above the
Hezekiah- Manasseh-Amon
lunette)
Fresco, 245 x 340 cm
Vatican City, Sistine Chapel
1510

Prophet Jeremiah
Fresco, 390 x 380 cm
Vatican City, Sistine Chapel
1511

Libyan Sibyl
Fresco, 395 x 380 cm
Vatican City, Sistine Chapel
1511

Prophet Jonah
Fresco, 400 x 380 cm
Vatican City, Sistine Chapel
1511

*Separation of the Earth
from the Waters*
Fresco, 155 x 260 cm
Vatican City, Sistine Chapel
1511

*Creation of the Plants
and of the Sun and Moon*
Fresco, 280 x 570 cm
Vatican City, Sistine Chapel
1511

*Separation of Light from
Darkness*
Fresco, 180 x 260 cm
Vatican City, Sistine Chapel
1511